THE EGG ROCKER

BOOKS BY JACK GUNTER

Wally Winchester Adventures:
Original Finish
The Egg Rocker
Mother of God

*A Pictorial History of the Pacific Northwest
Including the Future*

The Gunter Papers

THE
EGG ROCKER

JACK GUNTER

A WALLY WINCHESTER ADVENTURE

Jack Gunter

#2

Flying Pig Publications
Camano Island, Washington
flyngpig@camano.net

This novel is a work of fiction. Names, characters, places, and incidents either are products of the author's imagination or are products of historical record or geographic descriptions used fictitiously. Any resemblance to actual persons, living or dead, is pure coincidence.

ISBN 13: 978-0-9841841-1-8
ISBN 10: 0-9841841-1-2
All rights reserved.

Printed in the United States of America by Ingram Books

Cover design from an original painting by Jack Gunter

Journey I

Chapter One

Camano Island, Washington

The pair of vintage Native American baskets sitting precariously on the dashboard didn't block Wally Winchester's view of traffic ahead as he drove north on Interstate Five, but they were a distraction, particularly the Tlingit basket with the rattle in the lid. His eyes danced between his score and the late afternoon commuter traffic near the Camano Island exit. He chided himself for driving with 2,000 dollars worth of fragile Indian handwork sitting unprotected in front of him, but couldn't help smiling as he marveled at intricate patterns woven a hundred years ago.

Three boxes behind him in the van held the rest of the afternoon's picking: a hand-hammered copper bowl, a collection of mechanical lamps from an old factory, and a Victorian burial contraption, unopened, in the original box. He'd promised himself he'd pull off the highway and put the baskets safely in the back with the rest of the booty; but, as he turned toward the shoreline and the bridge to the island, he turned up the volume of the blues station on the radio. He was almost home.

In the Pacific Northwest, a constant drizzle shows up the same time Daylight Savings Time gives back its hour. Wet weather and

early darkness rule here, unquestioned, until April, when sunlight returns.

Under a layer of thick overcast, the last gasp of clear tangerine sky gleamed above the distant Olympic Mountains. Orange and purple and brown light kissed the cloud bottom, turning it into a Technicolor quilt with a sawtooth sunset fringe. The shortcut to Rocky Ledge Way took him over Camano Heights, past its startling panorama of Puget Sound, down into the bungalow community on the west slope of Camano Island. He lived at the end of a cul-de-sac on Rocky Point Drive. A weathered black and gold-painted sign at the top of the driveway announced "Wright's Rest Home" in fancy Victorian lettering.

Wally saluted the old sign and smiled. He collected objects designed by Frank Lloyd Wright, or thought he did, owning two 1950s knockoff chairs and a bath towel from the Arizona Biltmore Hotel.

His five-year flirtation with the prettiest girl on the island had grew into a partnership a lot like marriage and a cliff-side dream house with picture windows open to spectacular sunsets over the Olympics. Living with Rae Roberts included a two-story 1930s hand-built settler's beach cottage with a daylight basement, near the house. Thirty feet of front yard, dotted with gnarly pines and madrona trees, ended at a precipice with 90 feet of nothing to the rocky beach below. Behind the house, a concrete driveway climbed steeply toward the road above. Two acres of old second growth trees and raspberry thickets buffered the back yard. Wally negotiated the driveway through towering trunks of Douglas fir, hoping Rae was already there. He spotted the tan Ford Explorer parked in the gravel clearing above the cabin and smiled.

Nothing for you today, Rae, darn it, he thought. He enjoyed scouting out odd camera parts and old snapshot albums for his lady, a photographer by profession. He glanced into the back and flipped on the interior light, unable to remember the last time he left his van

2

without an armload just for her. He weighed his options and reached for the baskets on the dash.

Something was up. Wally knew it walking into the kitchen from the mudroom. The usually antique light-filled kitchen was dull amber, lit only by tall candles glowing yellow over the Stickley director's table in the gloom; vintage Mission oak rippled in the flickering light, an effect Wally found pleasing, but unusual. Soft music was playing.

What is it? he wondered. *Salsa? Castanets? Appalachian Dulcimer?*

"Rae?" he asked softly.

Silence.

Tomatoes bubbling with cilantro, corn tortillas warming in oil, and chili peppers tweaked his nose.

"POP!"

He followed the sound toward the dark bedroom door; a trail of *National Geographic* magazines, lit by a turn-of-the-century sconce, littered the carpeted floor like steppingstones.

Wally followed the paper path, dropped his voice to a growl, saying, "Rae Roberts? This is the Homeland Security Police. I'm here to inspect your hard drive."

A voice wafted from the bedroom like perfume.

"Hi, honey. Welcome home."

Wally craned his neck around the doorframe for a peek. His favorite bookcase, a dark Limbert glass-fronted cabinet displayed his best art pottery, ceramics too pricey to leave out on a table. His scan scrolled past Austrian Secession chairs and tables and a large window with drawn curtains.

"Hello ... lover." Rae sat on their low, simple mahogany platform bed. Her back rested against the wall, a flannel sheet pulled up to her armpits. She wore a tan pith helmet and apparently little else,

her pert short haircut framing her attractive face, chin up in a cocky smile.

Her motor-drive Nikon hung from a leather strap around her neck.

Wally started. "Is that a telephoto lens, or are you glad to see me?"

"That's supposed to be my line, hon."

She moved her shoulders and a breast slipped into view. Then the other. Foam from an uncorked champagne bottle sparkled on the side table.

"This is quite a reception. What's up?"

"I think that's my line, also, Mr. Winchester. Why don't you loosen that antique dealer's collar and help me celebrate?"

The cause for celebration wasn't clear, but Wally began to unbutton his shirt. He was down to the last button, shoes kicked off, when he noticed the high-hipped cocktail glasses on the bentwood side table next to the bed.

"Looks like you dropped some magazines." Wally carefully poured champagne into the Josef Hoffmann glasses, a recent eBay score, and turned toward the bed. Her nude thigh greeted him as he pulled back the sheet and slipped in beside her.

"Did you notice which magazines?" Rae asked the question as if it were normal to carry on a conversation wearing nothing but a pith helmet and a Nikon. "You missed some clues."

Her nipples, as usual, were at attention, clouding Wally's logic flow. Two drops of the champagne puddle fell from the base of her glass and landed on the upper curve of her breast, shimmered, then rolled into the valley between, where they formed a larger droplet.

Wally's gaze followed the two wet tracks down into her cleavage. Remarkably, tiny bubble streams still rose within the drop nestled there.

4

"Those aren't the clues you're supposed to be following, Sherlock. What kind of magazines are on the floor?"

"*National Geographic.*"

"OK, now can you smell food cooking?"

"Yum."

The droplet of wine continued its journey south, across her well-defined ribcage. He followed it with his eyes till she brushed it into a wet smear on her belly.

"Wally! Pay attention! Hear the music?"

"Latin, sounds like."

"Just like the food, bub, it's South American. Do the math."

Wally brought his head up and looked her in the eye.

"Camera, magazine, safari gear, salsa music ..." his eyes widened. "You got a photo shoot? In the jungle? In South America? Mexico? East LA?"

"I got the brass ring! *National Geographic!*"

"Wow! I'm so happy for you."

"The call came out of the blue around noon. From the art director. Seems she saw my pinhole photo in that magazine article. The one with the phantom young people."

Wally knew it well. A shoreline view of Fort Defiance Park in Tacoma. Handmade pinhole camera-f250. Exposure time, 10 minutes. Strollers, children, type-A personalities on cell phones, skateboarders, old people on benches, old growth trees and a granite cliff face as a backdrop, people evaporating into gossamer streaks as they moved through the photo frame. A lot of life passed in front of Rae's handmade pinhole during that 10 minutes, but the ageless shoreline and its forest were the only things captured clearly by her long exposure. A young couple on a distant blanket appeared as two hazy heads above a blur of arms and legs.

It was a very popular picture in Pacific Northwest photo circles. The Okanogan Museum of History and Art, near the Canadian border, featured the photo in a group show. It had landed Rae, along with 15 other pinhole artists, in the July issue of *Photo World*. Now this!

Wally settled back beside her. "About time they realized how good you are—"

"Listen, Wally, they told me that archaeologists in Chile have made a big discovery. They've found the remains of a human encampment. Maybe 20,000 years old. Lots of accessory artifacts.

"*National Geographic* has the exclusive. They asked their art director to come up with a new angle. She remembered the Fort Defiance Park pinhole shot from *Photo World*, and asked me what kind of images would result from a long exposure of archaeologists digging and moving.

"I told her the photo of the dig site would be crystal clear with human movement causing a significant blur. An archaeologist sitting, brushing dust off an artifact would be solid with a smear where the hands should be. A person who moved all over the site during the exposure would hardly show up at all. She likes the irony, says she lives in New York City. Tells me I'm in. I get a 20 photo spread, humans as the fleeting artifacts. They're offering me a free two week trip to Chile, Wally, and I can take a guest. How's your Spanish?"

"South America?"

"Yes, Wally, we're going to South America."

"Hot damn, girl," he said. "I've had South America on my mind."

Amazingly cool antiques in South America were one of Wally's best-kept secrets. His awareness of a vast undiscovered decorative art storehouse stretching 7,000 miles from Texas to the tip of Tierra del Fuego had been growing since two months ago. He'd

found a link to a Spanish- and Portuguese-language version of eBay. He'd visited South America every week since then, scrolling through the used furniture, lighting, and old transistor radios offered by Brazilians and Chileans and Argentines. Their target customers were other South Americans. Their site had no provision for English translation.

Wally liked that. A techie buddy had turned him onto a web site that translated text and even other web sites into English—sometimes with hilarious results. He liked that also. Convinced he was one of the few Anglos who knew of the sites and, therefore, could search for his dream objects without competition, he scanned the columns of online auction photos, ignoring the foreign words, jumping over to a translation when he found something worth looking into.

He hadn't dared buy anything from the site yet, though he'd been tempted to sign up and bid for a German tin toy and a collectible pair of gimmick eyeglasses in their original 1910 cardboard box. Neat objects from South America beckoned to him every week on the computer monitor, but he was shy of the payment process away from the safe haven of PayPal. A pricey Western Union money order and 10,000 miles of trust were a daunting proposition.

Wally called it "virtual picking," a sport, a diversion on a weekday evening while working on a bottle of cheap Merlot. For him it was a harmless exercise in "what if?"

The idea of actually traveling to the source in person was electrifying.

Rae sat up again, pulling Wally's attention back to her pretty breasts.

"Well, Wally, whaddaya think? Do you want to go?"

"Besa muy bicho, señorita?" Wally tossed out an attempt at a really bad pickup line, remembering some locker room Spanish.

"Oh lay, señor."
Wally put down his glass.

Chapter Two

Camano Island, Washington

Sitting naked from the waist down in an ant-shaped 1960s chair, Wally gave the computer monitor the finger. Warren Zevon croaked out *Werewolves of London* quietly in the background. The aroma of an uneaten South American dinner permeated the basement office. Wearing Rae's safari khaki shirt and her pith helmet, he sat at the portal to the World Wide Web.

"Let me in, you son of a bitch," he mumbled as he peered into the monitor's glow; he clicked *submit* again and a warning appeared:

UNABLE TO ESTABLISH A SECURE CONNECTION! PROBLEM WITH SECURITY CERTIFICATE FROM THAT SITE.
INFORMATION YOU VIEW AND SEND WILL BE READABLE TO OTHERS IN TRANSIT. AND IT MAY NOT GO TO THE INTENDED PARTY ... CONTINUE LOADING THIS PAGE?

The screen offered a *Continue* and a *Stop* option. He grimaced and clicked *Continue*. A Spanish-language membership form appeared. As he copied the URL address for pasting on Babelfish, his free translation web-helper, he noticed a blinking desktop icon signaling incoming e-mail. Wally opened the mail window to South Camano Charlie, a local techie who kept hacker's hours and apparently never slept, looking for wee hour conversation.

"Wally, you up? Got your ears on?"

"Doing a little after-hours shopping south of the border." Wally typed back.

"Still looking for your big score?"

"I think I've found something fucking amazing for sale in Argentina, but can't get into the site to buy it. Goddamn foreign language forms. They keep asking me for my Argentine home address."

A membership form, with bright yellow accent bars highlighting a page full of questions and prompts in badly translated English, now shared the monitor screen.

"Why are you looking for things in Argentina?"

"I'm betting that nobody I compete with looks there." Wally typed. "Imagine a minor league eBay with a whole continent's worth of the bizarre and mundane for sale. All in Spanish or Portuguese. None of this stuff gets to the big eBay page."

"What's for sale in South America that keeps you up so late?"

"All kinds of things. Old and newer used telephones, lot of radios, mostly. Seems that two dealers in Brazil and Argentina are selling about half the items on the site. The stuff for sale is mostly mom and pop—bad ceramic figurines and lamps with poodle-dog shades. Ever look there?"

"Never."

"In Brazil there's a Tiffany Studios bronze and glass box for sale. Nobody's tried to buy it. I expect I could win it with a 300 dollar opening bid. Unbelievable. Great Bakelite 1940s radios on sale there, too. No bidders yet. Five days left. I can buy a *pate de verre*, that's French for "paste of glass," box in green, with nude ladies on it. Really nice work. French, you know. Figure it about 1920 vintage. Could be Lalique. And then there's a Philco *Predicta* TV set that looks like it fell from space in 1952."

"South America's a long way off, amigo."

"I've always been afraid to bid on anything bigger than a breadbox because of shipping costs, but Rae just got invited to South America to take photos for a magazine, and I'm invited. Me being actually down there changes everything."

"You going to fill a container?"

"Probably not. It's Rae's trip. I don't want step on her good time with a complicated business deal. Going there personally does allow me to consider buying a piece of furniture and bring it back on the plane. That's what I'm doing tonight. Looking at furniture, found something really, really good on a site, *Mercadolibre*. Terrible photograph. Seems to be an Austrian rocking chair, coolest design I've seen. Ever. A high-end piece. Collectors call it the egg rocker. I want a better photo or description but that means registering in Argentina's site and traveling through non-secure cyberspace to communicate with the seller. Even then the forms don't translate."

"Fucking forms. I hate computers. And by the way, Wally, congratulations on finding the caps key."

"Yeah, it's that little button on the left of the keyboard. I only use it for emphasis. I hate computers too, except when I'm drinking wine and shopping. Don't worry, I'll get in. I've got to buy this chair. Respect."

Forty minutes later, Wally e-mailed back: "I'm in. I bid. I bet I get it. Hot damn."

"Crazy fucker. How do you know it's real?"

"I'll figure that out when we get there."

"South America is huge, you know. Argentina is the size of the United States."

"From what I can determine from the Spanish, this chair's in Rio Negro. I think that's a province. We'll be somewhere near the middle of Chile, close to the ocean, on Rae's assignment."

"Have you looked at a map? All of Chile is close to the ocean."

"I can dash over the border into Argentina if I win it, and pick it up."

"How much did you bid on this chair, the image of which you can't quite make out, in some foreign country you've never been to, sold by an amateur you've never met?"

"Only 500 so far."

"Five hundred what? Dollars, pesos, Monopoly money?"

"Not sure yet. Whatever the Argentine dollar is. Must be less than US dollars. Don't you think?"

"You don't know what the numbers mean and you're bidding anyway? You're a nutcase, Winchester."

"Who cares? Five hundred of anything is cheap for this chair if I get it. I'm willing to bet no one who knows the egg rocker has ever found this site. You need a PhD in Spanish bureaucracy to get logged in. I think I'm all alone on this one. It looks like the auction runs 20 more days. By then we'll be in Monte Verde, Chile. I'll just drive over to Argentina and pick it up."

"Driving over to pick it up might mean like driving from Seattle to LA, you know."

"I'd drive to LA twice for this son of a bitch. It's the EGG ROCKER!"

"What do you mean, 'egg rocker'?"

"It's a bentwood rocking chair in the shape of an oval—designed by an Austrian genius, Josef Hoffmann, in 1900. A brilliantly simple, elegant design. Last one that showed up was estimated to bring 50,000. That was back in the 1980s, at a Christies' art nouveau auction."

"How do you know it's the real thing from 10,000 miles away?"

"If anyone has gone to the trouble of faking this chair, they would have made better photos, and they wouldn't be selling it for

peanuts in an obscure Internet auction in Argentina. It's gotta be right."

"Good god, good luck, and good night!"

Wally checked his messages from the day before. Only one was of interest, an e-mail from Serbia. Yvgeney Ivanchenko, a Russian Wally had met on a crazy weekend on Vancouver Island the year before. Yvgeney was miserable, according to his rambling two page missive. "I'm tired of this country," he wrote. "There's an anger here that people wear on their sleeves. The anger inside is greater yet. You can see it in their eyes. So many outrages. I've heard tales of atrocities that make Stalin look like the Flying Nun."

Despite the sad tone of the message, Wally smiled. *Good old Yvgeney*, he thought, *still thinks he's an expert in American pop culture*. He read on.

"Next week, the UN sends me to Milosevic's private retreat in the hills outside Belgrade. What a crazy world we live in. Searching for stolen religious and art treasures in this godforsaken land is the most difficult assignment I've ever received. Unraveling the web of lies and misdirection here is more difficult than guessing an Alfred Hitchcock ending after five minutes. A Frenchman and one bodyguard and I have been granted one day to search the Serbian version of Camp David. Part of a complicated plea-bargain that Slobodan cooked up at his trial before he died. I miss my sweet Lucy. I even miss you. Even your job as an antique dealer looks good to me right now. Wish me luck."

A faint glow on the horizon signaled the approach of another day. Wally typed back, "Don't forget to wear your iron underpants, my friend. And keep your head down."

At 4:15 a.m. Wally hit the sleep button on the screen and went searching for the last of Rae's champagne

Chapter Three

Over Central America, altitude: 40,000 feet

Wally often thought out loud under the pretext of conversation. Rae is used to it.

"I sometimes wonder," he said, "if I'm the only North American Anglo who looks at Brazilian eBay in the original Portuguese."

She sat beside him in the exit row that Wally had demanded. Most of the passengers on the L-1011 Flight 334, nonstop to Santiago, were asleep, aided by the cocktails provided by LAN Chile Airlines. Two miles below, a white blanket of moonlit clouds covered what Wally figured to be South American jungle.

"Are you still talking about the chair you bid on last week?" asked Rae. She was working her way through the second Sam Adams Ale of the flight.

Wally was thinking tall women always look good drinking beer. Illuminated in the dark plane by the reading light, she looked sporty in an L. L. Bean-type safari shirt. The toes of her hiking boots protruded from the bottom of the airline blanket. The overhead light made her red-blonde hair glow angelically as she rolled her eyes, bent her head back to her book.

Wally thought he looked sharp, too. His khaki shirt had two pockets with flaps and snaps instead of buttons. His jeans said, *Unemployed auto mechanic from Detroit on vacation.*

Flight 334 was nearing the halfway point in a red-eye hop with a 7:00 a.m. arrival in Chile.

"Do you think your film got through the new bomb detectors?" Wally was on small bottle number three of a pretty decent Chilean Merlot.

"It's only really fast film, anything over 400 ASA, like Tri-X gets wiped out. The film for the pinhole shots is really slow, that's where I get my clarity. My film is only a little more sensitive than toilet paper. It'll get through anybody's neutron ray machine."

"How about the other gear?"

Rae had brought a backup Nikon along with a 2 1/4-square format Kowa Six SLR from the 1970s, old but still capable of wonderful photos.

"I'm shooting slow film in all the cameras, Velvia slides and pro black-and-white. It'll all be fine. How about you? Did you remember to pack some memory?"

"Two chips, 240 megs."

Wally patted the pocket that held his Olympus Camedia, a little workhorse that had vastly improved his life as shoot-from-the-hip antique picker, the best 400 dollars he ever spent. He looked out. The moon was somewhere else now, hiding on the other side of the earth. They were over Colombia, according to the LAN route map at the back of the airline's magazine. Wally stretched and opened the *Lonely Planet Guide to South America* again. The lack of information that both Wally and Rae had concerning anything about South America would fill a book, and it did. That book was open in front of him.

He knew the shape of the continent from third grade geography; he knew most of the country names except for the Guyanas, and maybe which one is Paraguay and which one Uruguay. He knew that Brazilians speak Portuguese and people in the other countries speak Spanish. Rae's understanding was also limited. She knew that there was a huge ecosystem in jeopardy in the Amazon Basin, and she had a smattering of information about Argentinean

politics because she'd seen *Evita* in New York City on the stage and another time as a movie.

"We'll be following the Andes south, according to this map," Wally said, switching back to the magazine. "I hope we catch the mountains at sunrise before we land."

"We'll see plenty of peaks from Santiago to Puerto Montt, hon."

He closed his eyes and slept.

Wally the rheumy-eyed gringo appeared to be in charge when they exited the L-1011 in Santiago.

"Are you sure we don't need traveler's checks or US cash?" Rae had asked before the departure.

"Leave it all to me, babe."

Wally's vast storehouse of knowledge of the Chilean nation, including the entry requirements, had been gleaned during a two-week attempt to log on to an Argentina eBay site. He'd thumbed through the *Lonely Planet Guide* as he struggled with the on-line Spanish language forms. After a couple of days reading the guidebook in front of his monitor, he felt like a native.

The path into the airport brought them past a group of fellow Americans queued up at a booth bearing the sign, *Reciprocity*.

"We don't need any reciprocity. I've got an ATM card." Wally said, confident as he steered Rae, rolling her two suitcases behind her, up to the sparsely populated lines at the customs and immigration booths. A couple in front of them at the checkpoint received approval with the "clunk-k" of the stamping tool and passed through toward the Chilean morning beyond. The attendant in the box signaled them

forward with eye contact and a nod. Wally stepped forward with an air of assurance. Rae, dragging the bags, followed him to the window.

"*Buenas dias*," he announced, using one of his three known phrases. He mustered up his best foreign tourist smile, designed to exude confidence, friendship, and trust simultaneously.

The attendant scowled as he opened the first of the pair's passports. Wally's declaration of entry sheet stated that the reason for visiting Chile was "b. Vacation." No need to alarm the locals that the world's savviest antique scout was in their midst. He held his vacation declaration in a folded square.

"No good." The stern guard spoke the bad news in bad English, looking back and forth at Wally and the passport.

"*Reciprocita ... aquí.*" He pointed to the passport book, and then back to the bedraggled group of North Americans backed up at the bypassed kiosk.

"I guess we have to get some approval back there after all," Wally translated to Rae, trying to avoid the daggers building in her sleep-deprived eyes.

"Wait here with the luggage and I'll go over and straighten this out."

"Our connecting flight leaves for Puerto Montt in 40 minutes, Walter."

"Don't worry, I'll be back in a jiff."

Wally ambled over to take his place at the end of the reciprocity kiosk. Four transactions later, it was his turn.

"Two hundred dollars, please," said a hatchet-faced woman inside the booth. Various statements in Spanish had been taped to the window from the inside. Wally peered in between the pronouncements and disclaimers. He had a difficult time maintaining his innocent tourist smile.

He pulled the ATM VISA card out of his wallet, which he carried awkwardly in the front right jean pocket as precaution against theft, as did all savvy travelers. The card had been sold to him by his neighbors at the Wells Fargo Bank as the only and sure way to get cash in South America without getting screwed.

"No credit card, señor. Cash."

"Look, señora. I just got here. Where's the ATM machine?"

"*¿Porqué?*"

"El machino for cash," Wally said slowly. He began to get nervous as he scanned the sterile, secure chamber between the airplane and the immigration booths, where he'd already been turned back. If there were a cash machine here, he couldn't see it. He turned to address his frowning partner, sitting on the luggage, tapping her foot. He attempted to wipe the rising uncertainty off his face.

It was unsuccessful and she caught it.

"What's wrong, Indiana Jones?"

"Aw, Rae, how much cash do you have on you?"

"Right here in my pocket?"

"Yes. Right here."

Rae's scowl deepened. She dug into her jeans, pulling out a matted wad of green.

"I've got 55 dollars."

"Shit."

"*A donde ATM?*" Another triumph of eighth-grade Spanish.

The hawknosed woman pointed out past the barriers.

"*Usted es suposed para tener doscientos dólares con usted en el efectivo de Estados Unidas, idiota, la máquina de la atmósfera está hacia fuera al lado de la calle, buena suerte.*"

She spoke it quickly, apparently knowing that none of it was getting through.

"Out there, past the customs guys, somewhere out in the terminal?"

"*Sí.*" She smiled.

"We have about 24 minutes to catch the connection to Puerto Montt, Wally."

The vague memory of the word "reciprocity" came to mind as something he'd meant to get back to in the tourist guide. Wally banished the troubling semi-recollection and focused on the problem here. He thought about asking some of the few remaining North Americans to loan him the cash necessary to get to the ATM machine, but realized that he'd been warned, in the same tourist guide, about people like himself.

Avoiding eye contact with Rae, he summoned an attitude of relaxed superiority, and sidled as un-cockroach-like as possible to the only booth still manned in the nearly empty hall. It was the one marked for diplomats.

"Excuse?" Wally now assumed that by dropping the word "me" from "excuse me" it would sound a little bit more European, and thus clearer.

The soldier looked up.

"*Ya quiero a ATM machino.*" Wally asked.

The stout guard pointed to the customs inspection station awaiting him down the hall, another barrier between Wally and the outside terminal.

"*Yo no hablas el stampo. Ya quiero ATM?*" Wally pointed to the blank spot on the passport for the reciprocity stamp. He was glad that the old Spanish lessons were coming back so quickly.

The guard looked at Wally's best hopeless face and then to the clearly pissed off partner sitting on the luggage and realized that justice would not be denied. He gestured for Wally's passport and he got it.

"Go on," the guard said, pointing to the terminal gates beyond.

Wally's heart leapt, thankful for this egregious breach of airport security.

Thirty meters ahead, he got the same break from a bored customs official. The next hurdle was the Chilean cop by the x-ray machine. Wally, now without passport, wanted to be remembered by this guy upon his return in five minutes with a fist full of cash. Pulling on his cheeks like Bozo the Clown, he wiggled his tongue and made a scary face, embarrassing himself, but hoping for memory insurance on the way back in.

"*A donde ATM?*" he asked again to strangers in the terminal who looked like they'd been to a bank lately. Hands pointed to the exit door to the street, 50 yards away. He ran.

Fifteen minutes left.

A group of taxi drivers stood chatting near the door in the shade of a canopy between Wally and the cash machine. They parted to let him through.

Wally nervously looked behind him and slammed in the debit card.

A "welcome" in Spanish appeared; the message was unintelligible, except for a yellow lettered option labeled *Continuar*. He pressed the metal bar beside it. More Spanish appeared on the screen.

This must be where you enter your code, Wally surmised. He punched in the month and day of his birthday: 1010, and looked for the *enter* button. No such word appeared on the screen.

Twelve minutes left.

Wally pushed all the buttons on the keyboard, one by one, looking for a response.

"*Transaction Cancellar.*" Out came the card.

"Fuck!" He sent the card back in and checked his watch.

Eleven minutes left.

One of the taxi drivers offered to show Wally how it worked.

Nice try, you swindler, he thought. Wally was sure that this *muy mal hombre* hung out near the machine for a living and ripped off unsuspecting English speakers like him, particularly panicked fugitives from the reciprocity booth. This cash machine probably was his turf.

After three more attempts, he allowed the stranger to look over his shoulder while he ran the card, cleverly hiding the keypad with his body as he entered the secret code.

The taxi driver pointed to a Spanish box on the screen that said, *Touristmos*.

Wally pushed it, chose *English*, and saw familiar words.

Nine minutes.

Wally punched in $200 US and heard the sweet sound of whirling gears. A handful of crisp Chilean currency appeared. He grabbed the cash, bowed to the crook, who perhaps really was a taxi driver after all, and bolted for the gauntlet he'd just run, toward the mantrap in front of immigration and customs.

"Here," he said to the beak-nosed reciprocity matron. He'd won.

"American funds only, please." She smiled in return.

"It's all here. It's in pesos!" He slipped her the receipt.

"American funds, please." She slowly extended her finger toward the adjacent kiosk, which apparently changed money for a profit.

"Bastards."

Eight minutes.

There was no one in the booth. Wally chanced a glance at Rae. Her anger had turned to indifference, a much more dangerous state. He spotted a woman smoking a cigarette near the enclosure's only

window. Wally pleaded with her by raising his eyebrows and holding up his fistful of Chilean cash.

She nodded, and took another drag. Then one more before she stubbed out her butt and sauntered back to the money exchange kiosk, which she opened slowly with a key.

Seven minutes.

Changing the pesos back to greenbacks cost Wally an additional 20 bucks.

Hatchet Woman smiled blandly as she stapled the required ticket into each passport. An amused immigration guard smiled and let them pass.

Five minutes.

It was about 100 yards to the ticketing counter. They power-walked the distance in 30 seconds. As the attendant tagged their luggage, she whispered, "Go, go, go! Your plane is about to depart."

They ran.

Three minutes.

The doors were still open at gate 26.

Nobody checked for explosives in their shoes.

They slipped into adjoining seats in the exit row by the wing.

Wally finally took a breath. "You see, honey, if you know people, you usually can get what you need—even in a foreign country."

No response.

The jet rose from the Santiago smog and headed south, with a view of the Andes Mountains in Wally's window.

Rae remained silent, reading about Anne Lamott's personal relationship with God.

Wally watched Chile's north-south highway, a dark ribbon 20,000 feet below him, as it disappeared over the horizon in front of the plane like a flight plan. A wrinkled backbone of snow-covered, jagged peaks passed below his window. Through the window across the aisle, he saw the blue of the Pacific Ocean.

Puerto Montt National Airport was a series of Quonset huts, each large enough to house a DC-3, but not the LAN Chile jet he arrived in. A three-story control tower, fashioned in weathered wood with a zigzag series of steps leading up the side, reminded Wally of an Oregon mountaintop fire tower.

A small group of greeters met the disembarking passengers. Four held handmade signs reading: "Pornatello," "Cortez," "Menendez," and "Roberts."

A short Chilean lad, who looked about 25 years old, held Rae's sign. He introduced himself as "Julian" in passable English. He had the black mop of hair that seems to be the Chilean genetic plan. He wore it short and gravity-fed, reminding Wally of a youthful Roman-nosed dark-haired Julius Caesar.

Welcome, Señorita Rae Roberts," he announced with a graceful half-bow. "In our country, it is the custom to kiss the right cheek of a woman, perhaps not making contact with the lips, but still making the kissing sound. May I greet you this way?"

"Of course." She said, offering her cheek.

The diminutive youth delivered the greeting on tiptoes and turned to Wally.

"The men, they shake hands, only." He smiled and winked at Wally inoffensively, offering his hand. "I'm here to take you to your hotel in Puerto Montt. To get you ... 'settled'... is that the correct word?"

"*Correctomundo, amigo*," said Wally, mindful of the ache in his buttock.

"Then in the evening, after siesta, we will drive to the site of the new discovery and you will meet Professor Lucas-Schmidt, the director. OK?"

"Siesta sounds *bueno* to me," said Wally.

Exhausted, they collapsed in the rear crew seats of Julian's new white Nissan pickup. From the airport the road was wide and new and nearly deserted. Wally's first South American landscape was a modern industrial zone of bright new boxes with tilt-up concrete walls, big parking lots, and shiny new fleets of vehicles. *Signs of a good economy,* he thought. Multinational prosperity petered out quickly and turned into miles of small garages and tire stores as the road brought them into the city.

Wally nodded with approval as they entered canyons of vintage buildings, ornate and European, showing the patina of 100 years of entropy in the salty South American air. He drooled in anticipation. Good things once filled these structures: chandeliers and rugs and European furniture and art.

"Are there any antique shops in Puerto Montt, Julian?"

"I don't know the word, señor."

"Antiques. Old things. Chairs. Tiffany. Lamps."

"Oh, *lampa. Antiguares!*" He scratched his head. "No, señor. I don't know of such places in Puerto Montt."

"Darn. How about used furniture? El auction. Maybe a consignment shop?"

"Ah. *Si. Renate, auction. Consignaciones.* We have a few of those, I think."

"There you go ... we're going to get along just fine."

Wally caught Rae's reflection in the driver's mirror, saw a grimace and eyes rolled skyward.

The white Nissan passed a large city park. Throngs of pedestrians clogged the sidewalks and filled the walkways on the open

plaza. A statue of a liberator dominated the center. Daylight vendors hawked their wares, and packs of dogs ran at will.

Julian pointed to a crumbling façade with movie posters flanking a triple door to the lobby. "This is a sad week for our city," he said, pointing to the belle artes balustrades that cupped the circular upper windows.

Julian continued, "Five more days and the town theater will close. Next month it will become a bank."

Wally guessed the building dated to the 1920s, when art deco design was just around the corner. "Can we stop here for a moment?" he asked.

"Wally."

"Just for a minute, babe. I love old theaters. We might not get back here later, it would be a crime not to get a photo of it before it disappears."

"I'm beat, Walter, make it short."

"I promise. Pull over, amigo"

They wormed their way back down the block on foot, through a constant flow of attractive Chilean people. Wally remembered to transfer his wallet to his front pocket.
Again.

The marble façade of the theater building turned out to be faux marble painted on the outside plaster, as did the Greek half-columns that flanked the entry doors. Wally loved it even more. He always likes it when people use art to change a gray reality into gold. They walked past posters advertising the second *Lord of the Rings* movie in the original English with subtitles in Spanish. Wally looked up at the high ceiling, knowing what would be there.

Six light fixtures hung suspended in the fading grandeur of the lobby. Massive, they befit a once-important building. Triangles in white-frosted glass fanned out from three-foot diameter rings that held them, slipper-fashion, in highly figured gilt metal arms. The curtained auditorium beyond promised many more. A single missing panel would be a snap to replace in the States.

"What's going to happen to these *lampos* when the theater turns into a bank, Julian?"

"Wally ..." Rae stood by the door, backlit by the Puerto Montt noonday sun.

"Perhaps we can come back here later in the week, señor," said the Chilean.

"Count on it, amigo."

Condor de la Plata was a three-story, stucco-covered 1930s nod to modernism, five blocks from the town square. Their room was clean, with two mid-size beds and a nicely tiled bathroom that offered a bidet as well as a toilet. A window opened to the view of the roof next door and a church steeple. Wally glanced around the room for designer furniture, as he had in the lobby and the hall outside. He saw nothing interesting, surprising in a building shaped like a machine-age Bakelite radio. Nor had genius been employed in the interior décor. The light fixtures were off-the-shelf 1960s cans and the carpet was rayon industrial weave, hotel grade, with no character other than a wine stain near the refrigerator.

Rae was giggling in the bathroom, playing with the plumbing of what Wally referred to as a girl toilet. "I've always wanted to try one of these," she said.

Wally joined her in the bathroom, his head cocked; he sniffed his armpits, licked his hand and pressed his hair down into a ragged part. He winked.

"Forget it, lance. I need about 16 years of sleep and a shower before I meet the director of the archeology project for a face-to-face at 5:00 tonight. Yikes! That's about three hours from now." She kissed him hard on the mouth. "Tonight we'll make bump bump. I love you madly, and we'll do bad things in a foreign country in an exotic art deco building all night long when we get back ... but now I gotta crash."

Wally had no beef. Only willpower held open his swollen eyelids. He pulled the spare blanket over him and dreamed of theater chandeliers.

Chapter Four

Condor de la Plata; Room 12, Puerto Montt, Chile

Rae brought Wally awake with a minty kiss.

"Siesta's over, Rip," she whispered. "Time to meet the famous scientist. Want a cup of hotel coffee? I brought some up for you from the lobby."

Wally nodded and then grimaced at the taste of instant Nescafe half-dissolved in a cup of lukewarm water. He said, "God, this is a primitive country. I thought they grow coffee here."

"Get over it, it still has some caffeine. We've got 10 minutes until that nice young Julian picks us up. Wait till you try the shower. It's a generator of random unpleasant temperatures."

Wally was rubbing scalded areas of flesh when Julian showed up at 4:30. The pair blinked back sleep as they crawled inside the white pickup.

The road to the archaeological excavation site was a two-lane meander from the bustling city center through ramshackle hillside barrios to the west and out into the sparsely populated countryside. Tire repair shops and neighborhood meat emporiums gave way to low rolling hills and dry river valleys dotted with scrubby forests of stunted Chilean pine and larch. Behind them, rising from a smudge of industrial smog, a massive volcano poked its fat yellow-white cone into the late afternoon sky. A light-brown-and- purple wrinkle, the bare summer slopes of the Andes, were the eastern horizon.

"What exactly have they discovered at this new site, Julian?" asked Rae. She knew what lay ahead, but she wanted to get Wally up to speed.

"The new discovery site is in a valley with a stream in the middle not very far from the Monte Verde Camino excavation which is ... how do you say it? 'Grandfather' of the new archeology in Chile these days. There's the Monte Verde Road now."

A rough stone auto path headed north into a series of low hills. A small mercantile, sporting a vintage Pepsi sign, stood at the corner; a massive ox, yoked to a wagon fashioned from the back-end of a 1950s Chevy pickup flanked it. Julian drove past it and continued: "A 20,000-year-old village, with tools and human artifacts was discovered back there, 10 kilometers up on the Monte Verde Road, señors, 10 years ago, when a farmer and a team of oxen fell into a sink hole. Many important articles about Monte Verde appeared in the archeology magazines. They caused important men of science in other countries to be very angry. My employer called them 'stuffed shirts,' men who denounced the validity of these findings because it didn't fit into books they had already written. He claimed this discovery destroyed the accepted story of human migration into the Americas that they call the Clovis Point Theory. The Monte Verde findings push back the arrival date by 10,000 years and also causes damage to the Siberian land bridge idea because the ocean was higher then. One by one these famous men—skeptical men—is that the correct word for unbelieving?"

Wally murmured yes.

Julian continued. "Skeptical men, archaeologists, have visited the site, eager to find fault with some aspect of the research. They have flown home shaking their heads. In this job as a driver, I have met many of them. They arrive wearing that chip on their shoulder, and leave dejected."

"You do well both as a driver and an interpreter, Julian," Rae said. "Your English is excellent."

"Thank you, señor—" He hesitated, unsure of her marital status.

"My relationship with Mr. Winchester here makes me an 'ita', not an 'ora'." Rae gave Wally an elbow.

"Thank you Señorita Roberts. I learned English as a tour guide at Torres de Paine National Park far to the south. The place we're going to is older than that. It existed long before Monte Verde Village, according to Professor Lucas-Schmidt, my boss."

It was the first time Wally had heard the name. Rae nodded sagely.

"The discovery was made by a student, you know. They call them graduates."

"Graduate student."

"*Si*. This student, a young woman, was enjoying a romantic picnic with her boyfriend from Puerto Montt—my friend Nathaniel, as a matter of fact. They were, as you say, making sex when she reached under the blanket to remove a protrusion that kept poking her bottom."

Wally held back a witty interruption; it was too easy. He glanced at Rae. She gave him "the look." Julian continued.

"The obstruction, strangely, turned out to be the figure of a man carved from soft stone. We call it grease stone."

"Soapstone, probably," said Wally, master of easy deduction.

"*Si*, soapstone. I've heard the word applied. *Quatro* centimeter … four centimeters in length."

"Have you dated it?"

"There is no way to measure the time of carving."

"How about radiocarbon or the thermoluminescence methods?" asked the veteran *Discovery Channel* student. As usual, he knew just enough to be wrong.

31

"If you change the composition of the chemicals. For instance, by baking in an oven ..."

"A kiln?"

"*Si*. Or by stopping the uptake of chemicals by the death of a living thing, or like turning to carbon in a fire. All these times can be determined. But not simple carving and polishing of a stone. That doesn't change the chemical percentages, so science is no help. Fortunately, the professor has other methods of dating. The style of the carving and the subject matter, for instance, tells us a lot."

"You mean like an art deco figurine can be dated to the 20s, where an art nouveau form dates closer to the year 1900."

"If you say so, señor, the answer is yes and no," said Julian, as gently as he could. "The style is resembling of no known South American culture. There's nothing to compare it to here. The closest stylistic match is a statue called the Venus of Willendorf, a large-chested female figurine carved in Austria. In Europe! Thirty thousand years old, this statue."

"Those Austrians."

"Fortunately other objects in the same excavation can be dated, so we do have approximate age."

"Why didn't you say that before?" asked Wally, having wasted a perfectly good art deco metaphor.

"You asked a different question, señor."

"How old is it then?" asked Rae.

"Professor Lucas-Schmidt estimates that the carving is part of a ballplayer figurine group. The date is 25,000 years ago."

"Wow," said Wally. "An ancient ballplayer. Cool."

They crossed a nondescript bridge over a trickling stream. Julian slowed and turned onto two tire ruts disappearing into woods at the end of a field. There was no road sign, no announcements that something amazing was being unearthed down this cow path

somewhere past the trees. Wally twice bumped his head on the little cab's roof as they bounced across the meadow.

Rae felt only anticipation and the growing excitement of a professional challenge. She strained to see signs of archaeological activity at each turn of the rutted track. She mentally checked her equipment, felt sudden panic, and then reminded herself that it was only an introductory visit and a look-see. She didn't need anything but a smile.

As the track crested a hill, she caught another glimpse of the Pacific Ocean on the horizon. Human activity was visible in the valley below: five vehicles and a series of tents at the edge of the cottonwood collar that followed the stream through the valley.

Julian parked in front of a tent designed for functional living, not camping. He opened the pickup passenger door for Rae.

"Here, you will meet Professor Lucas-Schmidt. I will escort you back to your hotel when you are ready."

Wally trailed behind the pair as they ducked and entered.

The tent was more spacious than it appeared. Despite the remote outdoor setting, it felt like an office. Two well-made aluminum tables and a number of chairs sat on a bright red- and purple-striped woven floor cover that gave the tent its South American flavor. One of the tables was employed as a desk. A large easel held a dry-erase board covered with carefully hand-lettered notes and rough maps in fluorescent red marker. Two file cabinets stood against the back canvas wall behind a sturdy metal industrial shelving unit holding tagged artifacts.

The man sitting rigidly behind an open laptop appeared physically fit and proud of it. Rae noticed tight shoulders snap back upon her entrance. When she first looked at his face, his eyes caught hers and refused to let go, daring her to break contact. His eyes were dark and endless at the centers, with the pupils larger than she would

have expected with the late afternoon sun illuminating the tent. Surrounding these pools were beautiful rings of peacock feather blue, a color Rae had never noticed in an eyeball before. Crushed beetle wings and Tiffany glass came to mind. His hair was pure white, cut short and receding at the temples.

She blinked a couple of times as she neared the table, snagging a glance at the brown button-down safari shirt, long sleeved and buttoned right to the top, behind the very tight triangle of a Windsor-knotted, light-colored tie.

Wally checked out the interior, reading the tent layout like a magazine. Neat and organized to the extreme, it told him a lot.

Guy's right off the boat from the Fatherland, the way he sets up his space. Bet each item has a 90-degree relationship with the tent stakes. He's in a fucking tent for God's sakes, and, still, he has his furniture marching. Wally glanced at the precise handwriting on the dry-erase board.

He turned to face the scientist, who said, "Welcome, Miss Roberts, I was looking forward to meeting you. *National Geographic* has shown me examples of your work. Very interesting photographs, in an imprecise, arty technique." He rose from his table as Rae reached it. She leaned forward slightly, expecting the Chilean right cheek kiss as the greeting. A handshake was offered instead.

"I'm quite happy to be here and to be working with you, Professor Lucas-Schmidt."

"It would please me if you called me Rolf."

"Then I'll be Rae. And may I present my partner, Walter Winchester? He also specializes in old things."

She winked at Wally as the men shook hands. Wally noticed a steady grip, using exactly the right pressure, with none of the finger-flexing and wrist movement that suggested personal bonding. He noticed the incredible blue irises.

"Have you been involved in archaeological research, Mr. Winchester?" There was a definite Germanic inflection in the carefully chosen English words.

Wally found himself calculating how he'd do with this guy in a fair fight. Probably not well. They were both of medium build, but consistent muscle tone in the other man's posture suggested a powerful package.

"I uncover objects from the nineteenth and twentieth centuries. I specialize in what you might call modern art."

"You are an antique monger, then," Lucas-Schmidt said, his interest instantly dimmed. "The profit here, in Chile, is measured in degrees of understanding, not in hard currency." He pointed to the shelving units, covered with tagged artifacts that Wally hadn't yet examined. "I hope you will respect the sanctity of these discoveries while you are on the premises."

"Hell, I'm just the boyfriend here, Siegfried," said Wally, surprised at the catfight spontaneously erupting.

He reminded himself not to screw up Rae's big opportunity and cranked it down a notch, "My clients (*sounds better than customers*) are a lot more interested in *Architectural Digest* than in the *Journal of Archeology*. I specialize in lamps, oil paintings, and furniture designed by architects. Your contribution to the storehouse of human understanding will be safe from my nimble fingers, I assure you."

Wally Winchester was on his best behavior, though it had occurred to him that a 30,000-year-old figurine from this asshole's collection would look just great on his Stickley bookcase.

"I'll be doing my own thing in other parts of Chile while Rae works her magic here. Perhaps some evening over pisco sours we can swap discovery stories."

This sentence was Wally's most diplomatic version of "Check please!" He noticed the relief on Rae's face and executed a short head

bow toward Schmidt, figuring it was a good time to leave the tent and have a cigarette with Julian.

He withdrew and joined Julian back at the transport. They leaned against the pickup fender and watched the cadmium-red South Pacific Rim sunset spotlight the trees on the ridge above the darkening meadow.

Chapter Five

Condor de la Plata; Room 12, Puerto Montt, Chile

Rae's voice mingled like church music with the late-night sounds of the Chilean street below. "Thanks for keeping your cool with Professor Schmidt, babe. He sure seemed to want to get into it with you. You didn't even open your mouth, and he was on your case. What'd you do to piss him off?"

"Slept with you, I suppose. He seemed quite interested in you straight away. The pompous ass."

"I can handle the professor. And you're the only man I want, Bronco Billy."

"I think I'll get a rental car tomorrow and stay out of your hair while you work with Professor Blue Eyes. Maybe I can hire Julian to be a driver/translator, and check out the consignment shops. See what I can turn up."

"That's a good plan, hon. I'll need all my concentration getting light readings and calculating exposure times. Not to mention tiptoeing over fragile egos. We'll have all our evenings together ..." She snuggled against him with her fingers tracing a familiar path south. "And we have the weekend to go sightseeing. And don't forget, you have to find an Internet café to check on your online auction."

"The chair. The egg rocker." Wally had forgotten about his Argentinean eBay experiment. "It closes tomorrow, some time—what's the date today? The twelfth, isn't it?

"Nothing like 16 hours in the air for screwing up the old internal calendar. Thanks for reminding me. Now ... how can I repay you?"

Rae mustered a tired wink.

Chapter Six

Cibercity Telephonica, Puerto Montt, Chile

The Internet café rate of $1.50 per hour for a workstation linked Wally to the rest of the world from computer number seven. Music from the Cars's *Candy-O* album filled the room. He thought, *I bet I'm the only person here who has a clue to the lyrics.*

Most of the Chilean patrons filling Cibercity early in the morning looked under age 25. Wally guessed most were students out of school or unemployed youths who somehow had money for nice clothes. Indigenous genetics ran thickly in this gene pool: dark hair, short stature, and prominent noses were nearly universal. Wally looked around the smoky, modern interior and marveled at the beauty of the women. They were all knockouts—every one in the café. Amazing. Long dark hair flowed like ebony waterfalls.

Cibercity was the third Internet café Wally encountered on a two-block walk past Euro-style 1920s brick buildings skirting an aging central park near his hotel. Simple ceiling drops of two or three light bulbs diffused by pastel perforated metal triangles were hip and welcoming light. It was brighter and more cheerful than the first two.

The screen lit up. Wally is a Mac user, and this was a PC, but the operation seemed to make sense. The Spanish language was the problem. He searched around on a monitor screen of foreign words for a hint, maybe a recognizable icon, to lead him to the Internet. He saw a

familiar *e* for Internet Explorer and clicked on it, gaining access to his mailbox at Whidbey-net.com. He looked at the clock: 10:45 a.m.

Wally had tried to interpret the Internet access rates when he walked in. They were posted on the wall behind a beautiful almond-eyed twenty-year-old in charge of communications in the room. He had puzzled over the Spanish words and large numbers of some currency before giving up.

Don't worry about it, he'd reminded himself. *They'll know what to charge.*

The pretty manager had turned on his computer for him after a number of attempts at conversation in rapid Spanish. Smiling, Wally listened to her at length and tried not to look like her grandfather as he sat down.

Wally's first full day in South America had started off innocently enough. Rae had been whisked away by Julian at the crack of dawn, off to her first day of photo work with Herr Professor. Wally had decided to stay far away from the excavation site. He was going picking.

He had fashioned a plan for his first foray into what he believed was an unsuspecting, fertile antique picker's dream. It was a simple plan.

1. Find an Internet café, (if they had them in Puerto Montt), and check his e-mail and the online auction.

2. Rent a vehicle with some carry space and buy a map.

3. Get to an ATM and fill up his wallet with Chilean pesos, which were

currently trading at about 12 cents to the US dollar.

4. Muster the current 22 Spanish words in his communications arsenal and begin networking.

Networking was Wally's strong suit. He prided himself on his ability to scope out the antique scene in a new town. "If antiques are truffles," he once said at the Brimfield Flea Market after a jug of wine, "I'm a truffle pig." Twenty years of picking junk in new locales with an empty van and a pocketful of cash had taught him that the shops of greatest interest always flourished on the ragged edges of a city center in neighborhoods where buying new things is not an option for the locals. After that it was all about asking the right questions and following leads.

The electronic mailbox disgorged its contents onto the monitor with a *ping*. There were 22 messages waiting for him, not including spam. Most of the e-mails were irrelevant, since they were 10,000 miles from home: Two notices about Chamber of Commerce meetings he'd miss. *Good.* Photo of a table for sale from a Yakima antique dealer held no interest. Furniture with barley twist legs had no collectors he knew of.

Then a bidding reminder from *MercadoLibre* with an "End of Auction" warning.

The Austrian chair, The Egg Rocker! *Fuck. I'd almost forgotten. How much time left?*

He linked up with the Argentine auction page and entered his password to check his bidding status: *Twenty-three hours to go. That should close tomorrow at…*Wally glanced up at the clock. *Nine fifty-five a.m.*

"High bidder–CamanoWally." *Good. Still on top.*

He made a mental note to return to the site before nine the next day.

The last e-mail was from his buddy, Yvgeney, concerned about his upcoming inspection of a Serbian presidential hideaway. He ended his mail with "I've decided to leave UNESCO, my friend. This will be

my last search in this godforsaken country. I've had it up to here with madmen and thieves and zealots. Time to stop and smell the flowers, as they say."

Just like a Russian in his directness, Wally thought.

He continued to read: "Lucy and I have discussed it. We think a month in your country is required to reset the compass and plot a new course. Do you still have the spare cabin? Or have you filled it up with old Stickley chairs?"

Wally thought, *It is filled up with old Stickley chairs, thanks to that estate sale in Everett last month, wise guy. I can move them.* Obviously, his friend needed some serious R&R. Rae had kept in touch with their old neighbor, Lucy, since she left Camano Island with Yvgeney a year before to open a stall at the biggest flea market in Paris. He couldn't wait to tell Rae Yvgeney planned a visit. He read on.

"Perhaps you and I can put our heads together and come up with a joint venture. Good cop/bad cop. Butch Cassidy and Sundance."

Yvgeney had been a "listener" in the former Soviet Navy before he went to work rescuing stolen art for the UN. He still believes he is an expert on American culture after six years of listening to the FM audio of *Miami Vice* and *The Simpsons*.

"I'd rather buy and sell antiques instead of rescuing them."

Wally chuckled and thought, *If he wants to escape from madmen, thieves and zealots, he's going into the wrong business.*

"Stay safe," Wally typed. "Tell Lucy that Rae will be dying to hear her scandalous stories from the city of love."

Exit computer. It was time to play the antique game.

Warm Chilean summer sunshine flooding the tree-lined business district blinded him; the park across the avenue teemed with

vendors, craft tables, jugglers; youngsters by the hundreds joined the crowds and a couple of packs of roving dogs.

Wally Winchester and Yvgeney Ivanchenko on the road again, he mused, thinking of the e-mail. The thought dissolved into a memory that filled Wally's head as he walked down the crowded sidewalk. Images of Vancouver Island, off the west coast of Canada flickered by like a slide show.

An outrageous forgery, an auction, and an up-country picking trip had thrown Wally, this Russian, and his one-time neighbor, Lucy, together a couple years back. Their friendship had survived even when Yvgeney trundled back off to Europe to save more stolen art, and dragged the perky British neighbor girl off with him to try to start a shop in Paris. Lucy's stated reason for joining Yvgeney in Europe had been to watch the Russian's back, an activity she claimed to enjoy.

Wally instructed himself to be on the alert for Spanish language signs that suggested rental cars. Time to quit rubbernecking, rent a truck, and get to work.

After two days in South America, Wally had noticed that nearly every vehicle in Chile is a white, four-door Japanese pickup truck with the crew cab. *Standard equipment,* he concluded, *for the family of five and the sheep.*

He rented one with a red interior. *Guy's gotta have a little soul.*

The price for a week-long rental with unlimited mileage was 240,000 pesos, or about 400 US dollars. The ATM was next.

He found that a guy could spot cash machines by looking for lines of people queuing up for pocket money on a sunny Tuesday. After his airport fiasco, Wally had no trouble negotiating the maximum amount of Chilean cash the little machine would issue.

With a vehicle and lots of spendable cash, Wally figured it was time to find the great treasures he imagined were all around him in this unexploited wonderland.

Catching the word *Remate* or *Consignaciones* in a sea of Spanish language storefronts, at 30 miles an hour, while watching your ass in an auto war taking place in a South American city is not as easy as it sounds. By two in the afternoon, Wally, the master antique networker, was still batting zero. In the hot afternoon sun, the fat wad of Chilean pesos was beginning to stick to his leg like a pocketful of Velcro.

This part of town felt right to Wally's picking radar. Squat, dilapidated wooden shacks lined cracked, broken sidewalks; scattered groups of listless men squatted on door stoops, smoking. He passed a pig, a huge monster, chewing on something where the sidewalk met the road in front of a *Ferreteria*. The stuff inside said Hardware Store.

Antique shops in the United States have the advantage of the rare combination of letters—t-i-q-u-e—embedded in every trade sign. Wally had 20-400 vision, but he could spot a signpost with a "tique" fragment printed on it from a quarter mile off in bad light in the rain through a dirty window. True, he'd pulled into some *Boutique* parking lots before he realized his mistake, but generally his picking vision was akin to an eagle's.

Wally had passed the twelve carne shops, notable by some kind of red-stained dead creature hanging in the window, when he spied a white crew cab pickup filled with school desks, parked adjacent to the open door of a loading dock. Another group of surly men hung out near the tailgate watching two strapping teenagers unload the pile.

No souvenir shops on this block. Wally felt at home now. He pulled over and parked a couple of storefronts down.

The business next door had a small hand painted sign that spelled *T-a-l-l-e-r*.

A glance inside the small front window revealed ductwork and shaped sheets of galvanized metal. Wally peeked into the dingy interior just to make certain the tin whacker inside wasn't sitting at some rare piece of furniture used as a worktable. No luck. Just more grime and gloom inside.

A small neon sign in the neighboring window, next to the active loading door spelled out *C-o-n-s-i-g-n-a-c-i-o-n-e-s* in orange light. Wally would have missed it if men hadn't been unloading used furniture out front.

To get to the open door, he mustered up some attitude and walked toward a group of down-and-out locals. The men were all of small stature, with Chilean-European ancestry in various stages of genetic mixing. There were some mumbled grunts and shuffling, but no one called him out. He straightened his shoulders and put on his *I'm not your bitch* face and passed, unmolested, through the general assembly by the door. The odor of stale urine flashed by as he entered.

The main showroom was fairly dark despite the gaggle of light fixtures hanging from the ceiling. Wally craned his neck and scoped out the array with a practiced eye. Nothing special or even interesting from a high design point of view tweaked his radar beam.

Satisfied that the ceiling was not interesting, Wally scanned the rest of the room. As his eyes adjusted from the afternoon glare, he saw what he expected: Formica-topped tables, 1970s swivel dining room chairs in slightly rotten plastic, carnival-type glassware, the kind given away at Texaco gas stations in the 1960s, chrome dining sets with deflated foam rubber seats. Against the wall, he saw a phalanx of rolled room-size carpets standing like Crayola Crayons.

The standard glass showcase next to the cash register held a typical thrift store collection of useless older things like sad irons and

brass medallions commemorating South American dictators. A pre-Columbian-type sculpture caught his eye. A small ceramic of a fat, primitive native holding a bird. Years of disappointment had taught Wally to distrust all pre-Columbian pottery found in thrift store display cases. Here, particularly, it was a no-win situation. If it were fake, he would be stupid to buy it. If it were real, he'd have to smuggle it out of the country and hope not to get caught.

Wally looked over to a messy array of costume jewelry, searching for Spratling Mexican silver, just in case. Factory-made jewelry was not one of his specialties but Spratling silver had a chunky, art deco look that even a guy could recognize and he had a collector in New York City. As far as Wally was concerned, only costume jewelry from famous, recently deceased people seemed to bring any money.

A familiar mental conversation was bouncing around in his brain: *What do you expect to find here, a Tiffany saltcellar? A Lalique perfume bottle? It's a junk store!*

As he continued his analysis of the showroom, Wally spotted the door to the back chamber over on the wall between some rolled up Karastans and a large, torn print of mountain scenery held tenuously in a mousy maple frame. He squeezed past a shiny exercise machine into a cavernous storage area.

The two youthful workmen he'd seen from the street were talking near the now-closed loading door. The school desks were stacked three high, he figured, for the next auction. Four long ceiling drops of weakly fluttering fluorescent lights cast a cold green glare on the depressing collection. Two of the lights created an annoying buzz, audible even to Wally's wounded ears.

The air in the warehouse was cool. Aging wood and perfumed fabric of the lower classes mixed with a disinfectant smell. Nothing noteworthy. Strewn about were low couches in brocade with machined

metal feet, Formica-topped tables, and mass-production ceramic lamp bases with plain cloth shades.

A quick survey told Wally there was nothing interesting, but it taught him a lesson. This was the first such store he'd found in South America. He realized there is no difference between picking here and in Anytown, USA. Both involve searching through mountains of flotsam and jetsam, hoping to stumble upon a jewel.

The owner stood behind the cash register. He looked more European than native. A thin mustache, thinning gray hair and sharp chiseled cheeks under metal spectacles suggested Yugoslavia or the Baltics.

"*Hola.*" said Wally.

"*Com es ...*" came the shortened reply.

Faint strains of Bob Dylan singing, "Knock knock, knockin' at heaven's door" floated through the room from an unseen radio.

"*Me yamo Wally.*"

A quizzical look. Maybe annoyed. He removed his glasses and fussed with a handkerchief to polish the lenses.

"*Et tu yamas?*" Wally tried again, realizing that he'd grabbed a phrase from Latin 203, or maybe Shakespeare, instead of his eighth grade Spanish class.

The storekeeper tilted his head and crinkled his nose.

"*I am antiquities hombre, about thirty annos,*" Wally weakly ventured.

Nothing. Dylan crooned softly behind the awkward lack of conversation.

"*Ustead tambien?*"

The man seemed to be getting pissed.

Wally reached into the back memory vault, searching for more words.

"*Ya kiero* old chair." No, that didn't do any good at all.

This guy isn't trying very hard, Wally thought. *He must think I'm a recently escaped wing nut from the Institute of Speech Disorders.*

A light went off—literally. A snap and a crackle and a pop with a brief bright burn of the filament, the sound of a bad bulb in a frail chrome fixture going south. The proprietor had dropped to the floor at the loud pop like a veteran of South American politics.

Wound up pretty tight, amigo, Wally thought. As he turned to look at the distraction, his own light internal bulb reminded him of the Stickley picture book he'd brought along on the trip for situations like this. He bowed to the flustered manager and dashed out to the white truck.

Holding the reprint of a 1910 Stickley Furniture Company catalogue above his head like a triumphant Southern Baptist minister, Wally Winchester again leaped into an attempt at networking, a big leap for someone who hadn't got through "My name is ..." yet.

"Ah," the proprietor exclaimed. "*Antiguares*! He smiled and began acting like an antique dealer.

Dah ... Wally said to himself, noting that the owner of a store that sold antiques had not bothered to notice the similarity of the word, antique and the word, *antigueres* in a perfectly friendly sentence.

"*Hey, yo kiero Tiffany lampo, amigo.*"

Wally made the shape of a table lamp with his hands. He was forging ahead, now, as if he'd met an old college buddy.

"Tiffany Lamp," repeated the kid from the suburbs. "Lalique, Galle.... *vitreooo*." He'd noticed a plate glass storefront with a word that looked like *vitrioo* a few blocks back. *Certainty "glass" also means "French art glass,"* he thought, and he was right.

"Loco Americano" escaped the shopkeeper's lips.

"Indian baskets. *Nativo*." Wally was tempted to point to a little 1970s wicker wastebasket, painted pink with six or seven sheep decals

48

pasted on the lid, and linking it with the word *Nativo* as a conversational path that would lead to the owner pulling some rare Indian baskets from the back room, but thought better of it. This fellow would lead him to a shelf of Hefty Bags, he concluded, the way things were going.

He noticed an office door with a wire-mesh window in the dark corner to the right of the street entrance. Diagonal light from a late afternoon sun raked across a simple mahogany desk with little on it save a telephone. *For a junk dealer, he doesn't have much of a collector's jones,* he thought.

Inside, he spotted a glass-fronted lawyer's bookcase in shadow, its back against the outside wall. It was the first interesting thing he'd seen. There was a large boat model sitting on a stand on top. Objects were discernable behind the bookcase glass, but Wally couldn't make them out through the windowed office door.

"Can I look in there?" He made a monetary counting gesture, pointed, and made the "let your fingers do the walking" sign with his hand.

It worked. The shop man opened the office door.

The boat model was wonderful in a folk art kind of way. Gray primer over rough-cut blocks of wood formed the hull and superstructure of a Chilean Navy gunboat or a small destroyer. Wally guessed it to be 60 years old. Pencil-thick deck guns bristled and brass wire formed railings, stairs, and rigging lines. It wasn't a kit. It was somebody's winter project, or an engine room diversion on a long Antarctic sortie. "Lots of fun." He classified it. Worth 200 to 300 in a good auction up north.

He felt a stir of excitement. Getting into this little office was the stroke of well-manipulated pluck and perseverance. Ninth inning discoveries like this had often turned long, fruitless, thousand-mile picking trips into legendary journeys.

"Can I look into the bookcase?" This was the owner's domain. Wally wasn't a customer in here. He was an invited guest in a private domain. He knew the etiquette of the private stash. The lump of money sticking to Wally's leg suddenly felt reassuring.

"*Si, da nada.*" So much for the language barrier.

Chapter Seven

Condor de la Plata; Room 12, Puerto Montt, Chile

"The objects they've found there are astonishing," Rae said while lounging under a soap-bubbled tub full of steaming water in the little Euro-style bathtub. Long wet legs, bent at the knees, rose from the suds. Wally saw two pink pirate ships draped in soap bubbles. Dusty safari-style clothing and underwear littered the bathroom floor.

He sat beside her on the bedroom desk chair and listened. One eye was assigned to watching her emerging and submerging breasts. The other monitored his right hand cranking a lever on a break-your-heart postwar German construction toy he'd pulled out of the bookcase late that afternoon.

"You see, babe, this lever controls lowering the clamshell bucket."

The open jaws of a gray-painted, stamped tin toy dredge ratcheted lower on its little chain as Wally pushed down on an orange-tipped toggle. He was maneuvering the 50-year-old toy over Rae's submerged chest like a puppeteer. With a plop, the dredge-bucket fell onto a puckered pink nipple, half under soapy water.

"Hey!" Rae said in mock challenge. "Be careful with that claw."

"OK, men," Wally softly grunted into the little toy cab in a false, deep, Joe Six-pack voice. "Careful now, it's a big one. Gentle as she goes!"

"Walter ...Wally, please listen to my story."

"OK."

He shook the bathwater off the metal collectible, purchased for 30 American bucks. The folk art Navy boat and a couple of ancient

native baskets he'd found on the bottom bookcase shelf now lay on the bed in the next room.

"Tell me more about your day ..."

"Well, the objects in this valley appear to be much older than the Monte Verde settlement to the north, just as the driver told us."

"Twenty thousand years plus, right?"

"That's the official number. Rolf releases that dating estimate to keep conservative archaeologists from going bananas."

"Oh, so it's Rolf now."

"Stop it Wally, everyone at the site is on a first-name basis. You know I'm not attracted to tall, handsome blonds."

"If he's a blonde, then I'm an Armenian. That guy was raised in a cave. Probably the one where the fish and the salamanders have no color, and besides, the man's on steroids. I could smell testosterone cream on his chest."

Heavy eyelids tilted back. "Sounds like I have a green-eyed boyfriend."

"The guy gives me the creeps, Rae. He's got something up his sleeve. I hope you watch your back when you're working there."

"I love you, Wally. Thanks for worrying about me. That means a lot."

She pulled herself upright, her arms resting on the porcelain rim. Soap bubbles slalomed off her ski-slope breasts.

"You, in particular, shouldn't worry about taking chances—"

"I'm an expert in risks. It's true. That's why I'm worried. I've known a lot of con men. Hell, I do business with them. I'll tell you, Professor Tightass is not the saint he appears to be."

Rae's expression softened.

"Let me show you how much I love you," she said softly. "Afterward we'll chat about his discovery. And then, maybe you won't feel so nervous."

She extracted her long lanky body out of the bath. In the warm South American evening air, she took the towel Wally handed her and wrapped it into a bun around her wet hair.

Rae walked languidly to the bed, careful not to bump the folk art boat model as she lay down beside it. Inspired, she carefully picked up the wooden Navy project and put it on her naked chest, pretending she was the ocean. She said, "I think your boat is in heavy seas, Captain," she said with a devilish grin. Wally unbuttoned his shirt, smiling at the scene before him.

He said, "God, I love good folk art."

"OK, let's go back to my day today at the site," Rae said to a sleepy lover. "Do you want the amazing maybe story, or the pretty good sure thing tale?"

Cooler air puffed in through the open window. The sheet was tangled at their feet, the model boat sat safely on the floor.

"Tell me the sure thing. I'd rather guess at the amazing one."

"All right, today they found a model of a sports stadium, 30,000 years plus."

"No shit, a model?"

"Cross my heart." Pinkish blotches slowly faded on her chest as the flush left her skin. "Near the creek. Sticking out of a clay bank. It looked like sort of a geometric boulder among a bunch of natural ones. The cook found it. Now he gets his name in the books. He's ecstatic. Gave everybody steaks for lunch. Fortunately, he was smart enough not to disturb the site. He kept his old Chilean hands in his pockets and found Rolf, I mean Dr. Lucas-Schmidt, right away." Rae faked a look of submission.

Street noises floated in through the open window. A soft cacophony of cars and music mixed with the barely noticeable city

smell of nearby restaurants going strong at midnight. Wally smiled, realizing he hadn't even noticed it till now, 45 minutes after Rae started rubbing herself with the boat model. Now he lay back and focused on the wonderful foreignness of the street din, a brand new audio track added to his lifeline of sound memories. He didn't seem as concerned about the first names of rivals right now.

"Hey, wake up!"

Wally had drifted into a jet-lag stupor. He rubbed his eyes and slapped himself on the cheek with an open hand. "I'm with you," he lied. "Go on with your story."

"Now the stadium model we found today was really amazing, and I got most of it in the Nikon. No time to set up the pinholes. Too much going on, anyway. I'm surprised to see scientists work that fast. I expected a weeklong grind with dental pick and toothbrush, but they had it out by midafternoon. And they found more figurines in the surrounding soil. That process is continuing tonight. They hired a second crew."

"They pulled a major artifact out of a cliff in one day?" Wally asked, stifling a yawn. "That seems awfully brutal archaeologically."

"The clay was pretty soft to dig through. They marked the face off in a foot-square grid and removed a cubic foot of clay at a time. It filled a hundred numbered cardboard boxes. Rolf called it a low-rez catalogue. He said that was plenty tight."

Wally was losing his grip on the conversation. He creaked out a sleepy question.

"What was the amazing maybe?"

"Dr. Schmidt thinks this culture goes back to before 30,000 years. Way back. Really, really way back. You know the discoveries in Africa by the Leakeys that trace the beginnings of mankind?"

"Sure," Wally answered, raising his energy for a groggy quiz show challenge, "Homo Australopithecus and that other group that didn't make it."

"Schmidt is looking for evidence of a separate line of the genus Homo whatever that started here in South America. He thinks he's found a link."

A light snore told Rae she'd revealed the "amazing maybe" bombshell to a sleeping person.

Chapter Eight

Room 12, Condor de la Plata, Puerto Montt, Chile

Angry Spanish from a morning TV news show filtered through the scattered breakfast conversations. Rae, eager to see the new finds, had left again with the sunrise. Wally sat alone over the second cup of the worst coffee he'd ever tasted.

"*Hola!*" he signaled the stern-faced farmwife waitress, delivering another plateful of stale white bread toast across the room.

"*Buenas dias tambien,*" he continued when she approached. Good old *tambien*. He thought it means "also" or "once again." It seemed like a good word to put at the end of sentences, figuring that it added a little sense of familiarity, particularly if he'd seen the person before.

"*bue ...d—*"

"*Ya quiero café con* beans, no powder."

He pulled a little plastic tube of powdered Nescafe from a bowl on the table, made the shape of a gun with his fingers, and shot it twice.

"*Aqui,*" she said menacingly, pointing to the remaining unopened coffee packages.

"*No, café con beans* ... grounds ... Juan Valdez."

Wally made berry-picking motions with his fingers, made eye contact, his hands pantomiming motions of a person pouring coffee beans into an imaginary hopper, then cranked his fist in a grinding-type circle. This scared her even more. She withdrew into the kitchen. Wally gave up and took another sip of the bitter cupful in front of him, resuming his daydream about the Austrian chair auction ending in three hours.

He considered raising his bid.

MercadoLibre opened to the colorful home page Wally was beginning to know by heart; holding his breath, he punched in the item number. A little graphic appeared and suggested time going by. The screen blinked. There it was. The Egg Rocker. No change in the bidding since yesterday. Wally's breathing resumed.

Great.

Searching amid unfamiliar phrases, he checked the time remaining till he found it.

Less than one hour left.

Doe-eyed youngsters lounged and chatted up front, sipping lattés. The same beautiful manager ruled the roost. She'd smiled at Wally as he entered and smiled.

That was good. He looked back to the monitor to see the photo of the chair.

Look at those little added wooden knobs on the back of the ovals that form the rocker's body, he told himself. *It's a nice touch. Keeps the sitter from rolling over backward on a healthy rock. Probably saved a few lives in old Vienna.*

It was time to up the bid. Wally studied the grainy photograph on the auction page. *Only one view, with a shower curtain as a backdrop. Hard to believe a chair this good is being sold this way. But that's the point, isn't it?* He remembered the day he found the link to the Spanish language auction sites, a footnote at the bottom of the eBay home page. Wally lived for the discovery of unknown cubbyholes, competition-free areas where he could graze for great objects unmolested. Lacking the cutthroat instincts that many of his contemporaries used so well as business tools, he relied on guile, brains, and creative thinking to maintain an inventory of cool objects for sale. The lack of a fat bank account didn't make it any easier. The

East Coast boys and their big trucks, big checkbooks, and flexible moral codes filled vast warehouses with great furniture, nifty collectibles, and leaded lamps. Wally had a modest inventory, a handful of really neat things in his shed, with another 20 inside the house. He competed by finding corners where a big brain and a network gave him an edge; in "rock-paper-scissors," he figured himself to be "paper."

Mission oak and the Arts and Crafts Movement are among those corners. Wally started looking for Stickley in the mid-1970s when almost nobody wanted to have anything to do with it. No one collected it yet and few auction houses even bothered to offer it for sale. The clunky, dark oak furniture had been viewed as the ugly duckling of the antiques world, hardly worth bringing home. He'd been one of a small group who found it worth pursuing. They had the field to themselves for years before the rest of the world caught on. Another low-competition collectible, even today, is Austrian decorative arts. He was looking at some today, fully expecting he was the only gringo in this auction who gave a hoot about Josef Hoffmann. He looked at himself as the point man for a group of determined collectors.

Wally looked again at the grainy image.

A bad photo is good because it can hide the magic, he told himself, *and disguises great value. If the chair is right, it's worth what, 25,000? I bet I'm the only one who knows that. That's a big maybe. Perhaps Christie's has a guy assigned to look at South American digital auctions once a week. I doubt it. It's also an obscure chair. I doubt many people have seen a picture of it, let alone heard about the auction in 1984, where one of them sold for $42,000 to a private collector.*

Wally refreshed the page: 49 minutes left. High bid was still a thousand and something in Argentine money.

Current high bidder: CamanoWally.

He looked at the picture of the chair and wondered if it were real. He was thinking about raising the level of bidding. He scolded himself, *wipe the stardust out of your eyes, Camano Wally, and have a good close look before proceeding*.

He looked for the *enlarge* button for the fuzzy little photo, but there was none, either in Spanish or English. In the grainy pixilation of the low-end monitor, it was possible to see a cutout pattern on the chair back. Wally tried to remember what the cutout shape was on the big money egg chair sold in 1984. He remembered a secessionist shape, perhaps an oval.

This could be an oval, it was impossible to tell. *So much the better.*

Suddenly it became clear. The chair was real and free from deceit.

Yikes! This is scary, he thought. He looked again at the terrible quality of the photo. It was the key. The photographer was a rookie, not a savvy pro with a fake masterpiece for sale. If the owners expected to make real money with this object, they would have used a quality photograph. Now he *knew* he had to own it.

He scrolled to the *bid* button at the bottom of the long web page. A raised digital lozenge with *Calcifo*r printed on it suggested a *Bid Here!* prompt. Wally pushed it electronically with a left click. After another password search, he raised his bid to 5,000 Argentinean pesos, or about 1,700 US dollars.

"Real time" on South American backyard Internet auctions means pushing the *refresh* tab and waiting for the site to reboot. Just like the United States. On dial-up modems, like the little café here, that was a ten second razzmatazz, and then you saw the same page with new numbers.

There were 35 minutes left when Wally bid, and checked his status.

Everything was the same.

Panic.

Did it get my bid? Did I guess the right Spanish buttons?

Thirty-one minutes. High bid 1,000 something. CamanoWally still high bidder.

Relax, Wally-boy he admonished himself. *You're the only bidder so far. The bid program won't place the higher offer against the first bid, you just have a higher top end.*

Chubut Province was listed as the location.

Wally idly wondered where in Argentina that is.

Probably close to Chile, he reasoned, *somewhere to the east, over the Andes Mountains. If I win the chair, maybe I'll drive over some beautiful mountain pass into Argentina and pick it up personally.*

He brightened at the thought.

Thirty-four minutes to go. Time to check on the world up north. E-mail from Seattle contained no important messages, except a note from Yvgeney and Lucy. They were set to arrive in Washington state in about two weeks. As soon as the present assignment was concluded.

Good.

With 22 minutes left, Wally noticed a change. The high bid was now 1,510 Argentine pesos. Someone new to the action, a dealer probably, taking a wild shot at the relatively low current bid. Wally's second bid had kicked in at 1,510.

"Tough shit, loser," he murmured out loud to himself. "I'm way ahead of you."

With one eye on the time left in the auction he Googled a foreign currency converter, figuring it was time to find out what the Argentine peso was actually worth before fine-tuning the last bid. A

US dollar to Argentine peso calculator told him that there were four pesos to the US dollar. This chair, he figured, worth many thousands in a real New York auction, was--at 1510 pesos--sitting on a ridiculously low bid, *like 350 bucks,* with only a few minutes left.

Refresh again.

The window reformed.

Another late bid. CamanoWally still ruled at 2,510 pesos.

Here we go.

Refresh again.

Wally looked at the new page.

Twelve minutes to go. $3,010. The end game was on.

I should raise my bid, he thought. *I'm looking at a 40,000 dollar classic.*

He scrutinized the image. Dark and grainy, sitting in front of a plastic drapery, it sure didn't look like one of the most innovative chair forms of the twentieth century. *If a New York dealer is the competition,* he reasoned, *that means at least two people on the auction site know how valuable it is.* Against a real professional with a serious bank account, Wally knew he'd be left in the dust. Against a bunch of local South Americans 8,000 miles from the marketplace, he figured his current bid would rule the day.

He checked again.

Two minutes left. A new attempt bumped the price to 4,010 Argentine. The chair had finally reached interest at the thousand dollar level. "Hello big boys. Welcome to the bid snipe rodeo," Wally whispered to the glowing screen.

They're trying to test my limit.

Wally scrolled to the bid button and jumped the bid to 30,000 in Argentine pesos. "Fuck you," he said softly to the South American ciber-opposition. With a bank account back home sitting on $7,500 US

dollars, this bid meant all his chips were on the table. Done. Ten seconds left. He refreshed again.

The monitor read, *Finallazo offerta*: 26,000 Argentine. CamanoWally.

"Yahoooo!" the cry leaped out of his mouth, startling the youthful crowd.

"I've got it," he yelled to no one in particular before ramping the exclamation down to a very loud thought. *I own an original Egg Rocker! Hot damn! Hot damn! What amazing times we live in. A guy who didn't know a computer desktop from a computer desk two years ago can find and purchase the chair of his dreams on the Internet.*
He didn't pay attention to a nagging unease, blaming it on the grainy photo of his chair on the monitor.

Chapter Nine

Archeological Site Near Puerto Montt, Chile

Rae was easily spotted at work. Her backside, aimed at the late afternoon sky, triggered a Winchester smile.

Three men and a woman wearing casual slacks were crouched in front of Rae in the camera's field of view. Wally recognized the archaeologist from a distance. Pure white hair and starched tan cotton.

He noted another female. Electric red hair spikes topped a pretty head; to Wally, she looked as if she would be more at home in a Santiago disco than a museum basement. She wasn't digging and dusting like the others. There was a vigilant air about her that suggested military training.

A square of folded canvas sat nearby in the shadow of a workman—*ready site protection in case of an unexpected downpour,* Wally assumed.

He walked forward carefully over the uneven terrain, making a racket despite his attempt at unobtrusiveness.

Rae looked up at her partner's noisy approach. She was holding an exposure meter. She smiled and silently mouthed, "Oh shit."

Lucas-Schmidt watched him warily. With an audible sigh he stood up, carefully placing his notebook on the spot where he had been digging. Brushing imaginary dust off the sharp creases of his shirt, he strode toward the intruder.

"Don't walk any further in this direction, Mr. Winchester."

Schmidt pronounced "mister" with a snarl, turning a proper greeting into a slur.

"The placement of markers is *sehr exakt* here."

Rae cringed and went back to metering.

Wally stepped forward relentlessly.

"What's that you said, Mr. Science?"

He advanced two additional steps, as if to get within earshot.

Schmidt stifled a snort and bit his lip, modifying the exhalation into a "Haarrrummmph!"

Both men stopped about three feet from each other, eyes locked. Wally spoke to Rae without looking at her. "Sweetheart, I'm here to invite you to a night of romance on the island of Chiloe."

He continued to stare at the archeologist and was once again fascinated with the lack of color in his irises. Movement in Wally's peripheral vision reminded him of the underlings toiling away at the exposed protrusion beside them; he could sense a change in the posture of the redhead, at the edge of his right side view. He sensed not malice, but definite alertness. He casually scuffed at the sandy soil with his right foot, flipping some carefully plotted pebbles onto the professor's nicely polished shoes. The pale blue color diminished as the pupils ratcheted larger, betraying double outrage.

"I have one more photo before I lose my light, Walter." Rae said. "About 20 minutes more. How about waiting for me back at the parking lot?"

It was an order. She softened it.

"My camera is an extreme wide angle. I don't think *National Geographic Magazine* wants your backside on its pages."

Wally flashed his best Mel Gibson smile at the professor, whose eyes said "Get out!"

He turned from the glare and nearly stepped into the spiked redhead, who had magically and silently crossed the 20 feet between them. She stood at his side and looked up into Wally's face with a

disarmingly blank expression. It unnerved him. There were no introductions.

His retreat began on the bank of a dry streambed. The strange, silent woman walked alongside, her gaze fixed on Wally, unbroken as she traversed a difficult, rock-strewn terrain. She looked to be about 25 with black, expressionless holes for eyes over a Aboriginal nose and a small, mirthless mouth. Cute, considering she seemed to be dead inside. Like a rainforest dweller on familiar ground, she moved silently, paying no attention to the uneven path. He felt as if he had been analyzed by a superior being, and found unnecessary for further interest.

As they neared the parking area near the main project tent, she stopped and stood motionless. Wally continued toward the rental truck, but couldn't resist looking into the director's tent through the open canvas sides. He slowed his retreat and edged closer.

The recently unearthed stadium model sat inside on the folding table he'd seen two days before. A jumble of tan ceramic figurines the size of small Barbies had been positioned on the bench-like seats of the ancient maquette. They gave the sporting artifact a crowd of spectators—a lot more than spear points and stone tools. He was impressed.

"Private property." The speaker had a familiar, deep German accent. The professor appeared from the back of the tent and walked forward, positioning his body between Wally and the goods. "If you persist in your meddlesome intrusion, I will have you arrested."

"This find is amazing. Do you really think it's 20,000 years old?" Wally wasn't nervous about any personal trouble, but he had realized that the quirky romantic gesture he had planned would be spent apologizing unless he fixed it soon. Besides, the enormity of the discovery was impressive. Sure beat the hell out of finding a factory-made dining room set in a thrift store.

Lucas-Schmidt's pale face softened slightly, as he tried to understand the praise. "Please wait in the car. These findings are not public. Your girlfriend's assignment will terminate if you keep up your harassment."

Checkmate.

"Congratulations on your discoveries, nevertheless. I'm leaving now, Professor. I won't intrude on your site again."

He knew that if Rae got bumped, she would never forgive him. There was no right or wrong out here, just two men in a tent in South America with a silent native witness.

Lighten up, stupid, or Rae will spend her days selling single cigarettes at a 7-Eleven, knowing you wrecked her big chance, he admonished himself. He dared one more observation, embarrassed at his own humility.

"Reminds me of Willendorf Venuses on steroids."

"What?"

"You know, your figurines resemble the famous Stone Age European figurines after a couple of years on performance-enhancing drugs. Look at the forearms on this one. She looks like Popeye!"

"Goodbye, Mister Winchester."

Chapter Ten

City of Ancud, Chiloe Island, Chile

"You want to drive into Argentina?" Rae asked.

Wally recognized the angle of her eyebrows. He knew from experience there is never really a good time to bring up harebrained schemes, but he barged ahead, "It looks like I can make it in a couple of days, honey. It's an egg rocker. I don't trust a rookie foreign dealer to pack and ship it back to Seattle. The seller photographed it in front of a shower curtain, for Christ's sakes. We're already down here. I can pack it right. It could be worth 30, maybe 40,000. How's the chowder? Mine's great!"

Rae, no stranger to Wally's boasts of big-ticket scores, watched him squirm. In conversations he was always on the verge of making a ton of money. His reality was that he still drove a 1977 van and frequently checked under the couch cushions for coffee change.

"This is the best seafood I've ever tasted. Don't change the subject. Do you know I almost got fired today?"

This was the third time she had brought up this point: once on the chilly ride from her jobsite to the ferry dock 30 kilometers to the south, once on the half-hour ferry ride to Chiloe, trumping a romantic boat ride with a soft orange Pacific Ocean sunset at their backs; and now.

Wally picked a seafood shape from the buttery bisque in front of him and popped the morsel into his mouth. It crunched and melted at the same time. He asked, "What was the name of this soup again, seafood chowder?"

"*Mix de Mariscos a la Provenza.*" The pursed lips parted only to let the wonderful shellfish in.

"I apologized to his highness, you know. In the tent, with the redhead looking on. What's the story about her?"

"She's a security expert, sent to protect the artifacts. I don't think she knows English. I've never heard her speak."

"That explains her attitude. I think they got her from the poison dart crowd in the Amazon. She moves like a leopard. Something powerful about her. Such a little body. Gave me the willies."

Freshly baked bread still steamed on the platter with tiny trays of salsas and olive oils and dark vinegars.

"Why did you have to come onto the site? I thought we agreed."

"Your project excavation is halfway to the ferry dock to Chiloe; to this great place, honey. I figured, 'why make Rae travel all the way back to Puerto Montt, if we would pass right by the site again an hour later on the way south?' When I was checking for maps of Argentina, I heard about this restaurant and the moonlight ferry ride. It was supposed to be a night of love. I didn't expect Dr. Schweitzer to get on my case just to pick you up. Honest, hon."

"Just where is this town in Argentina? I have an important party to attend on Saturday at the home of one of the dig's sponsors. That's five days from now. It's important that you're there. Are you sure you can drive to another country, cross a foreign border twice and get back here on time? Wally, you don't even speak Spanish."

"I don't exactly know where it is yet. I haven't had time to find it on the map. It took a while to find a map of Argentina. This is Chile, remember? I heard they don't get along. And guess what? What a lucky break it would be if it were in a province directly across the Andes Mountains from here. The passes are said to be spectacular."

"This is not as simple as a skip and a jump. I worry about you."

This was the first time Rae seemed anything but pissed in the last two hours. Wally took comfort in her concern. His wounded psyche had been on Orange Alert from the time the German professor's chin first stuck out.

"Actually, honey, I did sort of find the region on the map. It's right across from here after the Andes, only a little farther south."

"A little farther?" Rae knew the distortion of Wally-math.

"Just 300 or 400 kilometers down. It's not so far in miles, you know. Like one western state, say Washington, or Oregon. I figure one day's travel, one day to sightsee, and one day back. The truck's new. The rental company allows passage to Argentina. I checked. They said all the paperwork's in the glove box."

"In Spanish, Anglo."

"All the border guards speak Spanish. They can figure it out."

Rae put her head in her hands and closed her eyes, listening as he turned three dangerous assumptions into a plan.

The first one was "A couple of days." Any figure Wally Winchester uses in a sentence is likely to be inflated or deflated by a factor of three, depending on why he uses it. The rule is, if he's bragging, divide his number by three. If he's complaining, then multiply.

The second warning phrase was, "I don't know exactly where the town is yet."

The third scary warning was "pretty much directly across the Andes mountains." That meant, "Crossing the highest mountain range in the Western Hemisphere on alpine cliff roads is fine because the scenery is spectacular."

"You have to promise to be careful," she said. She felt fear and anger dissipate, probably thanks to the seafood in the bowl, the ferry ride in the sunset, and the really good red Chilean wine.

Real perked coffee arrived; Wally's eyes looked skyward in thanks. They ordered *Panqueque con dulce de leche*, which turned out to be thin crepes with fresh berries and sweet cream, and *Tortas Caseras*, a crisp toasted waffle stuffed with ice cream with a drizzle of hot fudge sauce.

Wally watched her savor the rich dessert and felt safe to speak freely again.

"Tell me about this party on Saturday," he said.

"Have you heard of Claus Braun, from the Future Club Foundation?"

"Who hasn't? Wasn't he up for a Nobel peace prize, a few years ago?"

"I've never heard that, but I'd be surprised if he hasn't been considered."

Spots of the crepe filling had lodged at the corners of her mouth. Wally considered leaning over and licking the offending confection off her face, but held back, distrustful of his social radar.

"I've seen him interviewed on CNN. He opens safe houses for street kids in dangerous places like Brazil and Indonesia and Afghanistan, right?"

"Yes, calls them Future Clubs. Gets poor children off the streets and gives them food, safety zones, and a little education. Like setting up YMCAs in Hell."

"Very cool. He looked like Steve Martin in a crewcut on TV. He lives near Puerto Montt?"

"Yes, on the other side of that big lake, Lago Llanquihue, they call it. Near the volcano east of Puerto Montt."

"Volcano Orsorno," Wally said.

"Whatever. He's the financial backer in the new excavation. A personal buddy of Dr. Schmidt. The team is invited to a big-deal

Chilean barbeque at his house. Including you, amazingly. They say he has a wonderful mansion filled with great antiques."

Wally perked up at the word.

"And by the way, stud, please try to get along with my professor, would you? He's really a nice guy when you're not around."

"We sort of got off on the wrong foot on day one. I'm sorry. I'll try, at least for your sake and a chance to drool over some antiques at his sugar daddy's digs."

"Fair enough, lover." Her voice got lower and she leaned closer. Wally could smell chocolate and blackberries on her sweet breath.

"If I remember correctly, Wally, there's a half-hour ferry crossing ahead of us. Does the rental have tinted windows? I'm thinking about joining the two meters above sea level club."
"Check, *por favor*."

Chapter Eleven

Puerto Montt, Chile

Tuesday morning promised another day of central Chilean summer. They got an early start, Rae off to capture slow-motion photos of a scientific breakthrough, and Wally down at the drab hotel lobby again for lousy instant coffee and stale toast. His Café a la Internet opened at nine a.m.

A response from the egg rocker consignor was waiting when he logged in. The seller was a woman named Isabella Gato, an attorney living in Esquel, Argentina. Wally's end of auction questions, posted the day before, were answered in passable English.

"Come on over and pick up the chair," she wrote. "The drive is not unreasonable from Puerto Montt, but not one to take lightly. Give yourself three days to get here and return."

Perfect. He'd be back with a day to spare.

As Wally inspected the map of Chile it reminded him of the map of Camano Island. A long, narrow vertical shape resembled, to him, an old wooden yardstick that the dog had chewed on, the bottom third of the ruler gnawed almost to shreds. *That's Patagonia.* He put his finger on Puerto Montt, about 10 inches from the bottom, looking for passages into Argentina.

After a bit of searching, Wally found Esquel, Argentina, on his map, not much of a population center if the size of the letters were an indication. *Just off to the side of Route 40.* Wally thought. *It must be a good road, looks like a major highway.*

Connecting roads across the mountains were few. Far to the south, near Esquel, a thin blue printed line wobbled westward over to Chile, but ended in a jumble of roadless islands and ferry passages. No help there.

He looked north instead. The map indicated a crossing over to Argentina through a pass called Paso Cardenal Samore, a hundred miles north of Puerto Montt. The pass altitude was listed as 1500 meters. *Piece of cake*, Wally thought.

Wally took note of the vast expanse of Argentina farther north; Rae had been right. The country is the size of a small planet with thousands of red and blue roads crisscrossing like an Irish drinker's nose. *I am lucky*, he congratulated himself, *to be headed to the Argentine Southlands where the travel choices are few.*

"Leave a message after the tone." Rae's recording.

"Hi, babe." Wally said to the tape. "I'm on my way. Wanted to tell you I love you in case the banditos get me in Argentina and hold me for ransom."

Back at the hotel, Rae grabbed the phone. She said, "I'll pay anything to get you back, at least up to 500 dollars."

Wally squawked. "I'm worth at least 750, cheapskate."

Rae said, "You won't believe what we found today. It happened during a 10-minute exposure. People got so excited that they probably wouldn't show up at all in the final photo. Such frantic movement will make them invisible."

Wally cut back in, "Maybe you get the magazine cover. Hey. I'm taking off now. I'll catch up with you on Friday. Looks like an easy trip. I'm keeping to the really good roads. See you in a couple of *mañanas.*"

"Wally, I love you. Be safe, and don't do anything foolish. And don't hang me up for the party on Saturday, it means a lot to me."

"I promise. Besides, what could possibly go wrong?"

The egg rocker's Argentine consignor had referred to the Chile-Argentina border crossing as "the frontier." Wally was beginning to believe it. Twenty miles east of Route 5, Chile's north/south four-lane blacktop, the good tar road turned to dirt. Off to the south, Volcano Orsorno rose, partially surrounded by its own cloud on a perfectly clear noontime day.

Rocks rattled against the truck bottom with a sound like small-arms fire as he drove through a cloud of dust from vehicles ahead. Wally believed that the wide earth road was designed for high-speed driving, despite the lack of asphalt. So did about half the other vehicles he encountered. As the foothills of the Andes loomed ahead, he found himself in a 60 kilometer-an-hour race, a controlled and continual skid, punctuated by encounters with ox carts and old gauchos in rusty Citroens trying hard to go 20.

Small hills in a rustic farmscape grew into long inclines through forested fields. Switchbacks brought more drama to the contest. Wally had one eye on the rear view mirror, the other watching for pedestrians, farm animals, and road hazards, both avoiding the glance at the frightening drop-off to the right. Alpine forests gave way to scrubby mountain brush and exposed rock. It was turning into a white-knuckle drive. He switched hands frequently, alternating the blood flow into tense, pale fingers. He kept promising himself to stop somewhere so he could enjoy it.

A sign on the right displayed a slew of Spanish words, Wally noted, including "Frontier."

Up ahead, around a long left bend in the road, a gate appeared as the frightening precipice leveled out into a broad saddle between two massive peaks. Two modest buildings flying the red and yellow Chilean flag on a sturdy pole sat on the left. It was dry; the yellowed grass and hardy dwarf trees grew where they could. A ring of bright green landscaping around the freshly painted structures suggested imported water.

Three vehicles, one an expensive town car, another a ramshackle mountain relic with sheep tethered in back, and the third, a government-marked crew cab, were parked in front. Wally eased the pickup between them and sighed, letting out the breath that he had inhaled five minutes before on the switchbacks as he allowed himself 30 seconds to take in the view.

Fifty miles of lowlands with a hazy Pacific Ocean at the horizon spread out past the forested hills below. Volcano Orsorno dominated the southern sky.

I wonder what these guys need to let me out of the country? The question cut short his tourist urge to gawk at the panorama. He went for the forms.

A handful of documents that he hadn't bothered to scrutinize during the rental process sat in the glove box. Thorough analysis of papers printed in a foreign language hadn't seemed important at the time. He chose one that looked like a registration and one with an official seal. Then he felt for the damp cardboard passport in his back pocket and entered the guard station.

Inside, white-painted wide-board walls held framed maps and declarations. A banded commercial carpet suggested mountain weavings. Single light bulbs in garage-style metal reflectors hung from twisted South American electrical wire. The air was cool and smelled of old cedar and road dust. Wally classified the space as well-preserved country rustic. It reminded him of a WPA Oregon lodge.

Two families stood in line, awaiting approval to cross into Argentina. One group was dressed in crisp Western clothes, two kids and a mom who would look at home at Burger King. Wally pegged her as the Lexus owner. She spoke in surly Spanish to the clerk as he handed back her papers and herded her brood toward the door.

A dour leather-faced native held the arm of a short woman with her hair in a kerchief as they approached the desk. A pair of quiet children wearing hand woven, brightly colored caps complete with earflaps, and traditional serapes looked at a map on the wall. The sound of a rubber stamp engaging suggested approval. They stepped away.

Wally stepped up to the desk and faced two officials wearing government greens, like park rangers. There was little hint of attitude from these public men, but then he hadn't spoken yet. He spoke: "*Hola, amigos.*"

They smiled and nodded. Out came a string of unintelligible Spanish.

Wally tried the shorthand that seemed to be the norm. "*Yo n...ab...Es...*" This was his short form for *Yo no hablas español*.

They looked back quizzically and unleashed another bundle of Spanish words. Wally thought he heard the phrase, *documentos e itentificacion touristico*. He handed over his passport. Good guess. They nodded.

More words in the shape of a question flew at Wally.

He delivered up the registration, nodding, and acting as though he had this conversation often. The smaller man dropped it like it was a handful of poison ivy, his body language saying, "What the fuck is this? I asked for the other paperwork!"

Wally offered the rental agreement. The Chilean guards looked at each other like they shared a private joke. More words were aimed

at Wally, forcefully delivered. He shrugged. That brought the level of weirdness up another notch.

"*Hablas español, English?*" asked the older guard.

He said, "*Pochochino*," and got the feeling that he had just ordered a coffee drink, instead of saying, "not much." He tried the Wally Winchester charm, usually effective anywhere. Opening his hands, palms up, he made the upward motion with the right index finger, suggesting, "I've got it!"

He turned and bolted to the vehicle, careful not to look like he was fleeing.

Forty seconds later Wally reappeared, depositing all the paperwork from the glove box on the desk.

The tall guard fingered through the pile of papers and extracted a document of unknown purpose. He held it up as if to suggest, "this one, stupid American."

Wally shrugged in his best "But of course" gesture.

Stamp, stamp, stamp.

Without any apparent Spanish skills, Wally Winchester had successfully exited Chile. His exodus was approved with laughter and a mumbled secret joke. He gathered the paperwork and withdrew. The short man followed and manually opened the gate.

One hundred yards ahead another set of buildings, in bright blue corrugated metal, flew a different flag. Wally set his chin and went for it again.

No park ranger greens here. Full military gear, complete with hats resembling the highway patrol in Moscow, reminded Wally of a scene from the movie, *Gorky Park*.

No tourist photos or suggested attractions decorated the austere Sheetrocked anteroom. It was all business. AK-47s, sidearm, gold braids, medals, and everything but bullet-studded bandoliers set the tone.

He walked over to a glass-fronted bank cage-type cubicle, brandishing his US passport like a "Get Out of Jail Free" Monopoly card.

The Spanish words here were clipped and harsh. He hoped they didn't know he's a member of the Democratic Party up north. Stamp, stamp, stamp, happened to the paperwork with no attempts at conversation. Just as well, but he was in.

Wally Winchester, now officially in Argentina, drove on down the mountain pass, blowing out little bursts of air, trying to get the tension out of his shoulders.

The copy of *Frommer's Guide to South America* beside him in the white rental truck described the Bariloche region as the "second most-visited place in Argentina." It suggested beautiful scenery and well-maintained roads.

The book was right about the beauty.

Snow covered volcano cones amid rugged, soaring peaks dropped down to a seemingly endless lake colored an impossible shade of turquoise. Heavy forests at the lakeshore marched up the steep slope beside him, ending where glaciers perched in cliff-top notches far above. Villa la Angostura, nestled on an aquamarine bay, signaled its city limits with a welcoming asphalt road.

Wally shook an inch of dust off his pant legs and stretched in the parking lot of a German chalet-styled lakeside bistro, thankful to have the rattling of small stones and plumes of tan powder stop for a while. He ordered a cup of coffee to go. It arrived perked, not instant. He gave thanks to an unseen Argentine god and ambled stiffly back to his vehicle. He savored the real brewed coffee as he drove onward to the east, eager to meet the chair of his dreams.

The smooth macadam road surface disappeared at the city limit, replaced with the usual crushed-earth topping. Six miles ahead, at the next lakeshore village, the asphalt returned. *Apparently, each town is allotted three miles of tar.*

After 70 miles of lakeshore grandeur, the eastward gravel T-boned a fatter dirt road called Argentina Route 243. He turned south. According to Wally's map, Esquel lay 150 kilometers farther, a distance, Wally figured, that gave him plenty of time to find a room and a warm meal before the sun set.

The eastern side of the Andes is drier than the west. Sagebrush and desert underbrush cover a stationary sea of suntanned hills. After an hour of driving, a large green sign with white letters appeared to the right. It was government billboard advertising the entrance to Parque Nacional Los Alerces.

Wally sipped a bottle of warm Diet Pepsi at the intersection as he consulted the guidebook and his map. Either the gravel highway southward or the park drive through the scenic attraction would get him to Esquel. The distances seemed about the same, though the park road was printed in a dangerous shade of light pastel. He looked ahead at the boring, tan hills, then to the Andes mountain chain, backlit by a late afternoon sun. He chose the park road, trading one gravel-strewn route for a more picturesque one, the route printed in very light pastel. He tried not to pat himself too hard on the back for the adventuresome choice.

He was 20 miles into the park when the realities of faint lines on an Argentine map became apparent. Wally found himself on a wide one-lane road. Homemade campers and trailer-toting Citroens filled with kids and grandma barreled past, not concerned, apparently, with the five inches of clearance between them. Wally learned to roll up the window before the dust cloud behind them began to settle.

An upward tilt of the roadbed signaled the beginning of the switchback cliff road he could see zigzagging up the steep mountainside ahead. A darkening span of still water opened below him. A lake with snow-covered peaks at its back emerged above the stunted trees. There was no shoulder on the right, only a drop-off. The roadbed was broken and rough. Wally slowed to 10 and crept ahead, doing his best not to look out the passenger window at the treetops 1,000 feet below. The sun was a low, yellow dome melting into the distant Andes Mountains to the west. The cliff wall beside him glowed with golden light. Wally regretted his choice of road. The scenic shortcut to the chair of his dreams now seemed ill-advised. *I'll look at maps more carefully next time.*

Sweat ran freely under his arms as he crept around a sharp, exposed corner at 10 miles an hour. He flipped his headlights and tapped out a warning with the horn as he rounded it, mindful of the 1,000-foot drop-off beside him. At the top of the incline, he found a welcome level spot and pulled over. The narrow mountainside slice that someone in the Argentine map business had labeled as a road began a steady drop toward the dark void to the right where the lake glistened.

Good, he thought. He took a breath and nosed the truck onto the rocky roadbed and started down into the dark valley below. A yank of the gearshift dropped the vehicle into low gear.

Nightfall replaced dusk. Peering into the darkness, he saw a string of oncoming headlight pairs far ahead, half a mile and 500 feet lower. Wally hurried down the scary descent, hoping to get less altitude and a safe place off to a wide spot before they met.

Switchback after switchback brought no wide shoulder. Each corner sent his high beams out into the void. Wally saw the first of the opposing headlamps lighting a corner up ahead.

Time's up! he thought. He could hear the deep rumblings of large diesels. He leaned on the horn, flashing the high beams, as the first of the huge headlights rounded the corner 25 feet ahead. He faced a choice between turning right and driving off the cliff or running headlong into the vertical wall to the left. He chose the wall and felt ragged boulders scrape the bottom of his truck as he closed the gap.

The pickup struck a rock higher than the bumper and halted, half tipped over, as the left wheels ran up the wall. Without slowing, a huge vehicle rumbled on by. Wheels the height of Wally's vehicle brushed the white finish of the rental. He felt it shudder and release as the behemoth passed him. A string of followers took their turn, but all missed the stunned gringo, nearly on his side to their right. No one stopped.

Wally managed a weak curse, "Assholes!" into the silent darkness. He felt his breathing resume and realized he was still alive.

After five minutes of quiet breathing, he could think again. The moonless alpine darkness was nearly total. His rental was still in gear, engine running. He found reverse with a shaky hand and backed the pickup off the pile of rock. Something wasn't right. Back wheels spun pebbles. The steering wheel jerked violently as he pulled free. He cringed at sounds of metal scraping against stone.

A flat tire at least and a trip to the body shop. Is there a flashlight included in the rental package? Probably should have checked.

He flipped back to high beams and gunned the wounded truck higher up the cliff wall. Reflected light granted Wally a glimmer of the destroyed front tire. He hoped that was all. Bitter gusts of much colder air buffeted the exposed scene.

It took some time to locate the spare, bracketed under the truck bed, and more time to scope out the jacking system. Even in the thin reflected light, Wally could see how badly damaged the wheel was.

Shivering in the night air, he completed the replacement and continued on into the chilly mountain darkness toward the lakeshore he knew was ahead.

Flat gravel suggested he'd reached the bottom of the grade. In the headlights a park sign appeared, announcing *Cabañas* near the shore of the invisible lake. The neon sign below it spelled *Kristal*, the popular South American lager beer. The best news of all was the third sign. It didn't need translation. PIZZA.

Wally Winchester magic knows no borders, he boasted to the screaming skeptical parts of his weary brain as he parked the pickup near the glowing opening to a safe haven.

Chapter Twelve

Archeological Site Near Puerto Montt, Chile

The sun was still high enough for about two more exposures, but the way things were going Rae felt she'd be lucky to finish this shot. A feeling that something was wrong nagged her. She'd tried to identify it, but failed. When she tried to dismiss it, it remained.

She said, "Can you guys move the night lights over a few feet to the right? This is a very wide-angle shot."

Crouched over her flimsy cardboard homemade camera, precariously balanced on a flat heavy stone, she felt a trickle of sweat as it ran down her forehead into her right eye. It stung. She wiped it off and rubbed her eyes, trying to clear her vision.

A workman, waiting for orders from Lucas-Schmidt, looked at her. The archaeologist nodded assent. Mumbling a few words in Spanish, the Chilean labored to drag the lighting tripod farther away from the frantic activity in front of her. He glared at the photographer, mugging a Spanish impression of a woman giving orders. His buddies laughed quietly and nodded their heads in understanding.

Off to the right the quiet redhead stood as still and comfortable as a tree. *Three days here and we've never spoken,* Rae thought. Deep black eyes. Nobody home.

Rae wished she had an ally here, or at least respect. She wished for the bulky clutter of view cameras and special lights and boxes containing electronic gizmos that would give her assignment the look of professional importance.

Rough men like these probably don't understand how a simple paper box can make a Pulitzer prize photo, she thought. *To them, I look like a third grader in arts and craft class.*

Rae measured the waning late afternoon light again, waiting for three diggers to resume the process of extracting artifacts from the sandy soil. The all-night excavation process meant that much of the discovery took place in artificial light. That made her job as a photographer more difficult. The two powerful generators brought in from Puerto Montt for night work didn't come close to providing the light she needed to capture images through the tiny pinprick opening she called a lens. Knowing that a pinhole photo really wanted bright daylight for a short enough exposure to capture the work force doing their thing, she had offered Professor Schmidt a chance to record the evening digging with the Nikon, which could take photos in any light. He'd been strongly opposed to the idea.

"Are you a spy, or are you a pinhole photographer?" he'd responded.

She'd thought it was sort of an extreme reaction to the question, but had let it drop. That meant she only worked during the day; today she was losing that light fast and she decided it was the best she could hope for. Pulling the masking tape from the metal plate with the pinhole, she started counting: "One thousand one, one thousand two..."

At 120 seconds, she placed a finger over the tiny opening and re-taped it.

Click.

One push on the metal door isolated the Polaroid camera back plate from the fading afternoon light. She pulled the unit out and placed it in the lightproof bag for processing in the states.

"I think I'm done for the day, Dr. Schmidt. We're losing the good daylight."

"Very well, Miss Roberts." She felt the coldness in his words.

After putting her gear in the daypack, she slowly walked the dry gully back to the project tent and looked for Julian and a ride back to the hotel.

The red-haired woman stared at her as she left.

Chapter Thirteen

Esquel, Argentina

The drive to Esquel was an uneventful two-hour sprint in the morning. A wobbly tire in the front end was troubling, but the egg rocker was in Wally's sights. He made himself a promise to fix the spare and deal with whatever else he'd fucked up in the front end later.

Wally ran the town's main street to get a handle on the e-mail directions from the lady lawyer he'd received a long yesterday ago. *La Belle Epoch* buildings in brick and stucco flanked wide streets, suggesting rural prosperity. He passed a city park that sported a fountain and the mandatory statue of a Spanish European liberator. At 10:30 in the morning it was filled with young people. Little kiosks selling knickknacks and fried things were doing well. Wally noticed a lot of public love. Same as in Chile. Hand-holding, kissing, and lounging predominated.

Don't any of these kids have jobs? Wally asked himself, despite a romantic's admiration of their choice of recreation.

He was searching for a street named Nineteenth of July that was promised to be four blocks north of the city square. He drove by an antique shop whose window offered a phonograph, an ancient RCA Victor with an outside horn. He made a mental note to find it later. On the next block, a small signboard with gold leaf lettering for the lawyer's office: *Isabel Gato, Abogado*, pointed to the second floor. He parked on the next street to the right and walked back.

Stale, warm summer heat, smelling of ancient paint and holding a hint of yesterday's cooking, filled the corridor when he

walked up the stairs. Her business was three offices down to the left. *Isabel Gato* was painted on the glass-topped door.

No secretary greeted him as he stepped inside. The space was clean and felt professional. A shelf of law books rested behind a potted plant.

Isabel Gato sat behind a silver computer monitor on a simple oak desk with a green felt top. Wally noticed the Apple logo and felt kinship.

"I imagine you are Mister Wally Winchester, alias Camano Wally, the successful winner of this chair." She was trim and pretty, and very young, wearing a stylish tan pantsuit appropriate for a barrister, even in the states. She spoke in broken, but passable, English.

She pointed behind Wally to the right, and he turned to look. There it was.

"Thank you, Jesus!" he shouted inside. The chair looked like all the photos he'd seen. Gulping back a gasp, he told himself to act civilized. With some effort, he turned to face the consignor.

"Walter Winchester," he spoke with a dry throat. "You are Señorita Gato, I presume?"

The attractive attorney stood and walked toward the bedraggled traveler. Wally leaned forward to deliver the accustomed kiss on the right cheek, internally applauding himself for his hipness to local customs. Sweet flowers came to mind. It was jasmine, he guessed, the scent of jasmine on her cheek.

God's first breath and the chair of my dreams. The heat in the second floor office added to the sensory stew. He felt dizzy and thought about sitting down.

"Señora, not señorita," she smiled. "But thank you for your thought. I have three fine children of which I am very proud."

She reached over to her desk to retrieve a framed family photo while Wally thought about the chair.

Was it here? He tried to keep the family portrait in focus but he was dying to break contact and look around.

"Fine family," he managed, keeping his eyes on a photograph that he didn't actually see. "I am happy that you have English, and also pleased to own this chair you have."

He managed eye contact again, but gave up and turned around. It was still here, exactly where he saw it a moment before. It hadn't disappeared and he did not wake up from a wonderful dream. It had looked right at first glance, and it still did. His heart leaped once again.

She spoke to his back, "The chair is yours, señor. Would you like to examine it? Of course you would."

Wally walked over to his prize.

"You like?" she asked.

"*Si, me gusto.*" The words in Spanish came without conscious thought.

It was smaller than he expected. Twin bentwood ovals bisected by a pair of diagonal braces. The simple wooden seat rose up with a little saddle hump across the front, as if to keep the sitter from sliding forward. Cylindrical back posts were spanned by another slab of Austrian plywood, and, just as he expected, pierced by a series of secessionist cutouts that suggested an oval.

Perfect!

Wally's eyes went to the prominent wooden nipples attached to the rear of the ovals. Those were integral to the safety of its sitter on a vigorous rock backward.

It was painted brown. This had not been apparent on the auction site.

Shit, he thought. *Oh well. It's the egg rocker. I can live without the original finish. I hope they didn't paint the bottom, where the label should be.*

He gingerly turned it over, exposing the upturned bentwood box that formed the seat.

No paint. Here, the old finish remained intact.

Thank you!

A branded mark on the perfectly oxidized beechwood spelled out J. & J. Kohn, Wien.

A paper label, faded yellow and brown, on the inside edge also screamed original. It displayed the company logo in fancy Victorian script. The little brown border of checkerboard squares confirmed it.

"I hope you like the chair, Señor Wally. You paid a great deal of money for it."

"It's perfect."

Gingerly, he placed 180 excited North American pounds between the ovals and sat down. It felt great, maybe even better than eating New York pizza.

"Can you tell me where it came from?" Wally's voice was like chocolate syrup.

"It is an estate piece from a local *estancia*."

Wally looked at her quizzically.

She explained, "During the colonial times, large farm houses were constructed for the wealthy landowners. Many of these grand structures remain. Most have been maintained through strong family ties and now are very popular with *touristimos*. Vacationing visitors pay large sums to pretend to be poor farm hands and live in restored servant quarters. They milk the cows, shear the sheep, and do everything the gauchos were expected to do. I think I'll never understand Europeans."

Wally half-listened, surprised at his own purring as he slowly rocked in his new chair.

Isabella Gato said. "The owner was a woman of eighty *annos*, years. She was a German woman, a nurse by profession, and was well loved by the people in Esquel who knew her. I represented the estate upon her passing. There were many old things there. She had never married and there was no listed heir. The will was very specific. It stated that sale of her estate was to be used to benefit a local orphan's home."

Wally's eyelids had snapped wide with the mention of "other old things."

"Where are the other items?"

"All sold, what a pity for you, I'm afraid, but this was the only object from Europe. The rest were local craftsman made. I placed anything worthwhile on the auction, *MercadoLibre*, but none of the regional items generated any real interest. Only this chair. I was amazed at the bidding, especially during the final five minutes. Many children will benefit from your generous offer. Thank you."

"Da nada, tambien," Wally answered. A fuzzy, relaxed happiness settled onto his brain as he rocked. He blamed it on the altitude.

He tried to hide a schoolboy grin as he stood up and lifted the rocker to his shoulder and turned to the door.

"Señor," she said.

"Yes?"

"Are you going to pay me for your purchase?"

"Oh, my God," Wally said. "Forgive me, how rude of me." He felt blood flush his face. He laughed nervously. "Do you take PayPal? I also have American express."

Chapter Fourteen

Archeological Site Near Puerto Montt, Chile

The trouble had started the day before while Rae made her pinhole exposures. Amazing things were coming to light in the digging. Figurines, implements, and small models of structures appeared with dizzying frequency.

It had been difficult to record the progress with a camera that required two-minute exposures. She'd expected sedate figures of scientists, seated and brushing aside 20,000 years of hard-packed earth, measuring and cataloging, and carefully plotting a three-dimensional cross section for the science books. Instead it seemed more like looting.

A pile of artifacts had grown as the process continued, placed unceremoniously in a wooden box for later analysis.

"I'm surprised the earth is so soft after so many years," she'd said to the project leader during a lull in the digging.

"I didn't know you have a degree in soil geology," Schmidt had countered.

Rae noticed a defensive response that caused her to wonder why he was so uptight in idle conversation. She shrugged and went back to her camera.

The photo she'd wanted to capture was the emergence of a green-crusted obelisk that had been discovered that morning, eight feet down in the growing excavation. She guessed it to be two and a half-feet long from the top edge protruding from hard-packed earth deep in the hole.

Three people in tan khakis were scooping soil into three cardboard boxes. In her photo the movement of their arms would cause the image to blur, suggesting digging. The seated bodies would appear well focused from the waist down where movement was limited during the exposure.

Rae looked skyward, guessing at the path of the noonday sun. It looked like a half hour or so before its westward path would illuminate the men. The composition she expected was a sun-drenched cliff side in good focus, with fuzzy human movement contrasting the permanence of the artifacts. *Five minutes more*, she figured.

"Professor?"

"I told you to call me Rolf." He spoke without looking up. More than two inches of the structure was exposed now.

"Try to keep as still as you can for the next few minutes. OK?"

"We're on a tight schedule, young lady. We're working three shifts, you know."

"Please don't stop working, Rolf. The movement will be beautiful. That's the point. With a little luck it will get your backside on the cover of *National Geographic*. It would help, though, if none of you got up and left the scene for two minutes. Fair enough?"

The mention of a magazine cover seemed to get his attention. He murmured instructions to the two others, and she pulled the tape off the pinhole.

It was then that she saw the cigarette butt, tan filter and all, lying exposed in the fresh earth next to the crusty green metal artifact. Schmidt reached down and plucked it up, closing his hand. Skewered in the late afternoon spotlight, with an active camera at his back, his movements remained fluid.

Rae wondered if she'd seen anything at all. *Maybe it was just a colored stone, or a painted shard,* she told herself. *Maybe it fell from*

*the normal ground above, stubbed out by a night workman on a
cigarette break—*

The alternative explanation was huge and frightening. So
preposterous, in fact, that she put it out of her mind and finished
counting the seconds for the shot.

"One hundred twenty. OK, everyone, I'm done. Thank you."

She taped the opening again and slid the film cover into place
in the back.

"I'd like to see this one when you develop it, Rae. When do
you do the processing? In the morning?"

Schmidt stood beside her now. He continued to brush
imaginary dirt off his trousers.

"I'm bringing the film back to the states to develop."

He twitched. After 20 seconds he said, "If this is such an
important assignment, why do you risk your masterpiece exposures to
the x-ray scanners and all the neutron beams they use these days?"

"It's OK, Rolf, I brought lead-lined film bags for the return
trip, but I understand your concern. I don't exactly trust the customs
process, either. I did bring a portable developing tank in case I need it.
There's probably developing chemicals in Puerto Montt. Hmmmmm
… if I leave early today, Julian can help me find it. Besides, Wally is
out of the country till tomorrow or Friday, so I've got my evening free.
Thanks for suggesting it."

She started to leave but turned back with a smile. "I was half
ready to do it anyway. You're my excuse."

He moved his face closer, white hair backlit. Pale, pale blue
eyes suggested the color of a tropical lagoon.

"If you're without company tonight, I'd love to take you to
dinner, you know, to discuss the project."

"Perhaps we can do both," she suggested. "There's a really nice restaurant I discovered around the corner from my hotel. *La Estacion*. Do you know it?"

"I've heard of this place. It is operated by Pakistanis, is it not?"

"Indonesian, actually, but they have a wide range of dishes. I'm sure you'll find something you like. Besides, then I can get right to the processing."

"Six o'clock. I will meet you there," he said with a slight bow. "You better get going or you won't find your chemicals."

It was almost an order.

Chapter Fifteen

Esquel, Argentina

Despite its relatively small size, the rocker's oval shape didn't fit in the abbreviated crew cab door. By turning it upside down and twisting, Wally managed to get it into the front seat beside him. He engaged the passenger seatbelt and buckled the chair in tight like a soccer mom securing a third grader.

It was now Wednesday, noontime, in Esquel. A reasonable plan would be to fix the tire for possible future use, check for front-end damage, and hightail it back north to Bariloche for the night. Then a leisurely gallop over the frontier to Puerto Montt. Estimated time of arrival, Thursday at two p.m. It was a brilliant plan that would gain him a happy girlfriend and bragging rights back in the USA.

Wally headed for the antique shop he'd noticed earlier.

It took three circumnavigations of the plaza, including a frightening wrong turn down a one-way street before he parked in front of the little antique shop with the old record player in the window. It was closed.

Closed? It was open this morning! What kind of outfit is this?

A sign on the door read: *Aperto 9 a 12 y 16 a 22.* He looked around the street to see most of the other stores closed tight for siesta.

The only open establishments in sight were restaurants.

Time for lunch.

Wally decided on *Mundo de la Carne*. With a line of citizens waiting at the door, it looked like a popular spot.

Something to do with meats, he guessed.

Inside he was faced with a bewildering buffet. A clear plastic hair shield covered hot trays of vegetables and steam trays of animal organs swimming in gelatin, or gravy, or unknown sauces.

Watch out, Winchester, or you'll be gobbling sautéed sheep balls or pancreas Alfredo, he warned himself. He chose meat presented in large sliced slabs, hoping to avoid the more exotic body parts.

The price for the experience was nine pesos, *completo*, which included a small bottle of Argentine red wine.

The frustrating little *Antiguare* store was still closed, so he ambled over to the park to find a bench and check out return routes.

Must be school vacation, he thought, watching the throngs of beautiful young adults.

He studied the map. The road back north, retracing the steps of the Road from Hell he'd just traveled, was out. That left good old Route 40 north back to Bariloche again, a journey of 130 kilometers, described on the map in thin red lines. *This could be my only time to explore Argentina, he thought. I hate to backtrack.*

He spied another option on the map. It was a little way south of Esquel.

A finger still greasy with mystery gravy traced a path that branched left about 20 kilometers outside Esquel toward a town named Trevelin. It sat at the edge of a heavily shaded region that Wally interpreted as "pretty big fucking mountains."

From Trevelin there seemed to be a connection to the Chilean side of the frontier. This was the southern route he'd rejected back in Puerto Montt, but now, in the relaxed siesta time among a park full of the handsome unemployed, he had the time to explore the options on the Pacific Ocean end.

True, the thin red line ended in a jumble of islands, he noted, but now he saw a link to the north. Two dotted lines radiated from the road terminus at a place called Chaiten out across the water toward the south end of the big island of Chiloe, the north end of which he and Rae had visited for the romantic dinner a few days back.

A ferry. How perfect!

This route was much more direct than the previously traveled overland road, and it provided another ferry ride to boot.

Wally retreated to the rental truck to find his travel guidebook. After examining the upside down egg rocker and glancing over to the dark consignment shop, he returned to the park to read about his new choice.

He pitied the run-of-the-mill guided excursions that tourists from the US use when visiting other countries.

These folks get shepherded along in buses, he mused. *They really never get to know the real people.*

A quick addition of the red-tinted mileage numbers between the towns gave Wally the official distance: 136 kilometers—less than 100 miles.

The antique shop owner was still on siesta when he returned. With his nose to the glass, Wally searched the dark corners of the interior, looking for an excuse to wait around. He could make out some old paintings hung inside tired frames.

Wally knew that the painter Frederic Church and other turn-of-the-century masters had spent time painting in South America, but these were not their work. No interesting light fixtures dangled from the pressed tin vintage ceiling. No undiscovered Stickley Mission oak tables had mysteriously found their way to Patagonia to rest on the carpeted floor. No old Colt revolvers brought here by Butch Cassidy and Sundance lay in the display case.

Time to head west, he thought.

A round, bearded face appeared at the door and turned the cardboard sign to read, *abierto*.

I saw nothing in there that I want, Wally thought. *I should hit the road for that ferry.* He turned, smiled at the proprietor, and entered the man's store.

Chapter Sixteen

Puerto Montt, Chile

La Estacion was a seafood and beef house with an ocean of color on the wall. Fabrics draped like rolling waves said South Seas. Large illuminated balls of wood and rice paper, hanging from the ceiling, cast a soft yellow light.

Rae scoped them out by habit. *Five years with Wally Winchester*, she thought, *and I can't enter a room without checking out the lighting.*

Her freshly washed hair was combed back and held in place with a South American version of Breck Superhold. She was happy she'd thought to bring the black pants and the Donna Karan top that Wally had found on eBay for her birthday. Rae liked her appearance in black.

"I approve of your choice, Rae," said Schmidt.

He had moussed his albino crew cut into stiff spindles that almost looked contemporary; Rae thought it actually came off as Edgar Winter meets Home Improvement.

His heavily starched light blue shirt with two buttons open at the top matched his eyes.

"I wish I'd hear from Wally," Rae started, aware of the male interest and attempting to set ground rules.

Schmidt stiffened, "He was foolish to attempt such a journey with his poor language skills. You say he was going after a chair?" It was spoken with some amusement.

"A very important chair. One he has always wanted to own."

The mention of ownership seemed to irk the professor. Rae figured him to be too obsessed with science to pay attention to what he sat on.

"With any luck, he'll get lost in Argentina, and not embarrass us at Claus Braun's dinner on Saturday." He paused. "I'm joking, of course, although I wonder why he must attend."

"He's my partner, *sir*. I'm sorry you two got off on the wrong foot. He can behave when he has to. You'll see. Tell me about the new discoveries."

Schmidt brightened and launched into listing the new finds. "Sixteen figurines yesterday, three bronze models of structures—"

"Let's order first, Rolf, and then I want to hear everything."

"Of course, forgive me."

Rae requested *Trucha Salmonada con fritas*, which she guessed to be really good salmon and potatoes. Schmidt ordered *Raviolis Bucattini*, a native Chilean dish, he explained. He asked for the menu's best wine, a Terrazas Alto Reserve.

As the waiter walked away, Schmidt launched into conversation about the work. "I think the dates of our recent objects will change the way we look at human evolution."

No beating around the bush here, Rae thought. *Wally would have said, "Why don't you get to the point, professor?"*

Still, the blunt announcement was astonishing.

"I can guess that what we're uncovering is 50, 60,000 years old, maybe more. I'm hoping to find fossil skeletal remains soon that point to a very distant past."

"That's amazing, sir, I feel very honored to be allowed to catch this day on film."

"Did Julian find you your chemistry?"

Rae was surprised that he left his discovery thread to discuss photographs.

"Yes, he did, at a photo shop. I'll use Dektol and a simple fixer."

"I'd like to watch you develop the film. Is that possible? I've always been interested in photography."

The food arrived before Rae could think of a way to say no.

Ten steps into the hotel room, Schmidt tried to kiss her.

"Hey, hold on there!"

She twisted away, feeling a meaty hand on her shoulder as he swooped around and pressed his mouth onto hers the second time. She pushed against his chest and gained an inch of personal space.

"Rae, I've seen the way you look at me on the site. The way you hold your head."

The hand clamped her shoulder harder as she tried to move away.

"This isn't why!"

Rae tried to talk against his crushing lips. Those eyes displayed a confident look. His other hand held her body in place.

It's OK. I'm OK. I can handle this, she thought, but the secure feeling was fading away.

She arched her back to pull her head away and said, "Was that a cigarette you found next to the bronze thing today?" It was all she had.

"I don't know what you're talking about."

The white complexion lost another shade. He let her go and stepped back.

"A butt with a tan filter. You picked it up."

"Yes, I do remember a cigarette. I removed it. It was a contemporary contamination. Happens all the time. Fucking Chilean

workmen," he said in a blustery tone. "I tell them, 'no smoking, you'll contaminate the site.' It's a sterile field."

Rae thought about her conclusion that the cigarette emerged from 50,000-year-old soil at the end of a little scoop, but decided to keep it to herself. She'd used up all her trump cards tonight, but he seemed to have backed off.

"Please leave, Professor Lucas-Schmidt. It was a mistake to invite you here. I'm sure we got our signals crossed. I have work to do. Please go. Good night."

She looked toward the door. It was an order.

Schmidt looked at the film bag holding the day's shoot. He began to speak, but stopped, then exited, ramrod straight.

Leaning against the locked and bolted door, Rae began to cry. *Where's Wally?*

Chapter Seventeen

Esquel, Argentina

The antique shop smelled of turpentine and mildew. As Wally entered, he passed the proprietor and detected garlic and seafood on the man's breath. After the experiences with the Puerto Montt used furniture market, Wally carried the Dover edition of *Stickley Craftsman Furniture Catalogue*.

"*Hola*," Wally said and passed him the book. He'd already scanned the interior through the window and had found nothing that interested him. A few dark corners still beckoned. He bent down to examine a pressed tin windup toy in the glass showcase.

A deeply accented voice said, "What makes you think a gringo can find North American furniture in South America, señor?"

Wally looked up, surprised at spoken English here.

"I can find Stickley anywhere, sir," he answered, standing awkwardly and offering the shopkeeper a hand. "Wally Winchester, at your service."

"Hector," the man said protectively. "Tell me, señor, are you a tourist? Are you here to ride the Old Patagonian Express? Many North Americans have come here since the book was printed about the train ride. Do you really expect to find this kind of thing here in Argentina?" Smirking, he held up the Stickley catalogue.

"Who knows what a guy can find when he's on the road, Hector. Never hurts to ask. Ever see this kind of furniture down here?"

"Never."

"Any art deco? African art? North American paintings? Gaslights? Old toys? Anything signed by Butch Cassidy or Sundance?"

"No, señor, I'm sorry. I have a modest shop. We sell local goods, estates of farmers and miners. Little of the objects you seek come this way." He turned away from the conversation to light a gas burner under a scorched, beat-up teapot.

Wally's eyes completed their flickering scan of the small dark store. There was nothing here for him. He turned to leave and said, "Do you know Isabel Gato? Her office is around the corner. I just bought a chair from her."

"You're the one," the manager said. "You bought the egg chair! You're the gringo from the United States. Of course I know about the chair. Everybody in Esquel has heard. You paid a lot of money, señor. Do you have the chair with you?"

Wally nodded and cocked his head to indicate it was outside in the rental.

"Can I see it one last time? I know it well. Isabel and I have worked together before. I was the one hired to appraise the estate it came from. I was the first to notice the Austrian factory marks under the seat. I knew it is a wonderful thing. We all did. It was I who advised Isabel to list the chair on the Internet auction in hopes it would generate international interest. And it did, didn't it? You noticed. What did it finally bring? Five thousand?"

"Sixty-five hundred US dollars."

"Excellent. Can I see it now, please? For the last time?"

"Sure," Wally said and led him out into the late afternoon light.

"Do you really wish to find more chairs like your describes?" The shopkeeper had returned to the sidewalk after

caressing the brown-painted oval of the upside-down rocker belted into the passenger seat.

"It's my life."

"There's an hombre in Jose de San Martin who claims to have a North American chair like those in your book."

"You told me you hadn't seen any of that kind of thing down here, Hector."

"I haven't *seen* it, señor. I just heard about it. Besides, now I know who you are. These are still dark times for Argentina, señor. Trust is not given freely anymore."

"Do you know which of the chairs it is?" asked Wally, reaching again for the Stickley book.

"Of course not. I told you I haven't seen it yet. We can try to call him if you wish. He's a hard hombre to reach usually."

"How far is this place, Jose de San Martin?"

"About 400."

"Miles or kilometers?"

"Kilometers, of course. I have no idea about miles."

"How's the road?"

"Usually it is passable at this time of year. I haven't traveled that way for a year or two."

"Can I drive it in a day?"

"Most times, yes. Nothing is certain in Argentina anymore."

Wally exited Ezequel with a phone number and a hand-drawn map to the village of Jose de San Martin between him and the egg rocker. Directions said drive 400 kilometers south on good old gravelly Route 40.

A crossroad was coming up at the outskirts of town. South, toward the village promising a Stickley chair, was a right turn. A left turn on 40 would take Wally and his egg rocker north, back toward the

Bariloche lake region and the pass he'd crossed in the Andes. Then there was the "shortcut" to the coast, an option that gained him new mountain scenery and two ferryboat crossings. As the intersection loomed ahead, Wally saw an adobe-covered shack that seemed to offer beverages; there was a Fanta Orange sign in the window.

Inside, as he sipped on a warm bottle of Becks, Wally added up the mileage numbers between him and the alleged North American Mission oak chair to the south: 30 + 42 + 57 + 218 + 68. The one-way total was 415 kilometers.

That's what, 250 miles? Each way? Five hundred total. What day is this? Wednesday? How much time do I have to burn before the party on Saturday? Thursday's the last day I have. I'll need all day Friday and Saturday for return travel if I want to get back to Puerto Montt on time. I can make 250 miles a day, even on these roads, but, man, that's close. The slightest fuckup and I miss Rae's big event. She'll never forgive me. Shit, it's too close.

This was a rare moment in Wally's obsessed career. He was about to pass up the chance of a South American Stickley score to avoid letting down the woman he loved. Even he was amazed. On a different piece of paper, he copied the information that led to the chair. He reconsidered, and copied it again, this time in the Stickley catalogue. He'd get a look at that chair, all right, but not this trip. He was going to do the right thing for once. His relationship with Rae is too important. He was going directly back to Puerto Montt. To his woman. Stickley furniture be damned. The setting sun suggested he find a place to sleep.

Wally settled into a bedroom in the youth hostel he'd found nearby. He got out his map to plan the shortcut back to Puerto Montt, the one with the ferry ride to Chiloe Island. There was a nagging thought, something he'd forgotten to check on, but he couldn't remember it. The question was lost in the shadow of his day's

adventures. Wally looked over to the egg rocker he brought into the room for safekeeping. Then he fell asleep, dreaming of Austrian rockers and beautiful women in North American chairs.

Chapter Eighteen

Room 12, Condor de la Plata, Puerto Montt, Chile

There was an odor in the room that Rae didn't like. Rae is an expert on smells. Neither offensive nor toxic, the scent still put her off. The aroma was subtle, like the trace of a person she couldn't quite place. When she tried to dismiss the alarm, her brain refused. It was definitely a smell. She knew it from somewhere, an odor she remembered, a chemical signature. Rae trusts her nose.

She closed the door and took a look around. Her clothes were where she left them. Personal items on the dresser seemed untouched. She looked to the spare film gear on the table by the bed. It was there. That was a relief. Unmade bedding told her the house-cleaners hadn't been through. The sharp, familiar smell of photo fixer called to her from the bathroom. Behind the wraparound shower curtains, two plastic trays for developing negatives sat inside the empty tub, as they had overnight.

A light-tight bag holding the other six 4 x 5 exposures in their metal camera backs still sat on the chair next to the tub. She hefted it and felt the weight she expected.

Two developed negatives hung from clothespins off a shirt hanger under the bathroom sink, behind the doors of a green-painted vanity, sharing space with a toilet brush and some Spanish version of Ajax Cleanser. She opened the doors and looked in. The vanity space had been the closest she could get to a dust free room in a two-star Chilean hotel.

She lifted the negatives toward the naked light bulb. They were good in their contrast, figures smeared against a sharp focus ground.

I guess everything's fine, she reassured herself. *It's been a funny couple of days. I wish Wally would call.*

Hunger tweaked, bringing her mind back into her hotel room. The little refrigerator held a package of cold cuts and some sliced white Chilean cheese. That would do for the evening. She had no interest in dining at any of the restaurants on the street below.

Solitude felt good.

Wally will be calling soon, she thought, *the bastard, he'd better.* Twelve more negatives, counting the film she'd exposed at the site, were waiting for processing.

Two Coronas and a lime would keep her company. She lifted out the developing trays and started running water for a bath. Perfumed crystals of the bath salt she sprinkled into the faucet flow burst into fragrance that covered her misgivings with the scent of apple maple spice.

The phone rang while she was toweling off. She sat back against the unmade pillows, feeling the cool breeze that followed the street sounds in from the windows.

"Hi, sweety," It was Wally. She closed her eyes in thanks.

"Hello, my brave adventure guy. Where are you?"

"I'm in this cool little village town, surrounded by giant peaks at the edge of the Pacific Ocean. About 200 miles south of you right now, as the crow flies. Called Chaiten. It's in Chile."

"Is everything OK?" She had learned to ask this question early on in any conversation from the road. Frequently the answer was, "Yeah, it's really interesting here." This usually meant some kind of trouble.

"Yeah, it's really beautiful here. You should see the volcano."

"Wally, what's wrong? Are you in jail?"

"Noooo. Of course not. I'm fine. I got the chair! The egg rocker! It's painted brown, but it's still wonderful. How's the photo work going?"

"It's weird, but don't change the subject."

"Well, remember the island we ferried to for dinner?"

"Chiloe. Of course I remember. It was two days ago..."

She stopped. She knew that given enough dead air time, Wally would reveal just about everything.

She waited.

"Well, babe, that island is right out there in front of me, about six hours across by boat."

Silence.

"Well, you'd think such an important link in the Chilean transportation system would have regular ferry service, you know, like in Anacortes."

Rae did not respond.

"Well, who would have guessed that ferries run here only twice a week, you know?"

"Not you, Wally. Obviously."

"You should see the volcano here. It's long and pointed, like a witch's hat. I think the people worship it here."

"When does the next ferry sail, Walter?"

"The next boat leaves Saturday morning. It's a six-hour crossing. It might get a little tight getting to that party."

"Oh, Wally! Oh no. You promised!" Tears welled up in her eyes.

"On time. I might not get to the party at what, five o'clock? I'll just be a little late."

"Five is what you promised. I'm not going to see you till Saturday night? Some vacation, eh? I don't like being alone in this town."

"Shit, I'm sorry, Rae. I already looked into a seaplane rental. No luck. Then I tried to hire a fishing boat, even if it meant abandoning the rental truck and renting another one on the island."

"And..."

"I couldn't get past the fishing boat part. They kept showing me pictures of marlins."

"Why don't you just turn around and drive back?"

"Way too far, especially now. Plus there are two more sets of border crossings that way. I'm not eager to face those boys again."

Silence.

"If you give me directions to that famous guy, Mr. Braun's house, I promise to get there, but not likely at five exactly."

"Bastard."

"Really sorry. You have no idea. Wait till I tell you what I found. You'll never guess what a guy told me today. He's heard of a Mission oak chair, maybe even Stickley, in a little village east of here. Can you believe it? In Patagonia, for gosh sakes. Honey, I didn't go after it, you know, 'cause I didn't want to be late for the Braun event."

"Nice job on that one." Icicles dripped from her words.

The second Corona downed, Rae pulled herself off the bed and attended to the photochemistry. She stuffed the hotel towel into the gap at the bottom of the bathroom door to minimize the light leaks and thought about the many places in the world where she would rather be.

Ten minutes later, while the last of the negatives floated in the fixer tray, she pocketed the glowing watch face she used as a timer and stood to turn on the light. These twelve images would make or break her future as a photojournalist. Holding the top negative up to the single hanging bulb, she could make out the last scene of this afternoon's silent shooting. The contrast was good. The rest of the

day's shots also looked acceptable. In the odd glare of the bathroom light, she started to visualize a magazine layout with her byline. She wrestled her thoughts back from future fame and continued her inspection, eager to examine the remaining negatives, the previous day's exposures. One of those photos would answer her questions about the phantom cigarette butt she'd observed. The negative was either in the tray or it was one of the few she'd managed to develop after fending off the amorous German.

The next negative was solid black.

Shit, that's odd. Must have accidentally exposed this one.

The next negative was wiped out also. These were the first three days of images. Panic set in.

She reached into the fixer with her fingers and extracted the remaining negatives. All black. Completely exposed and useless.

That's impossible! It can't be camera failure, the first four shots—today's photos—were fine, so were those two from the night before. Eight negatives lost? That's a catastrophic failure. The entire project could be jeopardized!

Rae mentally scrambled over procedures with the film backs and the dark bag. There was no time that they could have been exposed. The bag had sat here all yesterday in the bathroom. And the maid didn't even come in.

She opened up the back of her cardboard camera and peered in, looking for a source of ambient light. The camera was fine.

She slept with the deadbolt engaged, a chair jammed under the doorknob.

Chapter Nineteen

Claus Braun Mansion, East of Puerto Montt, Chile

A manicured circular drive led up to an ornately columned portico framing the open door to the mansion. Wally had driven the 20 miles of lakeshore at breakneck speed, watching the fat cone of the Volcano Orsorno glow yellow in the last of a Pacific sunset. He hadn't stopped to change clothes, but had managed to purchase a long-stemmed red rose from a street peddler as a "Get Out of Jail Free" card. It lay between him and the egg rocker on the seat.

A withered Chilean in full livery stood by the marble stoop to assist him when he stepped out of the rental truck.

"Take care of that chair in there, my man," he said.

The attendant glanced at the upside-down rocker belted into the bench seat and dropped the corners of his mouth like a French waiter.

Inside, people mingled in a bright, open entryway. Wally's plan was to quickly merge into a crowd of visitors to smudge over the actual time of his arrival. But as he crossed the threshold, he nearly forgot why he was there. The interior of this turn-of-the- century European palace was a German architect's dream. A forest of silver chain hanging from the high ceiling supported magnificent hand-hammered fixtures, pierced with square holes and hiding light bulbs behind skirts of Bohemian crystal. A phalanx of monumental paintings forced his attention to the back walls.

He saw what looked like an Egon Scheile nude, painted with tortured, perfect brushstrokes. Another painting flashed with gold leaf. It resembled a Klimt.

Even the floor shouted good design. Black-and-white marble checkerboard squares made him feel like he was walking through an M.C. Escher illustration.

Twin staircases in art nouveau iron whiplashes curled up to a balcony on both sides of the entry hall.

Josef Hoffmann furniture dominated the room. A pair of *sitzmachines*, Hoffmann's other perfect chair, flanked a great fireplace at the far end of the hall.

"Mr. Winchester, I gather. You've been expected."

The speaker was tall, maybe six feet one, with a mop of brown/gray hair framing a strong Nordic face.

He doesn't look anything like Steve Martin, Wally thought. *Dick Cheney on a good day? Maybe.*

A large hand came out in greeting. Wally shook it with manly pressure.

"Walter Winchester, sir. At your service." "Sir" came out unbidden. The man's presence seemed to require it.

"Claus Braun," his German bearing echoed his face. "Your lovely companion has been charming us with her presence, Mr. Winchester. You are a lucky hombre to have her at your side."

"I know, believe me, I know." Wally broke eye contact to scan the room for Rae. She wasn't in sight.

Braun was dressed in a white suit with a light tan silk shirt sporting a hand-painted tie. Wally guessed Salvador Dali.

"Nice tie."

"A Christmas gift from the King of Spain." His voice held the trace of a Spanish accent and none of the Germanic tones his bearing suggested. "Your young lady, Rae, tells me that we have similar tastes in décor."

"I love the interior here. Are you kidding me? Everything here belongs in a museum."

"Thank you. When you're the only known collector in South America, things come to you."

"Lucky you!" Wally found himself envious of the man's cheekbones, high and solid on his face. Even his breath was good. It smelled like chamomile tea.

"I had the advantage of a childhood fascination with Austrian design. When I acquired most of these things, they were not yet collectible."

"These things were born great, Claus."

The host's posture straightened with Wally's words.

"I hear that you search for design like this for a living. Your life must be interesting."

"You wouldn't believe what I found in Argentina the other day."

Wally glanced about for Rae while he talked.

"It's still in my truck outside. I'd be happy to show it to you if you need some air."

"Perhaps later, when the other guests have gone."

Wally felt the dwindling attention, so he changed the conservation. "Fascinating discoveries over there past Puerto Montt, don't you think?"

"Very important work. Yes, indeed. Professor Lucas-Schmidt hopes to rewrite the origins of civilization. I'm proud to support such a venture. Did you hear what they found yesterday?"

"No, sir. I've been in remote country lately."

"Yes, I heard, south of Chiloe," Braun's blue eyes focused on something past Wally's left ear.

"There's Dr. Schmidt and your associate now. Let's ask him directly."

Rae was radiant and distant. She looked him up and down, apparently noticing his three-day-old clothes. She wore a low-cut

peasant blouse with a bright silk scarf knotted and dangling onto her bosom, the top tucked into tight white fitted pants, fastened with an old silver concha buckle just below her exposed navel. Calfskin boots with three-inch heels completed the package.

"New clothes?" Wally sent out his very best goodwill vibes in a smile.

"I've been shopping." She glided over to Braun and placed a white glove on his arm. "Claus took me shopping this afternoon. He knows wonderful places."

"You never looked lovelier, Rae."

"Thank you, Walter." Her voice was cold.

"I brought you this rose. It's supposed to be a rare variety." He pulled the wilted flower from his vest pocket.

"Thank you, dear," she said. With a frown she tucked the blossom into her bodice. She winced as a thorn pricked her chest.

"Tell us, again about your discovery, please Rolf," said Braun,

"As you wish, Herr Braun. Perhaps our Mr. Winchester should read up on the sciences. I hate to bore the company here with fundamental facts."

"Please, professor. We love the retelling," said Braun. "Oh, wait a moment. Allow me to introduce my executive assistant in charge of security."

He motioned to a figure behind Wally. The redhead from Monte Verde Canyon appeared quietly at his side.

"Chana, I believe you've met Mr. Winchester."

Wally said nothing. *What a difference from the dry gulch standoff*, he thought. Her hot red hair was moussed down into a center-parted helmet that looked painted on. Her deep black eyes remained expressionless, but the smile on her deeply tanned and freckled face gave her the first human quality Wally had seen. Somehow, the grin was alarming, more like a cat leering at a goldfish.

116

"How do you do, Mr. Winchester? It is good to see you again."
She speaks. And she speaks English. Wally thought.
"Hello ... Chana? Is that right?"
"Yes, Chana. It is a family name from my village. It means Sandra."

Her voice had an aboriginal twang that suggested Spanish was her second language and English her third. The cadence was high-pitched and came out almost like a song.

Lucas-Schmidt grew impatient. "The Romanian discovery of figurines from the time of 40,000 years past is well-documented. Those artifacts have always, in some researchers' minds, suggested a separate genotype from the much-alleged discoveries by the Leakeys and others in Africa." His "Africa" barely hid his disdain.

Wally jumped in: "I recall they named her Lucy. Isn't that right, Herr Doctor?"

"Yes, the annoying habit of personalizing skull fragments. Went a long way to gain public acceptance, naming the skull after an English milkmaid."

"Well," he continued, "there are those of us in the archaeological field who believe in a multi-loci pattern for the beginning of mankind's evolution. What has been missing in the African model is about 2,000,000 years. Why do we have no art? No objects of worship, no evidence of logical thought until 1,000 generations later, when the first handmade evidence of human intelligence was found where? In Africa? No, in southern Germany. Where is the link? Show me a carved Venus from the Sudan that is 80,000, even 50,000 years old, and then I'll admit a connection."

He paused, "Two days ago Koenig, my assistant, uncovered a bronze that seems to date to pre-Willendorf times. A bronze that bears a resemblance to the Romanian figures that follow in time. Do you understand what that means?"

He aimed the question at Wally as though he were spoon-feeding him the words and continued, "It suggests a parallel path in the human evolutionary tree that begins in South America and ends in northern Europe."

"Remarkable work, Dr. Schmidt." Claus Braun beamed.

Wally shoehorned a question into the conversation, "So you're suggesting that another branch of the tree of life, one perhaps a bit more Caucasian, ended up in Europe and is really the granddaddy to us all?"

"We make no such claims, but a parallel evolution would make for some interesting genetic pools, wouldn't it?"

I think you have a screw loose, Rolfie, Wally thought. *It's a big leap from a four-inch statue to white supremacy.* He could see a swelling in Claus Braun's well-tanned countenance. Wally wanted out of the conversation. "Hey, you know what, I've got a picture of the chair I found this week!"

Wally reached into his vest and produced the little four megapixel camera, pressing the *on* button as he brought the screen toward their host.

Wally pushed a toggle and a photo of the egg rocker appeared on the screen. It showed the chair backlit in a Pacific Ocean sunset; an orange-glowing volcano dominated the left horizon.

"I had some time on my hands down in Chaiten, so I took the chair out to the ocean for some bathing beauty shots."

He clicked again. A different angle of the chair caught the fire of the sunset on its geometric planes. The volcano, this time, was over to the right.

Schmidt snorted loudly, "I don't have time for this ... this *Antiques Roadshow*." He turned to leave, looking to his patron for support.

Claus Braun was as white as his shiny suit. "Where did you get this chair?" he demanded.

"It was a village in Argentina, called Esquel."

"Esquel, of course."

He turned to Wally, taking a breath, and cleared his throat.

"I really must have this chair. It ... it is very important to me for my collection. Is it for sale?"

Wally began to speak and was interrupted again.

"It would mean a great deal to me. Please add that fact to your estimate. I can be very generous if I choose to."

Wally tried to speak but was interrupted again.

"There," shouted Schmidt as he reentered the conversation. He glared at Wally, who had just pushed the camera button to call up another view.

Braun took the camera from Wally's grasp and held it up close to his nose.

"There, Winchester!" It was Schmidt again. "You've taken a night of scientific significance and ...and ... and turned it into a ... flea market!"

"Shut up, you fool!" Braun said. "I want this chair!"

"But—"

"Silence! Now Mr. Winchester, what is your price for this chair?"

"It's not for sale. I collect this stuff myself, but I'm glad you think highly of it."

"How about 10,000 dollars?"

"Thanks for the offer, but no thanks, sir. I think it's a better chair than that."

"Twenty thousand, then. American, of course. Cash. Gold, if you want. Drugs."

Wally frowned. "I beg your pardon?"

"Really, Claus—" Schmidt was clearly disgruntled.

"If you open your mouth again, I'll cut off your allowance. Go on then. Serve some champagne to our other guests." Braun's loud voice was a clear dismissal.

Gasping angrily, Schmidt wandered toward the door.

"Now, Mr. Winchester, how can we come to an agreement?"

"Really Mr. Braun, I'm taking it back to the states. It needs tender loving care. I have a refinisher who's a genius."

"It's important to me that I don't lose track of this object." Braun said.

"I'll give you my cell number and e-mail if you like, and we can talk when I get back up north."

This was as close to no as Wally had ever been with an eager buyer. It felt pretty good.

Braun bowed in apparent defeat. He smiled and guided them toward the other guests.

Rae saw the archeologist, red-faced and ready for another confrontation.

"Control yourself, Wally," she said, as the redhead turned silently and planted her small tight frame directly in the flustered German's path.

The conversations around them ceased. Wally turned and saw the woman named Chana standing close to the German, lifting her chin to make eye contact with the taller Schmidt. Her nose was even with his pale chin.

Schmidt recoiled, his face a mask of uncertainty. Wally thought he saw fear in the big man's eyes as the scientist withdrew, backing away cur-like from the woman, into the shadows of the enormous room. She turned back to the group and looked at Wally, without expression.

Chapter Twenty

Room 12, Condor de la Plata, Puerto Montt, Chile

The emotional temperature in the hotel room was so cold crystals formed on Rae's already icy words when she spoke. "One week in South America. Ruined. One chance to break into the national photo scene. Probably lost." She was slamming unfolded clothes into her suitcase.

Wally studied three flat, T-shaped cardboard sheets that used to be boxes. He'd scored them from the vegetable stand across from the hotel. Two strips of tan packing tape curled off his arm. He squatted, reaching for a corner to lift over the rocking chair, trying to visualize the second cardboard meeting it like a Chinese puzzle box. He failed and let the corner fall back to the floor. "This will never work!" he moaned.

"There! I've got it." Three flaps met, completing a warped, misshapen, heavily taped cardboard cube.

"Half my pinhole negatives. Ruined. Have I got enough for a *National Geographic* spread? I don't know!"

Wally was deep in thought. *I wonder if I can pack that toy truck inside, between the rocker ovals.* I could wrap my clothes around the metal to keep it from scratching or being scratched, "Did we bring any rubber bands with us, hon?"

"Three hours late for the dinner at Braun's. How could you?"

Wally folded over his soft-sided bag and held the compacted form in front of the untaped flap of his homemade crate as if to measure. "One less bag to lug around, sweetie. See, it fits right inside the box."

"You nearly got Professor Schmidt fired tonight. You embarrassed me in front of Mr. Braun. You were rude to the doorman. I'll probably never get an assignment again."

Wally said, "Hey, did I tell you why Yvgeney's visiting us? He's quitting the UN. He wants to go in on a joint venture with me. He wants to team up and get rich by pooling our skills."

"You didn't tell me we're having houseguests right after returning from an assignment, Wally. Have to find a place for all those chairs out there in your shed. There'll be no room for Lucy and Yvgeney. Maybe you should sell some of them, Wally."

"I'll clean out that space, hon, the day after I get home. Don't worry." He kissed her cheek. "You know, sweetheart, as much fun as it's been here, I miss Camano Island.

"Another thing, I'm sick of the food here, Wally. Are you listening? First thing when we get home, we're hitting the Conway Tavern for a good old American burger."

"And a Starbucks, too. They make terrible coffee here."

"Can you get my bag into that box, too? We've got two connecting flights."

"Lotsa room, kiddo. Sorry for the hassle I caused tonight."

"Professor Schmidt had it coming. No question. Braun seemed to like you, actually, despite your boorish manners. He sure wants your chair."

"I could make a profit of $13,500 if I sold it to him today. And that's not Wally-math. At least give me credit for the big dog I am, baby."

"You did good, big dog. When are you going to sell it?"

"You'll kill 'em at the magazine with all the photos you rescued. I bet you discover that you grabbed some great shots. Don't you worry."

"Nice diversion, Wally." She kissed him like she meant it. "Do you actually plan to sell this chair, this egg rocker?"

Wally kissed her in return. When he leaned Rae back toward the pillows she allowed it. He said, "This chair will change our lives, trust me."

Chapter Twenty-One

Belgrade, Serbia

The road to Slobodan Milosevic's summer palace was a wide, beat-up four-lane blacktop called E70, or Route1, or Arsenja Carnojevica Boulevard, depending to whom you spoke.

All three labels appeared on the tattered NATO map propped up on the dashboard of an embarrassingly new and aggressive-looking Humvee transport, sporting a UN flag, as it left the city of Belgrade heading west. The vehicle's stiff suspension translated every pothole and hasty hot patch repair directly into Yvgeney Ivanchenko and Valerie Du Michelle's tired bones. The third passenger, the loquacious thirty-year-old translator named Ban Stjepan Kotromanic, didn't notice the jarring ride. The driver, the surly peacekeeper identified only by his nametag, Schultz, pinned to his green Kevlar overalls, said nothing. He appeared to be no stranger to discomfort.

A heavy autumn overcast hung over the city, obscuring the low hills beyond. Outbound traffic crossing the Sava River over a recently reconstructed metal girder bridge was light at 9:00 a.m. A few fishermen sat below on the empty docks, their lines slack in still water the color of lead. The new car smell of fresh vinyl and recent paint inside the peacekeeper transport contrasted with the joyless ancient stares of the Serbians they passed along the road out of town.

Yvgeney knew the look, the face of the new Serbia. Not hope, not anger, although that emotion was bubbling close to the surface, barely discernible through the hardened Slavic faces. It is tight-lipped resolve, keeping everything deep inside. He'd noticed an increasing grimness, the advent of a dark spirit, as they looked for stolen art over

the length of the former Yugoslavia, west to east, from relatively upbeat Slovenia through Croatia and Bosnia, down to Kosovo, and finally to Belgrade in the heart of Serbia. They had journeyed through gloomy, isolated areas, deep in the unspoken guilt of a thousand midnight slayings. Outsiders called it Ethnic Cleansing. For Croatian and Bosnian and ethnic Albanian people, it was former neighbors at the door with machetes and household propane tanks set on fire so murderers could wait in the darkness beyond the flames for fleeing residents to emerge. A thousand nights of horror.

The road improved outside the city center. Communist-era apartment high-rises, monuments to the Tito regime, and ruined factories, monuments to NATO smart bombs, gave way to rolling hills and forests and a checkerboard pattern of recently harvested fields, fading to tan. At Kilometer 15, a green exit sign signaled *Dobanovci* in Cyrillic. Dark evergreens flanked the entrance to a tree-lined valley.

"I'm surprised they're letting us into the compound this easily, Yvgeney," said the Frenchman. He had a habit of twirling the pointed ends of his substantial mustache when he talked. Yvgeney had found this nervous habit unsettling, but as they got to know each other on their Balkan odyssey, he'd chalked it up to French quirkiness. The men had seen too much of the raw side of humanity together to be bothered by personal eccentricities.

"This could be another token repository," Yvgeney said.

In 12 months, since peace had been declared by the United Nations, three storehouses of "saved" art had been turned over to UN authorities. In addition, a major collection of Croatian art had been uncovered by an art consultant for the Council of Europe in the northern Serbian town of Novi Sad. It had been packed and stored

underground by the Croats before Vukovar fell; the Serbs found it at the end of their three-month siege.

Du Michelle said, "I saw loot uncovered at Pristina last year before you got here. Underground repositories filled with religious objects."

Yvgeney knew the story, of course, but in deference to the god of whining, asked the questions anyway.

"All Orthodox? No trace of Catholic or Protestant, or Jewish or Islamic treasures? No Renaissance paintings? No real antiquities from Rome and Greece and Phoenicia?"

"Of course not! The Croats claim 50,000 objects missing. The Serbs put the number at 10,000—all Orthodox relics, now returned to Mother Serbia. I'll tell you, my Russian friend, these relics are going to be stolen and re-stolen another 20 times in the next 1,000 years, every time the boundaries wiggle. I'm waiting to find the storeroom where the other 40,000 objects are stashed. That's where you'll find your Rembrandt."

The road north wound through yellow pastures dotted with small stands of trees. Wind carrying a flurry of light, wispy snow buffeted the transport. There were few houses here. Traffic was sparse, with an occasional lorry or farm tractor getting the last of the hay in before the first snowfall.

"I took this job for the sake of art treasures," said Yvgeney, thinking of all the shattered lives, decimated communities, looted churches and empty museums they'd encountered. "In this country, I feel more like a homicide detective on the bunko squad."

"What's a bunko squad?" asked Du Michelle.

"It's an American police term. Object is to capture frauds and swindlers and con artists. I learned it from my friend Wally in Seattle."

"We're on the bunko squad, all right." Du Michelle agreed. "In the country of love thy neighbor and divide everything you hear by three, or multiply by 1,000."

Three months in the Balkans as investigators on the staff of the Cultural Property Program Manager of UNESCO had left the Russian and the Frenchman up to their weary necks in lies, vast anger, a cloud of unspoken guilt and suspicion and tons of data. He couldn't imagine how the Frenchman had lasted two years here, throwing light at the dark places and staying relatively sane.

"All madmen like Milosevic are just thieves at heart," said Du Michelle. "Look at the art Hitler stole. Sixty years later and we're still sorting it out. I bet our friend Slobodan surrounded himself with booty, particularly out here at his villa. It goes with the disease of megalomania."

The interpreter, who called himself B.S., spoke up. "The Tigers came to our village one night. They were a Serbian gang, privately organized. Terrible men. They rounded up all the males down to age 12 and led them away at gunpoint. They were never seen again. That left the women and children and the church and the relics. They used the children as porters to carry away our heritage. Then they locked them in the church, and set it on fire with gasoline. They were the lucky ones. They're beyond pain now. My aunt survived. She hasn't spoken in six years. She cries in the morning. She cries in the evening. The rest of her day she spends in her room, silent."

The transport was quiet inside, buffeted by gusts of winter wind.

Yvgeney spoke in a softer voice. "Perhaps we'll find something from your village here at the villa, and you can bring it home."

"Yeah, maybe. Maybe I'll find my sister's soul."

Up ahead, the corner of a chain link fence topped with concertina wire appeared at the crest of a rise in the road. They followed it for a half-mile until it was broken by a guardhouse and a gate. Beyond the gate, a paved lane led into a forest of tall black evergreens. The Humvee turned right and stopped at the yellow wooden bar. A young guard wearing Serbian Army fatigues walked out to the vehicle. His demeanor suggested their visit was unwelcome.

Yvgeney, the senior investigator, leaned forward and spoke through the open window. He used English. "I have an order here signed by the United Nations Commission on War Crimes in The Hague allowing us to search the grounds."

The guard continued with his dull, angry stare. B.S. translated through the back window. The youth reluctantly took the search orders, which, of course, he couldn't read. Du Michelle's fingers were at work at his mustache, his nervousness noticed only by Yvgeney. Two more heated exchanges in rapid Serbian, and B.S. eased out the back door, cautiously, and followed the soldier into the small structure. He returned a moment later and said quietly, "Stay here in your vehicle. He's calling his bosses."

The young guard emerged, carrying an AK-47. Another flurry of Serbian. Yvgeney's small vocabulary didn't help, but the guard's agitation was clear.

B.S. spoke quietly and calmly. "We can't enter until accompanied by a member of the Dobanovci local militia. He's been summoned. Please remain normal-acting. This fellow is not very happy with us." He rolled his eyes to suggest mental imbalance.

Yvgeney sighed. With slow, purposeful movements, he reached for his laptop and opened it. A ton of data from his travels in Croatia still needed inputting.

The Frenchman toyed with his mustache.

The driver closed his eyes and slept.

The Bosnian translator recited prayers to his dead relatives.

Outside, a light shimmer of snowflakes created a pastel landscape.

Rumbling vibrations signaled the arrival of a uniformed, helmeted driver on an army-issue Russian motorcycle.

"Only one." Valerie said it loudly. A message to everyone inside. "They only sent one."

"What do we have in weapons, Schultz?" Yvgeney understood his partner's concern. This is an important national site. The presidential retreat. A suspected Serb communications center. Twice bombed by NATO. *The Serbians have good reason to be sensitive about foreign intrusion into this special place. Yet they sent only one militiaman to supervise this insult?* He suddenly felt highly exposed.

"Just my .45, sir." Schultz's deep voice and German-accented English sounded nervous.

"Shit! Du Michelle?"

"Nothing here, boss. Just my Swiss Army knife."

"Well, set it to 'stun'." Yvgeney believed himself expert in American pop culture, after years of listening to American television in the Soviet Navy. "B.S., are you carrying?" Another American expression picked up in Seattle.

"If you mean 'Do I have a weapon?' the answer is no."

Yvgeney, too, was unarmed. He had nothing but a handful of UN paper with some big names on them. Not originals, just photocopies.

The rider dismounted, removed his helmet, and withdrew a carbine from its holder.

129

"He looks like INA," said B.S. His shoulders tensed as he looked into the face of his family's pain.

Indeed. Yvgeney was reminded of images he'd seen on posters of People Indicted for War Crimes (PIFWCs) pasted up on the walls of police stations in the war-torn regions from here to Slovenia. Most were still at large. Many were working, sheltered from UN justice, like this guy, in the dark, superstitious pockets of the Serbian hills.

Twenty years of ethnic strife and 45 years of Baltic superstition had solidified the deep lines in the militiaman's face in a permanent sneer. Yvgeney couldn't tell if the sneer was meant as a grin or a grimace. Three teeth were capped in gold. The soldier seemed to suppress a wince as he limped toward them; maybe a war wound. He smelled of garlic and old sweat.

"You have here no authority," the Serb said, in a valiant attempt at English. "Your United Nations is a pack of devils."

"We come with permits signed by your government, allowing us to search here."

"I don't care if Slobodan Milosevic, himself, has granted you permission." The militiaman made a spitting gesture toward the documents in his hand. "These papers will not get you past this gate."

"Slobodan Milosevic has given me permission to search these grounds. It's right here on page two."

"Milosevic is dead."

"He signed this order before he died. It was part of his plea-bargain agreement. Full cooperation. Please look, sir." "Sir" was forced. Name-calling at this stage would just stir the pot.

The militiaman paused and dropped his head down to interpret page two. Yvgeney looked at the man's face and wondered if his own mug looked as deeply lined and fixed. Growing up, he looked much more like a European than many of his Leningrad neighbors. His

ancestors had lived on the shore of the Baltic Sea, near Lithuania. Years of arctic winds and desert sun, he knew, had taken their toll.

The Serbian finished his study of the documents, and again approached the vehicle.

"These papers seem to be in order. Who's in charge here?"

"I am Yvgeney Ivanchenko, inspector for the Office of the Cultural Program Manager of UNESCO."

"These are just words and letters that are supposed to be important. What do you want here?"

"Your government has allowed us access to these grounds, sir. We're looking for artworks removed from other parts of ..." he hesitated. This area of Europe has many names, including the former state of Yugoslavia.

"I see that in these papers." The Serbian seemed more competent than his country bumpkin attitude and aroma suggested.

"I can escort you to the storeroom where the objects saved in the Bosnian, Croatian, and Macedonian boundary readjustments are stored, but this is a presidential palace, a sacred place for our people. You and the other foreigners must agree to restrict your interest to exclusively the art objects you are here to see. Do you understand?"

Yvgeney nodded.

"Do you have a list of art you are searching for?"

The word art was twisted through his unnerving sneer as he spat it out. It reminded Yvgeney of the way Khrushchev had ridiculed the Russian avant-garde art movement during the 1950s, and that New York mayor who tried to shut down the art museums when he objected to a painting.

"It's on my computer, here inside."

"I can print you a hard copy," the Frenchman volunteered from the back seat.

Yvgeney cringed about the amount of black ink cartridges he would exhaust in this exercise in diplomacy. He made eye contact with the Frenchman and wiggled his nose slightly, no.

"Save the ink," he silently suggested; the militiaman seemed to be ready to give in and allow access even without the printout.

"You, Russian, ride with me." The soldier pointed to the sidecar. "The others can follow in the car. The Bosnian heretic stays out here."

B.S. Kotromanic grimaced, narrowing his eyes in a look that characterized the region. He exited the Humvee mechanically, as if in a trance. His face was dangerous-looking, a mask of resolution.

Inside the vehicle, Du Michelle seemed disturbed. "This is way too easy, Yvgeney. Be careful with this man."

"Don't touch the machine gun." The militiaman's carbine was pointed down in a non-threatening manner as he gestured toward the mid-century weapon bolted to the sidecar. A round magazine the size of a silent movie film canister was perched on top.

"It's an antique." The Serbian laughed at his own private joke and climbed on the seat.

They powered up with a rumble and headed for a gap in the forest ahead, where the driveway split the dark trees.

The vehicle path to Slobodan Milosevic's presidential retreat emerged from the forest and crossed a stone bridge so old it could have been Roman. The NATO bombs that had twice rained on the compound during the compliance phase of the peacekeeping effort three years before had, ironically, spared it. Ocher-colored earth craters dotted the woodland meadows.

Yvgeney thought of the thousands of years of history exposed. Here, where three great civilizations converged, centuries of spilled

blood from cultures that couldn't coexist on the surface freely mingled in the sandy soil beneath it.

The motorcycle bumped and lurched as it zigzagged through a stretch of temporary road repairs.

"There's your smart bomb, Mr. UN." The foul-smelling driver didn't have to point. They bottomed out hard on the edge of a badly filled pothole.

"Bastards." The Serb mouthed a Slavic curse that fit his permanent sneer. "Why are you, a Russian brother, working with these swine? Look what they've done to my country!"

"I'm not here to judge. My concern is with objects. The war has put many priceless treasures in grave jeopardy. My mission is to save them." Yvgeney saw new construction as they crossed the fields of a woodland farm.

"You confiscate our art, you steal our tradition. I trust you as much as I trust peacekeepers that bomb us from the air. We recovered our own sacred objects from the hands of infidels. You will see."

Yvgeney knew they'd be inspecting a staged exhibit. Du Michelle had been right. It was time to watch their asses.

Valerie looked more apprehensive as he watched the motorbike wobble through the badly filled bomb craters dotting the road to the president's palace. During the time they spent in Slovenia, Croatia, and Bosnia, they'd been tolerated as meddling foreigners whose goals matched their own: the safe return of stolen masterpieces. Now they were in Serbia. Here they were the enemy, human faces on the bombs that NATO dropped. Here they stole the Serbian heritage with Xeroxed documents.

The little caravan approached another clearing, visible through a thatch of smart-bombed evergreens, dead now, and framing the

presidential hunting lodge, a château that looked like a rustic painting. Valerie opened his cell phone and uplinked a call to Lyon, France, to Alexander Bishop, his boss at UNESCO, to ask for some friendly faces to meet them at the perimeter gate for an escort back to Belgrade. Yvgeney had requested backup.

Yvgeney and the silent motorcyclist cruised past a nineteenth century Bavarian-style lodge, complete with six dormers protruding from the steeply sloped roof. Its angle suggested that heavy winter snowfall was a design factor. It appeared to be the main structure of the compound. Waning Balkan winter light bounced off shiny orange and tan slate. Fresh paint and crisp white window frames identified areas of the mansion the smart bombs had found. The repairs contrasted with old white clapboards and the dark window frames and shutters that gave this rambling extravagance of a hunting retreat its Bavarian charm.

The glaring driver said nothing as the motorcycle entered a grove of ancient oaks, alive after 700 years in an over-humanized war zone. Another great building, a huge Bavarian-style barn, loomed out of the light snowfall. The Serbian militiaman parked near the man-door and dismounted, still holding the carbine. Behind him was a 100 x 60 foot wall of new construction. A white-framed, large sliding barn door dwarfed Yvgeney and the Serbian as they watched the UN vehicle arrive, barely leaving tracks in the thin snow. Yvgeney watched his partner and the German peacekeeper emerge; the leather strap on the German's holster was undone.

"Did you get through to Lyon?"

"Everyone in our office is at a conference in The Hague, Yvgeney. The secretary is going to try to contact some Belgrade friendlies, to get us an escort at the gate."

"I hope we get back to the gate, my friend."

An overall-clad, black-bearded giant of a man opened the man door. The militiaman spoke to him rapidly, with numerous derogatory hand gestures aimed at the visitors. With a grunt and a hateful glare, the giant backed inward, toward the cavernous interior. The Serb motioned the visitors inside with the tip of his carbine. Without a translator, Yvgeney looked for an easy way to terminate the mission and return with a bigger force. He looked at his partner, who shrugged, shaking his head.

The rich smell of yesterday's manure filled his nostrils. Fluorescent tubes lit a functional livestock barn interior, with long rows of stalls along both sides.

Angry snorts rumbled from beasts unseen. The Serb and the giant exchanged words and laughed as the large man opened one of the sturdy pen doors and released a mammoth hog. It rushed the visitors, baring yellow teeth under curved tusks. The keeper roared in delight as he prodded the beast back into his stall.

A metal bulkhead at the far end of the barn showed chips and dents, evidence of NATO shrapnel. The caretaker opened a battered metal door, ushered the group inside, and started the descent of a long metal staircase. The walls were cut from the soft limestone, porous with pockets and gaps that formed geological niches. Living over a land of stalactite-filled caves and underground lakes and river systems, Serbians call their spongy bedrock *karst*. Yvgeney and the Frenchman had walked through many such repositories during their data-gathering across the former Yugoslavia.

Water dripped and seeped from the walls, streaking the rough-cut sides. Tiny stalactites continued to grow from the ceiling, a forest of limestone nipples above their heads. Another heavy metal door waited at the bottom of the metal-cleated stairs. The giant fiddled with a six-inch key in an ancient lock and opened the door.

To a treasure room? A staged bunch of icons? Or death?
Yvgeney blew the thoughts away and moved forward.

"Here is your storage, Russian." The militiaman stood behind them on the step above, rifle still in hand. He maintained his indifference to the other two, and directed his laconic remarks toward Yvgeney.

"A repository carved by God, Himself." He made a cross sign with fingers that Yvgeney figured had murdered 100 unarmed innocents.

The massive door creaked open on rusty hinges. Beyond it, the metal stairs continued down along the wall of a narrow subterranean canyon, 20 feet from wall to wall. The walkway hugged the cliff, disappearing far ahead and far deeper at a bend in the limestone slot. Somewhere below them in the dark cleft, Yvgeney heard the soft sounds of water droplets hitting stone.

The three UN personnel inched downward, single file, into the Balkan deep. The giant pig keeper and the sneering escort followed, their malice like a spear prodding the visitors along the metal catwalk held fast to the sheer wall with oversized, hand-cut bolts.

Yvgeney was acutely aware of the size of the farmhand and the barrel of the Serbian gun at his back. A single bare electric bulb hanging from a tattered cable illuminated the dark ribbon of an underground river, three feet across. As if performing ritual, the giant spit a wad of tobacco into the black water. Tiny albino fish rose to the surface to pick at the floating stain. Beyond the river, bridged with oak beams, more light spilled from another crack in the bedrock. Gold leaf and gesso glittered in the space beyond. As the group crossed the sturdy bridge, he allowed himself a glimmer of hope that his paranoia was unfounded.

They entered a natural amphitheater, 50 feet to the stalactite-draped ceiling, and 200 feet across. A quick look said 500 pieces of art

were housed inside. Dim light bulbs lit up a thousand years of Orthodox tradition, boxed, crated, blanket-wrapped, and lying around with their wooden lids removed. Yvgeney guessed the exposed objects were the ones the inspectors were meant to see.

The Frenchman spoke first. "Remarkable."

Yvgeney made a hurried inventory of the objects, mostly oversized icons and decorated wood panels. After a minute of silence, he said, "Looks like another Serbian chamber that's 100 percent Orthodox, my friend." He winked surreptitiously at his UN partner, careful not to anger the pig keeper. The giant reacted with a start as the Frenchman began to unpack the computer and camera gear. "Go gentle with the inspections, Valerie." Yvgeney spoke French in a low monotone, hiding the vocal inflections that might give meaning to his foreign words. "This fellow takes the objects in his care very seriously." In German he said, "Schultz, perhaps we won't have to shoot our Serbian tour guides after all."

Schultz snorted. His hands were open and tense at his sides like an American cowboy at a gunfight. He said, "The holster is still unbuttoned, sir."

"It looks like two days work to get this room cataloged," Yvgeney said to Du Michelle. "Staged or not, it's still stolen goods."

He turned to speak to the militiaman. "Sir?" The words still caught in his throat. Training told him to be diplomatic. "We would like to see the inventory lists and the descriptions of the crated relics."

The foul man laughed and spoke to the giant in Serbian. The pig master gesticulated wildly as he listened. He punctuated his answer by spitting more tobacco juice, this time hitting Du Michelle's shoe with runny brown drool. The Frenchman rose up, his posture like an outraged Paris waiter. Yvgeney knew the look well. He pursed his lips tightly but remained still.

The guard continued. "We will give you nothing. You may observe all of our holy relics, but you will not touch them. You will open nothing, now that you've seen our heritage, which we have returned to holy ground. Then you will leave. Back to your Roman or Islamic dens."

"We have papers that allow us to open anything. You have read them."

"Words on paper, Russian turncoat." He looked toward the giant. "Petric takes his assignment very seriously. If he gets upset," the sneer widened to a gold toothed grimace, "I might not be able to protect you." He shrugged with mock concern.

"Yvgeney," Du Michelle said, "considering our exposure here, perhaps we should log in the displayed objects and return in a more secure posture."

"Like our hotel room back in Belgrade with the door locked," said the Russian, speaking in French. He repeated it in German for their driver and reached for the laptop, heading for the first icon.

Yvgeney had no doubt the objects on display were priceless. The first three icons cataloged were eighth or ninth century, probably from Greece. Byzantine images of devotion and transcendence. He assumed they were relics from Kosovo, Serbian relics rescued from infidel appropriations.

They spent the afternoon in scholarly data entry with little time to draw conclusions or match the objects to the lists of stolen art. One by one, icons and panels were measured, described, and inspected for damage and physical state. Once again, as always during these discovery sessions, Yvgeney was filled with wonder at the amazing capacity of humans to recreate their experience of knowing God.

The militiaman and his pig herder stood by the door. Schultz maintained a watchful position between the pairs of adversaries near an elaborately carved marble casket. Du Michelle inspected markings on a sculpture base. Yvgeney, faced with a Serbian sham display, kept his conclusions to himself. He saw no need for a confrontation. Three necks were on the line and there were plenty of stolen masterpieces in the obvious tableau; even these easy ones had to be recorded. He knew they would be much more likely to make it back to the UN safety zone in Belgrade tonight if his "escorts" were comfortable in their charade.

He made note of the sheer volume and size of the objects and wondered how they could have been transported down the catwalk over the chasm connecting them with the barn. He tried to picture these heavy, awkward architectural relics being carried along the narrow catwalk and shook his head, concluding there had to be another way into this cavern.

Fat tire tread patterns crisscrossing the dusty floor caught his attention. He followed one set to a large, carved gilt-wood liturgical panel leaning against the back wall. The track disappeared under it. Images of saints in round-topped gold leaf niches sat above a series of rectangular icons at eye level. Yvgeney had entered the object into his database already, calling it fourteenth century. It formed a nine-foot square and was bordered with an ornate dark wood frame. He expected to identify it later as an artifact from a looted Serbian monastery now in Bosnian territory. Many had been stripped of their interiors during the terror of 1999.

Now fully alert, he noticed other tracks in the dust on the floor that looked like tire marks from a forklift. Most of them ended at the big panel.

"What's behind the shrine, stinky pants, another passage?" Yvgeney had asked the question idly, almost rhetorically, a "heads up"

message to his team, but he spoke it too loudly, and in English. Now the question was out and undeniable.

Yvgeney looked at the Frenchman and they looked toward the German. They all knew what he'd discovered. The Serbian escort looked at the giant and translated. The pig man bristled.

"I'd like to see behind this object, please."

The Serbian didn't move. Yvgeney walked to the heavy panel, curled his fingers around the corner, and pulled one side away from the wall. He knew the peril of his act. Wishing he had a brigade of peacekeepers between him and the two Serbians, he pressed his head against the cool limestone and peered into the tight gap behind the wooden screen. He saw a dark area, suggesting a good-sized hole behind it, in the cavern wall.

"Damn, Damn, Damn! This isn't good," Yvgeney whispered to Du Michelle.

The ratcheting sound was familiar to everyone in the room. Yvgeney spun to see Schultz, his cocked handgun pointed into the militiaman's left ear. Yvgeney rolled his eyes in disbelief, but the deed was done.

"I had no choice, sir!" Schultz said. "He had a bead on your back as you looked behind the relic." He thrust the muzzle deeper and twisted his captive's head. "Tell your monster to back off, Serbian dog, or I'll shoot him with the same bullet as it leaves the other side of your skull."

It was the longest sentence he'd spoken all day. There was no doubt the Serbians understood. With slow, deliberate motions, Schultz removed the rifle from the militiaman's hand. The sneer remained, growing stronger with a Baltic resolve that needed no translation.

"He was going to shoot you, sir." Schultz said.

Yvgeney said, "You did well, Schultz. I know you acted correctly." He stepped over to the standoff and took the Serbian

carbine from his driver's hands. "It looks, gentlemen, like we're going to back our way out of here all the way to Belgrade. Mr. Du Michelle, do you want to peek behind the big panel?"

Du Michelle spoke in German. "Give us 10 minutes, son, then we'll all take a sleigh ride to the front gate."

With his partner's help, the huge partition moved rather easily on the hard, powder-covered floor. A 5 x 6 foot tunnel led deeper into the Serbian *karst*. A string of light bulbs disappeared into the dark. Schultz urged his captives forward into the passage by increasing the pressure of the .45 in the militiaman's ear.

Green-stained limestone morphed into shiny metal and concrete and rebar. In the maze of catwalks, secret entryways and tunnels, Yvgeney lost his sense of north and south by the time they reached the second door, a modern vault entry fashioned of hardened steel. He assumed they were somewhere under the main structure of Milosevic's lodge. *It would make sense,* he thought, *for the Serbian leader to have his trophies under his retreat, where he could visit them with a glass of brandy and relax after a long day of ethnic cleansing.* The lighting was better here, glowing from modern sconces in Viennese cutout industrial grillwork. The door swung on machined brass hinges. It was unlocked.

Yvgeney entered first and scanned the room. No packing crates in here. Soft lighting, pedestals, and stainless steel shelving. There were good things in here, very good things. He waved the reluctant hosts inside and shut the safe-like door after assuring himself he could open it again from the inside. Now he would see the real spoils of genocide.

"In five more minutes I'm going to have to shoot this man," the driver said.

"I need 10 minutes, Schultz. Do you want his carbine?"

"My pistol's sufficient, sir. These men will not stand for much more of this treatment. These people are crazy." He moved the pistol to the Serbian's nostrils and pressed his head back with the barrel. The giant struggled to be still. The German glared in return. He said, "I'm going to kill this man if they move on me. It's not part of my mission. Please get this over with, sir."

"Ten minutes, Schultz," Yvgeney said. "And I'll buy you a cold Bavarian beer at the hotel tonight."

Ten minutes! he told himself. *Take a look at what the man stole, and come back next week with a full division and a flak jacket.*

"Ten minutes, Valerie! Get a sense of it and we'll come back! Schultz?"

"Yes, sir."

"Tight lines. It's American sailing slang. It means keep safe through vigilance."

"They're dead men if they move, sir. I think they know it."

"I'll take this aisle," Valerie said. He entered an aisle displaying gold-framed paintings and sculptures. "I think our mission has gone beyond its parameters, Yvgeney."

"Let's pray that we have friendlies waiting with our translator … what's his name … B.S., at the gate." Yvgeney raised his voice as he spoke across the room. "Have a look, Val, before our pig shepherd wakes up and starts protecting his castle."

Nine minutes and counting.

Yvgeney noted three early renaissance paintings, one perhaps a Pietro della Francesco. He filed them to memory. Above the oils on a shelf he spied a stack of framed 8 x10s in black and white on a stainless shelf. Yvgeney examined the top photo and recognized the faces of Hitler and Himmler, and maybe Goering sitting in a windowless chamber.

What a photo! he thought. He saw tiredness in Hitler's eyes and estimated the date as 1945. Intrigued, he picked up the second. A woman in the photo sat in a rocker of Austrian Secession design. She held a newborn child. Yvgeney's attention darted to the image of the chair. He remembered a chair like it pictured in an auction catalogue years before. Attributed to Hoffmann or Kolo Moser. *What a sweet form*, he told himself. A pair of perfect ovals held a cantilevered seat and back that floated between them.

"Say, art lover." A deep French voice bellowed from the other side of the hall. "I found something that you would—"

The room exploded and knocked Yvgeney to the back wall. He heard the sound of glass and metal shrapnel as it peppered the shelves above him. The room went black.

He woke up in a dimly lit pile of broken treasure. A metal shelf weighed heavily on his thigh. He slid out from under it and stood up on shaky legs. He felt pain now; a pattern of bee stings on his left side matched the red-tinted holes in his shirt. The taste of blood rolled into his mouth. Fighting nausea, he dashed to the aisle that ran down the center of the concrete vault and saw Du Michelle. Half his head was gone.

Wake up, Yvgeney! Time to stay alive. Pay attention! He looked to the entrance for Schultz and the two Serbians. A solitary broken light fixture hung from a single thread of frayed wire from the tunnel roof, swaying gently in a subterranean breeze.

The vault door was half-open. He staggered to the door and looked out into the tunnel, left then right. It was empty. He ran through the options. A left turn would lead back to the other chamber and the long catwalk to the pig barn. A right turn led into a modern area, probably under the main lodge. Yvgeney limped back to the still form of his friend, searching for the militiaman's carbine. It was gone. He thought about retrieving the laptop, but decided to concentrate on

survival. Turning toward the door again, Yvgeney chose a right turn into an increasingly contemporary unknown.

There was an audible snap in the electrical system, and the lights went out. Faint sounds drifted along the pitch-black tunnel. Yvgeney didn't recognize the source of the barely discernible squeaks and grunts, but his fear was escalating. With one hand out to the cold concrete wall, he continued his flight into darkness. There would be some other exit in this direction, either to the outside where a forklift could enter, or up into the main lodge, which Yvgeney was convinced was above him. Thoughts of Valerie Du Michelle flickered into his mind, but he chased them away.

The sounds were louder now. Definitely emanating from the old caverns and the pig barn. *The pig barn! Fuck!* The grunts now made chilling sense. He was the prey in a Balkan hunting game. *The bastards*, he thought. *They could have shot me after the explosion, but that wouldn't have been satisfying enough to that mean-assed, snarling Serbian.* He quickened his blind scramble, light pressure of fingertips on the wall his only reference.

A light fixture struck his hand as he fled, but his smarting fingers regained the cool surface and he kept up a semi-jog through the inky darkness of the tunnel. He smelled the Serbian and stopped. The noises of excited beasts were louder and more frightening. He moved forward again, but more cautiously, searching for an exit or a plan.

As he scooted, cockroach-style, as fast as he dared along the wall, Yvgeney's face encountered a soft wet pillow. He tasted blood and pulled back in horror. His hands traced the form of a still-warm corpse in the darkness. It swayed gently as he touched it.

Schultz ... Oh ... Fuck! The poor bastard!

Yvgeney had encountered death in his years with the Russian Navy. He knew the sticky liquid that coated his fingers and cooled his face. A howl rose up from somewhere close behind.

The boars have smelled the blood, he thought. He straightened up and ran, blindly with no purpose except trying to put some distance between him and his hunters. He hit the wall at a glancing angle at full sprint and kept his frenzied pace. A glow was barely visible in the darkness ahead. Terrible snarling erupted in the darkness behind him. The pack had found the German. He hurried toward the light.

A pair of square windows on the right was the source of the light. Yvgeney reached them and saw a staircase leading upward. He felt for a door handle but found a keypad.

"Fuck!" he shouted. The din of squeals and grunts was punctuated with the sound of large bones cracking and slurping noises. Yvgeney rattled the handle-less door. His fingers pried at the edges of the keypad, to get a purchase for pulling. He saw movement through the glass. He watched a man advance one step after another in the well-lit area beyond the door. Yvgeney screamed for help. Then he saw the smile, a wider sneer on a familiar face.

The pig man sat down on the third step from the bottom, just outside Yvgeney's window port. He was eating a sandwich. A wet avalanche of spittle and breadcrumbs spread down onto his matted beard. He smiled in a surprisingly friendly way and gave a little wave.

The Russian ripped himself from the surreal cheerfulness of the madman and stumbled back into the blackness, just to be farther from the horror. He'd be damned if he gave the Balkan pig master a ringside seat. He double-timed it into the total darkness with his right hand on the wall his only guide.

A crisp puff of winter air hit him in the face as he saw the outside door. Yvgeney had noticed the steep incline in the tunnel slope and had hoped there was a ground-level entrance somewhere up ahead.

It would make sense in a major underground construction project. The Balkan twilight shone like a search beacon as it flooded into the tunnel from cracks and shrapnel holes in a stout, but damaged, door. Through a splintered panel Yvgeney glimpsed trees and a meadow covered with an inch of the winter's first snow. Snorting behind him made him jump. Now the scent of blood led to him. He yanked on the wooden square and felt it loosen. He jerked it out and threw it down. Reaching outside, he felt for a handle or a hasp. His fingers found a metal thumb plate over a handgrip. He pressed it, felt the mechanism engage, and with an urgent pull, he opened the door to a Serbian sunset.

The gothic hunting lodge loomed behind him as Yvgeney scampered toward the cover of the forest. He calculated the distance and direction of the gate as he moved. The woods were soundless, insulated by the early snow. Dark circles of bare ground cover dotted the forest floor like high noon shadows under the sheltering evergreens. A loud snort penetrated his reverie in this fairyland of trees as he jogged. Yvgeney looked back. Dark, menacing shapes of champion Balkan boars stood out against the new field of snow behind him. Their snouts tossed the fluffy powder as they followed the scent of Schultz's blood on his footsteps. Squeals of delight followed the discovery of a new bloody footprint. Yvgeney also recognized the men's laughter as they followed the pack of swine. *Bastards*. They'd expected the Russian to escape the tunnel. This was part of their game.

Whipped by their giant master, the hogs stepped up their pursuit. Yvgeney turned and ran. A small stream soaked his UN-issue boots as he ran down into a gully and up the other side. At the top of the rise, the woodlands stopped, opening to a broad white field. The light was almost gone. A cold blanket settled over him from the starry sky now emerging. The fence was barely visible 500 yards away, a

dark straight line across the snow. Sounds of the frenzied omnivores reached him from across the little gulch. They spotted him and squealed. Then they attacked.

Yvgeney put down his head, sprinting across the wide meadow toward a distant fence that might mean a road.

He thought fleetingly, *how fast can a boar run in an open field?*

Navy survival skills had kicked in once he hit the open air, driving out the primitive brain responses in a hierarchical coup. Fifty yards out into the open from the woods, he turned his head and risked a look back. He stopped.

Seven giant hogs had stopped short at the edge of the forest. The giant and the militiaman were silhouetted beside them, immune to their bloodlust.

Yvgeney looked at the single line of footprints that led to his position in the middle of a snowy meadow. Suddenly he knew why the bloodthirsty beasts had ceased their pursuit. The Serbians' laughter stopped.

As if to prove his realization, a boar lumbered up to the meadow edge from the stream-lined gully below. Head down, he tracked Yvgeney's footsteps into the open pasture toward his prey.

A baseball-sized munition launched itself upward from the snow. Yvgeney recognized the Bouncing Betty, and knew what was coming. The boar looked back at the noise just as it exploded. The concussion reached Yvgeney as the boar's body hit the ground. It lay still, oozing onto the perfect snow. He heard belly laughs from the militiaman. Then the sound of a ratcheting shotgun.

Yvgeney's heart sank. His frazzled mind allowed him the thought that the whole escape had been engineered to lead him to this killing ground. The UN had not encountered many mines, at least new

ones, in undisputed Serbia proper, but this is a presidential retreat. And this is the perimeter.

"Do you like to dance, Infidel?"

In the rising moonlight, Yvgeney could see the militiaman's breath as he cupped his hands and shouted over the now-bloodier trail of footprints out into the paddock. Steam rose from the cooling porcine attacker. The shape of the giant raised his rifle and fired.

The concussion rippled the frozen soil under the Russian's feet. He felt the power of the slug in his bones. A dark slash of earth appeared in an explosion of new snow, inches from his left boot. Yvgeney minimized his profile, crouching to make his body smaller.

More laughter. He heard the ratchet noise again and closed his eyes. Images of boyhood life in Leningrad flipped through his brain like magician's cards. He saw his mother, bending over his crib.

Another pig blew up. The legless torso landed with a thump. The shrieks came now from the pig herder, as the herd lost its fear of the field. One by one the dark shapes ambled out across the snow to eat their brothers. The giant slapped them with his rifle butt, screamed for them to stop, and cursed orders in an anguished Serbian wail, but instinct trumped their training.

Another misstep, another explosion increased the feeding frenzy. Bellowing into the dusk, the giant took one hesitant stride out into the field and froze. Yvgeney heard the sound of the mine as it launched into the winter air. The noise of the Bouncing Betty is unmistakable. The militiaman at the forest edge dove for the ground. Yvgeney watched the drama play out like a scene from a silent movie. Feet rooted to his footsteps in the snow, he squatted in the darkening field to create a still smaller profile.

The giant stood still as the ordnance exploded at stomach height. There was a blinding flash and detonation. It took a few seconds for Yvgeney's sight to return and recapture the scene in the

moonlight. The silhouette of the giant still stood. Another movement alerted the Russian to the snarling militiaman, climbing to his feet, and picking up his gun. The giant fell.

The game was over. Yvgeney knew it. Even now, in darkness, the moon's glow lit the freshly fallen snow and framed him as a target. He was tired. He licked his lips and tasted Schultz's blood. He ached to give up and welcome the impact of a bullet. He looked around him in the exposed snow-covered minefield for cover. Saw none. *Think, Yvgeney*, he told himself. A favorite saying by his friend, Wally Winchester, popped into his mind. "If you really want to find something, look in the most unlikely place first." He scanned the field around him again.

He felt the impact at his feet and heard the rifle report, followed by a laugh. Yvgeney decided that not killing him with that shot was the Serbian's mistake. He rose and ran toward the shooter. Moonlight lit his footprints, the only certainty he had in a white meadow of death. He felt like a child as he matched his stride to the shadows of the indentations, oblivious to the man with the gun. Yvgeney's objective was just ahead. Four dead pigs and a giant lay still in the field before him. He stopped. Off to his left blood oozed from the body of the first pig to die. His feet left the safety of the footprints as he dove and landed on the carcass. It shuddered as a rifle shot echoed into the night. He eased his body down between the beast's legs, careful not to contact the deadly ground. Out of shooting angle. Another impact rocked the body in front of him. He heard a Slavic curse. Wetness covered his shirt; it stuck to his skin as it cooled. He had no plan but knew he'd taken a hundred percent chance of death and traded it for a lesser percentage. He heard undecipherable mutterings as the gunman walked the forest line, *Good old Wally Winchester,* he thought. *The sanest man I know.*

The notion bothered him. He returned to his options. He had one. *The giant. Did he have a weapon with him when he died? Can I get back to my footprints? Is his body large enough to use as a shield? It's only ten meters to the forest.*

A burst of gunfire shattered his thoughts. A moment later he heard another burst, emptying a clip. Yvgeney heard the voice of the translator.

"Hello UN guy!" he shouted. "Did you hear that last clip? That was for my sister!"

Neither man spoke for a minute. Then the translator asked, "Where are the others?"

"Dead," Yvgeney said quietly. He hardly cared if he were heard. But then he had a question. "Can you help me get out of here?" He was thinking of a helicopter, or a battalion of night minesweepers from Belgrade.

"The moon is full." The Bosnian spoke like a veteran of the Balkan reality. "The snow is fresh. I can see from the tracks in the snow that you already know the answer. Run back on your footprints like we all do."

As he stood alone in the cold Serbian night, gauging his ability to hit the widely spaced holes in the snow he'd created in a full-out run a few lifetimes ago, he shook his head at the madness of a world out of control. An odd moment of clarity settled his spinning thoughts. He realized the sanest person he knows *is* Wally Winchester. The thought made him smile. *I'm looking forward to seeing you, my friend*, he thought. *And make a living safely, buying and selling antiques.*

Journey II

Chapter Twenty-Two

Camano Island, Washington

As she drove back to Camano Island after a dinner of swapped stories, beer, and cheeseburgers, Rae rolled the sleeve of a thin black sweater over her arm, nut-brown from a week of South American sun. She held it next to Lucy's pale wrist and compared. She said, "We've got to get you some color, girl. Doesn't the sun shine in Paris?"

"In Europe, pale is in this year, sweetie." Lucy answered. Her British accent rose to a level of mock disdain. "But I wouldn't expect you provincials, living on an island on the back side of North America, to be up to speed with world trends. Besides, if I wanted a tan, the last place I'd go to get it would be the Pacific Northwest in springtime."

"We get lots of sun on Camano Island, dear," Rea said. "We're in a rain shadow, or haven't you heard?"

Lucy Adams tilted her chin to the visor mirror and inspected her complexion. She ran her fingers through a mop of unkempt black hair and flipped the visor back. She said, "The only tanning you can get here is in a booth or out of a bottle. I like pale, thank you. There's nothing more boring than a Sally back from vacation, bragging about her tan."

"Trust me," Rae said. "It was no vacation. I wanted to strangle Wally more than once, half my photos were mysteriously ruined, and a creepy German scientist put a move on me that made my skin crawl."

"Men are dogs, honey, we can agree about that. I got lucky with this one. As a matter of fact, I'm lucky I got Yvgeney back from Serbia in one piece. Your guy, Wally, is not as bad as most, you know."

151

"Tell me that again next week, Lucy. When my blood pressure is back to normal."

Rae noticed something was different when she entered the cabin. With the Chile trip two days behind her, the last thing she expected was a feeling of alarm.

Ten steps into the kitchen, a sense of violation surged. Instinctively, she looked around the interior and assessed the contents, searching for something out of place.

The lights were on everywhere, but that was normal. Wally's preoccupation with lighting kept a lot of twenty-watt bulbs burning.

No furniture seemed missing or out of place.

The rugs lay undisturbed on the hardwood floor.

She made a mental inventory of the pottery and art glass and the bronze or copper do-dads that covered most of the horizontal surfaces. Wally's treasures. She knew them all as dust magnets. Everything seemed intact.

"Wally, I think someone's been in the house while we were gone to dinner."

"Well, at least they tidied up afterward, sweetie," he said. "What's tweaking your radar? It seems normal in here to me."

"I dunno, something is not right. A smell, maybe. Or just a feeling." Rae was proud of her keen sense of smell and used to think she could have won prizes with her nose, if such contests were offered at country fairs.

"Probably like last winter," Wally said. "When we had a mouse in the water heater closet, remember, you kept blaming it on my socks till we stumbled onto it."

"If our Frida were a better mouser we wouldn't have a rodent problem."

"Don't blame the smell on my cat. She's a lover, not a killer."

"Really, Wally, something is giving me the creeps. It's a scent I remember from South America. I think I smelled it in our hotel. When I found the photos ruined."

She turned to Yvgeney, behind them now in the living room, "You're a genuine Russian detective. Can I get you to take this case?"

Deep creases in the UNESCO investigator's brow got deeper. He'd been party to the conversation and had already discovered two anomalies in the hall that suggested she was right.

"Did you lock the door when we left for dinner?"

"No, we don't have to, living way out here on the point. We were already in Chile when I found out Wally didn't even lock it when we left for South America. We e-mailed a neighbor to lock it the next day."

"It was locked when we returned tonight."

"I noticed that. And I went around front to come in from the porch, remember? I thought that you or Lucy probably did it, being new to the house and all."

"Wasn't us, I'm sure. Anything else?" Yvgeney asked.

"I think ... maybe it was a smell. One I didn't quite recognize, that gave me the willies."

Yvgeney wrinkled his nose for a purposeful sniff, but it was useless. He said, "Wally, do you have two flashlights?"

"Sure. Here by the door. But everything seems ..." he stopped, remembering that the verdict for not caring is always guilty when something bad happens later.

In the warm darkness, a refreshing breeze carried a few drops of rain. Wally felt them on his cheek. He turned the flashlight beam on the bare patch of garden soil under the window and saw nothing but

153

peaceful evidence that they'd been gone two weeks. Dead leaves and early fall cobwebs suggested undisturbed neglect.

"No one's been on this side," he pronounced into the wind loudly.

The other flashlight rounded the corner as the Russian approached, noisily breaking branches and rustling leaves. "Rae was right, there was someone here recently," he said.

"I didn't find anything on this side." Wally repeated.

"They were in the guest cabin, too, and around the outside windows."

"My outbuilding? My warehouse? The fuckers!"

"And my apartment, my friend."

"What did you see that I missed?"

"You are trained to see retail mistakes in antique stores. My training is discovering carefully concealed deception. Someone's been at all the windows recently."

"Not mine. Look here, the cobwebs haven't been disturbed."

"Yes, I see. She'd learned more stealth by the time she got to this window. Come here, I'll show you." Yvgeney stepped out of the illumination, into the darkness.

"She?"

"Follow me, I'll explain."

Around the corner they stopped at another window, glowing yellow into the Pacific Northwest night. The Russian pointed the beam toward the unmarked soil below it.

"Someone's stepped here recently. Not a very heavy person. Probably a woman or a child."

Wally peered into the dark space between two shoulder-high shrubs, laden with evening dew. He only saw neglect.

"There's a fingerprint up here on the sill."

Sure enough, a small brown smudge interrupted the pattern of condensation on the white-painted shelf.

"And down here the slug trail is broken."

Holding the flashlight at an extreme angle, Yvgeney illuminated a nearly invisible shimmer of gossamer slime. Above them two rhododendrons rained moisture on contact.

"See the trail and the dead leaves?"

Wally said that he could.

"These two leaves have been placed here to cover an interruption of the path. See?"

Yvgeney lifted the brown leaves and pointed to a disturbance in the reflective slime trail. He said, "She knew, and she took pains to cover up her step."

"Why do you keep saying she?"

"Mostly a guess. The fingerprint is petite. The footprint is still here under the dead leaves. Stepping on tiptoe was indicated by the ball and toe prints in the soft soil. They were covered again, brushed out with fingertips. One of them left the dirty smudge on the sill. The intruder was either a child or a woman or a jockey, based on these observations."

"Or a dwarf," volunteered Wally, trying not to be completely out-detected.

"Had a lot of trouble with peeping dwarfs these days?"

"OK, a woman. What about a kid? We do have a lot of vandalism and pilferage on Camano."

"Wally, you tell me about vandalism yet you leave your door unlocked."

"I don't have anything the little gangsters want. No flat screen TV. No cash. No guns. No expensive electronics. My dark, heavy chairs may be worth five thousand apiece, but they're of no use to these youthful thieves. They want *bling*."

155

Yvgeney said, "No teenager would have noticed the breaching of a slug trail and tried to conceal that error. This visitor has a very intimate relationship with the wild. I'd bet she was raised in an area where the population is close to the earth, probably an aboriginal tribe."

"All that deduction because of a slug trail ..."

"All that because she knew about the slug trail."

Inside again, Yvgeney said, "A skilled professional has paid your home a visit while we were eating those burgers, Rae, just like you thought. You have been the victim of what you Americans call a B & E. Are you sure there's nothing missing?"

"Perfectly normal inside. The computer hasn't been used, either. I checked."

Wally frowned, remembering his last eBay update. He'd checked the status of two items at five-to-eight, right before they left for dinner.

Lucy entered the conversation. "Someone is putting a lot of energy on this cabin, you know. This doesn't sound like random curiosity."

"Well, there's nothing missing and a shitload of valuable collectibles here lying around untouched. I don't owe anyone any real money. Neither Rae nor I are having affairs, lately. Huh, babe?" He backpedaled, "Anybody pissed at you, Yvgeney?"

"Lots of people, I'm sure. I've been nosing around at lot lately in dark, secret places where I wasn't welcome. It's the nature of my job. It's actually one of the reasons I'm quitting the UN. One of the reasons we're here. There's a lot to talk about later, once we get settled in. To answer your question, No, there is no one who would be out

here, in America, interested in either Lucy or me. Wally, do you have a gun?"

The question alarmed everyone else in the room.

A hundred feet behind the cabin, the thick grove of cedars provided all the cover Chana needed in the darkness. She adjusted the earpiece and adjusted the volume, content that she had recorded most of the conversation in the living room. The identity of the speakers was not a problem; one was a lady Brit, one a Russian. She knew the other two. She double checked the red LED that told her that the device was recording and sat back to listen.

"I once owned a Purdy, one of the world's finest shotguns. An amazing piece of art, with what they called a Damascus barrel, best steel in the world, and beat-the-band scrolling, probably 1854. I owned it for less than an hour back at a summer Brimfield show. Made 4500 bucks in 20 minutes."

"What do you have here in the house?" Chana could recognize urgency in the Russian's deep Slavic voice.

"I've got a sweet little Parker 12-gauge in the bedroom closet."

"That's more like it."

"Rae has to get the shells."

"It's my version of fail-safe." The woman's voice was easy to recognize. Chana had watched her take pictures with a cardboard box for a week in the South American sun.

A window in a back room of the cabin lit up and went dark again.

"Here you go, Wyatt Earp. Don't shoot your eye out."

A *shotgun*, she thought. *That's acceptable*. A long gun inside a confined space is less threatening than a handgun or machine pistol.

With her training it would be easy to just go into the *cabaña* and kill them all, she knew, but that wouldn't get her the chair.

If the chair had been there in the large room or in the other structure out here in the forest, where the other two lived, she would have found it, and she'd be gone now. She'd be on her way home, but the object of her journey wasn't here. The location of the chair would have to be revealed to her by the people inside.

She hadn't counted on the other couple. It would make her job more difficult if she had to act boldly. The Russian would be most dangerous. His words and actions suggested military training. He could be a formidable opponent. The other three didn't matter.

"Oh, and I have these." It was the idiot, Wally, speaking.

"You have a machine gun in my living room?"

"It's a Mac-11 submachine gun, honey. I didn't get the chance to tell you, yet. They came out an estate sale out in Darrington last weekend. And check this out Yvgeney, a M93R Select Fire Assault Pistol. Only eight of these are known to exist in the US since the weapons bans in the early 90s. *Click*. Look at this pull down front grip. This gun is a real bad mother!"

"Wally!"

"And look at this neat hand gun. It's called the Desert Eagle, a good Iraqi shooter."

"You should have your mouth washed out, Walter Winchester. How dare you bring machine guns into my house!"

"They're replicas, babe. Paint ball guns." Chana heard laughter. "BB guns for war-gamers. They're called blow back guns. Run off a canister of something called green gas. Pretty real looking, eh?"

"Bastard. Are they still dangerous?"

"They shoot pellets; supposed to be hell on coke cans or eyeballs if you don't play the game right. I wouldn't want to get shot by these without protective gear."

Chana frowned as she listened to the string of Anglo words. She would have preferred Portugese, her native tongue, or the Spanish she used every day. The English word, *replica*, confused her. She made a mental note to look it up later.

"*Armas automaticas, mierda!*" she said aloud. *A Mac 11. They have a M93, that's a bad gun. The stupid gringo is right. And a BB gun. Never heard of that one. And a paint ball gun.* Another model she didn't know about.

She'd noticed that Americans have a habit of naming murderous objects with pretty names. Like the phrase, Bouncing Betty, that described the land mine. There were others: Two metal containers no bigger than a cow named Fat Man and Little Boy, she remembered, killed a hundred thousand people in 10 seconds each in 1945.

She thought of the atomic bomb story fondly. The first time she heard it was in Manaus, Brazil, during a history of weapons class. It was her second favorite killing story.

Chana had loved weapons class. She took all three segments, but never heard of a BB gun. It sounded deadly. Her training was exhaustive in the world of arms, yet the BB gun eluded her.

Must be brand new. North Americans and their guns, she thought. *Now even the idiots in the cabaña have firepower. Guns even I don't know.*

My assignment is not so simple now, she thought. *The chair is nowhere in sight and my opponents are well-armed and nervous.*

A cold wind from the water beyond whipped through the branches above her. Chana was dressed comfortably for a Pacific Northwest fall evening. Northwest-style clothing, ID documents, a .22 caliber Ruger, and a map of Camano Island had been waiting for her in the rental car at Sea-Tac Airport, reserved in her passport name, Sheila Gomez, when she arrived this morning. A tan Gore-Tex parka and hood over waterproof pants and Sorrell boots fit well, a tribute to Señor Braun's organization.

She felt the wind caress her face. Fragrant needles in the fir trees around her hissed in the breeze. It was a sound that had many sources. A mountain stream crashing down a steep valley gorge made a similar noise. She closed her eyes and imagined it. The waterfalls crashed and tumbled, and the sound from the trees kept pace.

With a subtle nod, she thanked them for their gift of a waterfall. She felt a kinship with the big trees around her. They told her of their mighty parents, huge grandfathers, and cold glaciers ages before.

The Russian speaking in her earpiece was telling a story about a minefield. Chana popped the tape up and turned it over, figuring it was nearly full, and nothing in this Russian's current word flow would lead her to the chair. Many of his words were lost to her, but she knew the recording would get more attention later, by better listeners.

"Think of the wonderful objects you saved." The woman, Rae, was speaking. Chana noticed the moon reflected on the water outside.

"In reality, I was taking them from one collection, usually a museum, and giving them to another collector, who promptly sold them. For me, the joy of working with UNESCO was the networking, the discovery of a masterpiece in an unexpected place. It was like I was a homicide detective, and cultural icons were the victims. I excelled at that part. The rest was paperwork, up to my neck in political, religious, clannish, litigious, and diplomatic quicksand."

Small footsteps on the dry ground cover got Chana's attention. Another presence entered the dark canopy of her protective forest grove.

"*Hola, gato*," she said softly. "You're the gringo's kitty. Remember me? I met you in the *cabaña*. Lots of noise here in the windy dark. Good night for hunting. I hope you have better luck than I'm having."

The gray tabby brushed against her ankle. She purred a female greeting. The cat moved silently into the brush, deeper in darkness. *Two natural killers, acknowledging each other*, Chana thought. *Fellow travelers in the forest, each with a mission. One an instinct, one an order.*

More conversation squeaked into Chana's earphones. It was the Russian again, "Ironically, the snow on the Serbian meadow saved my life. The lucky footsteps from the forest edge through the new snow ended up indicating the only safe path out of the minefield. I was gearing up, mentally, for the dash back to the woods, retracing my footprints, when the revelation came. I think you call it an epiphany."

"Is that when you accepted the president of the United States as your salvation?" It was the lady cardboard box camera photographer speaking.

"No, much more amazing than that, although I admire the man."

Silence.

"Why the long faces? The man's a strong leader. Your country needs a powerful guy to keep the economy strong."

Surrounded by dark evergreens, hissing in the cold wind, Chana nodded. The president was indeed a badass. She admired him also. He was the face of her enemy. As the head of the Estados Unidas,

his picture hung on the walls of many Future Clubs. Not up on the main floor, but deep, deep below. In the classrooms.

"Anyway, I realized there in the minefield that I wanted to have a job like Wally Winchester, all the excitement and rewards of discovery, and no paper chase. It was the last idea I'd expected to pop into my mind when I was kissing my Lucy and the rest of the world goodbye."

"Many are they who have seen my search for greatness as a crusade, my son."

"Your crusade is a lot more like televangelism, Wally." The Brit woman was speaking.

"I bring comfort to the downtrodden. I take the heavy burden of owning a rare, underestimated antique from their shoulders, and I replace it with the security of government greenbacks."

The Russian said, "I've seen the way you network in the world of collectibles, Wally. You already know who will buy your goodies before you buy them."

"Why keep stuff sitting around?"

"Imagine what a team we'd make at the Paris flea market. Lucy has an outlet, quite a famous one these days. I have access to massive data banks, even if I quit the UN. I'm on a first-name basis with directors and curators of both famous and obscure museums. Plus, I've put away a lot of my salary over the years, in secure places and good American stocks.

"Your strength, Wally, is your ridiculous optimism, a nose for greatness, and a solid network of sociopaths_not to mention your wonderful ability not to care what people think about you. That gift gets you into a lot of places I'd never, never see."

"That's enough praise, Yvgeney. Think about the wonderful discoveries you've made."

"Saving art as a UN good guy is less about discovery and more about greed."

"Greed is good."

"You have a conscience, Wally, in a world filled with predatory opportunists."

"I'm a predatory opportunist."

"You're a lousy one. That's a positive thing. That's why I want us to join forces. We can build an enterprise based on honesty, skill, trust, and brains."

"Don't forget skullduggery. It's every good antique dealer's tool."

"And balls. Don't forget balls. That ability to be ignorant of embarrassment. The skill of walking up to famous people and causing a scene to get what you want. The knack of placing adventure ahead of personal relationships."

It is the woman, Chana thought, *still complaining about the scene her gringo boyfriend created in Braun's house last week.*

But it was true, she knew. Claus Braun was a confidant to presidents and kings. The idiot furniture salesman had shown him no respect at all.

Yet her master had stopped all conversation, even dismissing the esteemed professor, just to hear him talk. All over a chair. The gringo had apparently found something amazing, though she couldn't imagine such interest in something as simple as a chair. As a starving teenager in Sao Paulo, the value of a chair was the heat it would generate when it burned as she huddled in front of one of the many open fires that dotted the cold city at night.

"I think we've left Rae out of the consortium." The Brit.

"She'll be famous soon, all by herself."

The man, Wally, spoke. "She has a big magazine spread coming out soon, from the South America trip. In *National Geographic*."

"Rae, congratulations!" The Russian.

"You go!" The Brit.

"I can help this enterprise," said the photographer. "We can create sales and auction catalogs, in print or digital, and use my photographs and design skills. I'm excellent in the dark arts of promotion, but fame is not around the corner. Trust me. I'll be lucky if *National Geographic* finds enough usable shots to run the article. I lost half my work somehow, to a freakish light leak in a Puerto Montt hotel room."

Chana smiled as she listened.

That was I, gringa cucha. I was your light leak. Silly of you to leave your precious cardboard box plates out where I could find them in that heavy storage bag.

She had been assigned to provide security for the German, Schmidt. She had never seen him get so emotional. Her report on destroying the exposed photo plates seemed to relax him greatly. She remembered opening the little metal magazines that held the unprocessed film. One by one. A child of the forest, she could not imagine that a box constructed out of cheap cardboard could take photographs that were considered important when large, fancy cameras, some even with computers inside, were available. But orders are orders. The North American woman's career concerns were of no matter to her.

Gringo Wally was speaking, "This is not a good time to enter the fine art business, old buddy."

"Good God, Wally," the Brit, "don't tell him that. It's all he's talked about since he came back from Serbia."

"We're in the middle of a digital revolution. The garage mechanic and every shabby chic, white-painted furniture junkie with a digital camera can sell grandma's Stickley dresser on eBay these days. They can check for prices on the Internet auctions and find a buyer 1,000 miles away with a mouse click. We're headed for a time where loyalties, referrals, and good old-fashioned networking is a thing of the past."

"Wally, since I've known you, you've been complaining that loyalties, referrals and good old-fashioned networking are a thing of the past."

"See."

The Russian protested, "I've got connections all through Europe. The objects that I've run into during my UN years could fill Buckingham Palace."

"Were any of them for sale when you found them?"

"No. Most of the really great things were already in collections or in the basements of museums."

"Rule number one. Things that are for sale are far more interesting than things that aren't."

"You seem to find your share, Wally."

"Finding great things before they get to the Internet is really difficult right now. Selling greatness is always easy if you can get your hands on it, close to the source."

"I'm here because I want to finance a buying trip. You and me, partners," Yvgeney injected. "Are you interested, or do you want to talk me out of it?"

"You know, kids, I do know of a repository of great objects to find and get wealthy on. Fabulous things, still undiscovered. It's the mother lode of collectibles, and nearly no one is looking there. Do either of you speak Spanish?"

Chana hadn't moved from her dark spot. She was cold, but that was only a nuisance. The conversation in her earpiece was difficult for her to follow. All that rapid English was giving her a headache. All she wanted was a clue, a verbal clue to the whereabouts of the chair she'd been sent up here to retrieve.

"Portuguese? No matter."

"You are suggesting South America, the continent?"

"*Exactomundo, señorita.*"

"Consider the chair I bought there last week. I got it for about three grand, and it could be worth 30 or 40,000."

The listener perked up.

"You keep bragging about this invisible chair."

"You'll see it soon enough. My refinisher is a wizard. When I get it back, you would swear that Josef Hoffmann himself had just finished polishing it."

Chana's attention was now keen; her awareness of the cooling damp evening breeze was gone. She risked a penlight flash to check the recorder. Ten or so minutes of tape were left in the cassette.

Give me a name, gringo! A telephone number, or address for this refinisher, and you'll live out your miserable, greedy, capitalist lives, never knowing I was here.

"I have a photo of the chair still in the camera. Wanna see it?"

"Later," the Russian said.

"Tell me more about your undiscovered continent."

Rae, the photographer said, "I'm going to bed, folks. I know everything you're about to hear by heart. Need anything before I go? Lucy, did you find the towels and bedding I left out in the honeymoon suite?"

"Everything is fine, love. Sweet dreams."

After a chorus of "goodnights," a light in a back room window glowed briefly and was extinguished.

The Egg Rocker

The light rain had soaked down to Chana's skin. The chill didn't bother her, but her body was asking for food. Her stomach growled. A bag of tropical vegetables and fruits had been left as a gift in the back seat of the car rented for her at the airport parking lot. Familiar aromas had greeted her when she opened the door. It had been an unexpected gift from her Señor Braun. Essence of guava, papaya, and kiwi fruit filled her nose. It was a welcome reassurance in a strange cold country.

The fruit was still in the rental car, but that was two kilometers away, parked invisibly at a campground like the rest of the gringo tourists with their yapping dogs, loud beer drinkers and screaming children.

Chana had no fear of hunger pains. Hunger is like rain. As a child, she knew it as a second shadow, no more foreign than the one caused by the sun. One you saw, and one you felt. The shadow of darkness is the empty place on the earth where no light falls because it lands on you first. The shadow of hunger is another empty place. Both shadows seem to dissolve or sharpen at the whim of nature. As a child of the Brazilian streets, she had control of neither.

She sensed another mammal moving under the canopy of hissing evergreens. Very small. Very cautious. Prey.

Starlight revealed a field mouse, not comfortable in the breezy evening's noise. The tiny fur ball dashed into the open next to Chana's unmoving foot. It grabbed and sniffed an acorn from an oak tree up the hill and froze. The child of the Amazon Basin reached down, much to the creature's surprise, and picked him up in a gentle hand.

"Easy now, *rato pequeno*," she cooed.

With her right finger, she stroked the tiny back and felt a mini-shudder. Then she felt the tiny panic subside and relax into the first feeling of safety the mouse had ever known. Chana felt the tiny mouse's calmness and surprise.

"There's a *gato* out there who wants you for dinner, little cousin," she said softly, trying not to frighten the tiny creature with her human voice.

Her hand was cupped like a cradle.

"I'll bet it's always scary to be this low on the food chain," she said quietly. The sounds of her voice were high and melodic.

With a practiced motion of the wrist, she pinched the head in a soft reassuring grip and twisted the neck until the snap. She popped the little corpse into her mouth and swallowed him whole in a big gulp.

"Thank you for your visit, and your gift," she said.

She returned her attention to the tape recorder. She figured would need a tape change soon.

"And just two weeks ago, Yvgeney, in the middle of nowhere, in Argentina, I got a line on a Stickley–type chair that no one knew what to do with. It's supposedly sitting in a picker's house in a village called Jose de San Martin. Got turned on to it by an old fart in town where I picked up the egg rocker, for Christ sakes. Half of Chile and a bunch of Argentina has been settled by Europeans over the last 200 years, so all of their stuff is here for the picking, too. And their economy sucks right now, I think, so I'm sure we'll be buying right."

Chana noticed that the English woman finally got a word in, "Do you think you can find Eva Peron's lingerie collection, and the handsome chest of drawers that held it? I could use a show-stopper for my Paris antique booth."

"We'll put it on our list. It's all about networking."

"How about Nazi bigwigs?"

The Englishwoman again. "I bet they brought in some of that loot that Yvgeney chases after. Or used to, right, darling?"

Now the Russian spoke, "I don't expect that anything large or delicate ended up in the valises of fleeing war criminals. Maybe a little chair or so, or a small sculpture, or a little painting. I expect that escaping Nazis traveled with as much cash, gold and jewelry as they could get their hands on.

"I suspect the number of actual war criminals who managed to reach South America is pretty small. They captured Eichmann and found the bones of Dr. Mengele, right? There weren't that many high-profile Germans not accounted for.

"Most of the stolen booty from Europe ended up in Germany, before it was re-stolen by Russian and American museums. At least that's where I found most of it in my previous work."

"Don't forget the egg rocker that I brought back from Argentina last week disguised as a big box of luggage, Yvgeney."

Chana's mind opened again with the mention of the egg rocker nestled among the stultifying Anglo jabbering in her earpiece. She snapped a fresh tape into the recorder in time to catch the next sentence.

"Ah, the mystery chair again."

"Want to see a picture of it? It's still on my digital camera. I've got to download it onto the computer so I can e-mail a snapshot to this big shot in Chile. He's pestered me three times since I got back. Wants to buy it. I promised him a photo, but I'm keeping the chair, for now, anyway. It's right over there … let me show you."

"Wally, we're beat, love. Why don't you show us another time, when we don't have our time zones in a bunch."

"Tomorrow, then?"

"Sure, love. Ready, my Russian bear?"

"Just a few more moments with Wally, Lucy. We have a long year to catch up on. I need to chew the fat, as they say."

"I'm off, then. I'll leave the light on."

The back door opened. Chana watched a flashlight track lead the British woman to the *cabaña*.

She went back to listening to the two men. The Russian was speaking. Good. It was less painful to listen to his halting English than the annoying twang of the Anglo.

"I know some people. There's a guy in Mexico City that worked some assignments with me in Europe. He's an old soldier from Interpol, near retirement. He's always offered to show me around his country if I made the trip to Mexico. He knows art and antiquities, too. He's arrested some of the art thieves I uncovered with UNESCO. He knows Mexico City. It might be a good place to put our nose to the ground and begin our canvas of the continent. I have an old habit of starting a search on the periphery and working inward. I found you that way once, up in British Columbia."

"Mexico City, huh? I like it. I've heard there's a huge flea market there that fills a plaza on weekends. It'll be like shooting fish in a barrel. I propose that you and I begin a picking trip through South America by starting in Mexico City with a visit to your pal there. See what he can scare up for antiquities contacts. Then we'll fly to a handful of cities, like Buenos Aires and Rio and see what we can turn up. Your money, my skills, fifty-fifty split. Right?"

"After expenses, comrade."

Chana knew Mexico City. The Future Club had a cell there. She had helped to train the new recruits at that chapter before she became the right arm of Claus Braun. His sword. The most dangerous person that Chana had ever met was discovered at the Mexico City Future Club. Manuelita. Chana admired her ruthlessness.

Manuelita's mantra was, "Another street urchin kickin' ass."

She was in Indonesia this year, Chana recalled. More Future Club training. She was the trainer.

Chana watched the back door open, flooding the misty yard with light. The Russian loped gracefully across the dark gap to the glowing window of the guest shack. She couldn't see a weapon, but it didn't matter; she was finished for the evening.

She thought the chilly evening had been worthwhile as she jogged the two miles back to the state park campground and her rental. *I know who has the chair, a man named The Refinisher, but I don't know how to find this man. I know that the gringo and his amigo are planning to travel to Mexico City, and perhaps South America, next week.*

It was time to make a phone call.

Wally flicked on the computer monitor on his way to bed and opened the mail file. There were two more messages from Claus Braun. The first upped the offer to $30,000 US funds. The second asked if there was anything in his house in Chile, including the pair of *Sitzmachines* that Wally had liked, that he would consider in trade.

Now the conversation was getting exciting. He clicked a "thanks for the e-mail" response, observing the etiquette of the Internet. He headed for the bedroom through the dark, familiar maze of original Stickley furniture.

Chana opened the cell phone that Claus Braun had provided. A familiar voice answered.

"Hello, sir. Am I waking you up?"

"No, Chana dear. I was catching up on my correspondence. How is the assignment going? Are you safe? Do you have the chair?"

"My safety is of no concern. I don't have the chair in my possession. The gringo has placed the chair in the hands of someone named The Refinisher. Only the gringo, Wally, knows the identity of this man. He claims the refinisher has magical powers."

"The refinisher is the name of a man who removes paint or repairs wood damage to antique furniture or works of art, my sweet child. How do you come to know these things?"

"I installed a microphone and a transmitter in the gringo's house. I'll bring you the tapes of the conversations because you know more English words than me."

"Was everything you needed provided in the car waiting for you in Seattle?"

"Yes, sir. Thanks for the fruit."

"You are very important to me, my dear, very valuable."

Chana said, "I think the gringo and a competent adversary who is Russian plan to travel to Mexico City soon. Yvgeney is the name of the Russian. They plan to search for more chairs, and I think they plan to go into South America to explore a network."

"We have good people in Mexico City."

"I know, sir. Manuelita came from those streets."

"Ah, Manuelita, my Mexican weapon of mass destruction."

"Yes, sir ... sir?"

"Yes, my child."

"The woman photographer, Rae Roberts, was overheard saying that no one knew of the refinisher's identity other than the gringo, Wally, himself."

"Well, we'll just have to make sure he stays safe until the chair is returned, won't we?"

"Yes, sir. I will try to maintain his safety until the chair is secured. Do you want me to kill them after I have the chair?"

"We'll see. It might depend on how much fuss the gringo causes when he loses his treasure. Use your own judgment. I don't want to be on CNN. Not yet."

"What if these men fly to Mexico City before the chair returns?"

"I believe you should follow them to Mexico. I'll make the arrangements for your passage in case it's needed. Be safe. Stay with the gringo. Wait for the chair to be returned and send me the tapes in the morning by overnight mail."

"Yes, sir."

Chana liked the gringo's *gato* she'd met in the woods. The one he'd called Frida. She considered taking the cat home to Chile as a pet when her job was done.

Chapter Twenty-Three

Mexico City, Mexico

Flaps whined and dropped as the aircraft descended into a blanket of Mexico City smog. Wally watched a church steeple protruding valiantly through the rusty brown inversion layer like a lightning rod to God's love. Sunlight illuminated the industrial fog as it replaced the deep blue dome of the sky above. The aircraft interior glowed in the sepia-lit windows.

The blast of hot kerosene-scented air was expected, but still a shock.

"What does your friend Julio look like?" asked Wally. "Maybe I can spot him."

"He'll see you long before you see him, believe me."

"I have the eyes of a condor, comrade. Remember what I do for a living."

"He used to be as fat as Diego Rivera. I suspect he's unchanged. He's over two meters tall, also. Hard to miss."

Julio's toothy jack-o-lantern grin was indeed hard to miss above a sea of short, dark-haired greeters. Wally had been scanning the semi-modern airport interior looking for vulnerable public art when he spotted the Mexican looking back at him. The three men converged in front of a Starbucks booth.

"Wally Winchester, meet Julio Ignacio Martinez, the greatest policeman ever to nab an international criminal."

A thick, warm hand enveloped Wally's clammy fingers in a confident squeeze.

"Hello, amigo. Julio Martinez at your service."

The substantial black mustache dominated an oversized Mexican lip and cascaded over large perfect teeth. Wally looked upward into cavernous nostrils under deep-set eyes and a tangled mat of dark hair. The man's voice was as deep as his Mexican wrinkles.

"Welcome to Paradise, my friends," he bellowed clearly over the mind-numbing airport din. "Yvgeney, you look terrible. You're too thin. Doesn't Serbian food agree with you?"

"It's not that, Julie, it's all the sex."

"Nonsense. If too much chucha made a fellow thin, then I'd be a walking skeleton." He turned to Wally.

"Hello, Mr. Winchester, I hear you're on a mission to liberate Latin America from the burdens of European treasure."

"I'm here to help."

Chana blended with the airport crowd and remained invisible as she watched the three men retrieve suitcases from the Air Mexico baggage area and head for the parking lot.

The road from the modern airport started out as a wide, new, flat black asphalt boulevard reflecting the shiny face of international trade. As Julio drove toward Mexico City, the potholes, trash, and despair took over the landscape like a barely audible sigh.

The smell of 20 million souls quickly filled the aging, dented Honda four-door that Julio squeezed into as he sat behind the wheel. He darted recklessly among the increasingly thickening traffic on the rapidly deteriorating road surface, driving around lorries and Mercedes

town cars and donkey carts with little regard for safety. Wally thought the Mexican treated each encounter with oncoming traffic as a macho contest he wasn't afraid to lose.

"*Chingate!*" he yelled as an approaching bus forced him back into his own side of the four-lane jousting match. Bright-colored slum markets and tin shanties whizzed by. Listless men and stoop-shouldered geriatrics lounged and argued and sat, ignoring the hundred-degree heat and the ground cover of discarded paper and plastic and empty Fanta cans that mangy dogs and unwashed urchins sifted through, hoping for a lingering meal. Wally longed for the cool quiet of an air-conditioned ride. Instead he got warm, funky-smelling air and snatches of salsa music from a thousand boom boxes and the frequent crunch of tires over litter.

"Excuse me for asking, Julio, but my Russian friend here tells me that you have a lofty position in the UN as a crack Interpol detective. Why do you drive this old clunker?"

Wally heard the hearty grunt in the back seat where he sat and sweated. It might have been a laugh.

"Did you notice, my friend, that when we left the airport to go to the car that it was there? The guys in BMWs, they wake up every morning with their fingers crossed, hoping their little prize is still in the parking stall. No one, not even the *barracuditos* want what I've got. Why steal this *merde* auto when there's a compact disc player in the German car? Besides, in these streets I drive with more courage in the game of—how do you say it, Yvgeney? Russian roulette."

"In Moscow," added Yvgeney, "in Moscow one doesn't leave anything, even the windscreen wipers on, or in, their vehicle at night."

"What is a *barracudito*?" asked Wally.

"Ask your Russian partner. He got nipped once."

Yvgeney turned toward the back seat. His face looked tired, long creases and dark eye sockets exaggerated by a long flight and the heat.

"Bands of children, piranhas of the streets. Thousands of them live in the shadows here and in many other Latin cities. They have nothing to lose like my Julio here and this car. In bands of 10 or 20, they are as dangerous an opponent as you can face. They strike, steal, and melt away. Almost impossible to apprehend, they risk nothing. A perfectly formed adversary. They act in concert like a swarm."

Wally said, "I think I can handle myself in a confrontation with a handful of grade-schoolers. I used to be a substitute teacher."

"These children have never seen the inside of a school, believe me, señor. Nobody in this city should be underestimated, even the so-called police."

Without warning, the Mexican angled up a ramp onto a modern road elevated above the surface streets.

"This is more like it," Wally remarked, happy to be away from the depressing barrio behind them. A large cityscape of high-rise modern buildings loomed ahead through the haze.

Yvgeney and Julio exchanged knowing looks, as if they'd had this conversation before.

Julio spoke. "*Bastardos*, the Mayor, just spent 20,000,000 pesos to build this overpass."

"I think it is money well spent," Yvgeney added. "Shows the world that Mexico City is a place on the move, encourages joint ventures and foreign capital. Mr. Jose Q. Proletariat here disagrees. He wants the money to be used to buy happiness for the poor."

"Hey, you're the Commie, Yvgeney," Wally said. "What's wrong with helping the poor?"

"I'm a fan of private enterprise. Always have been, Wally, I don't see you shirk away from making a buck. There are ten million

poor people in this city alone. This big Mexican here," he jabbed Julio in the ribs, "and I have debated this point since construction began ten years ago. I think 20,000,000 in any currency for an elevated road that rides above the poverty goes a lot further than giving it away. What would you do with this 20,000,000? Give it to the poor? As what, a rebate? Good idea Julio, give each of them three dollars cash and see how their lives improve. Everyone gets a free drink and the money's gone. Here, at least, their imagination can take form."

"Sure," answered the driver, "they can look and see the Mercedes Benzes zooming by overhead and their lives will improve. Maybe a string of schools or a city-wide childcare system to allow the mothers to work and we wouldn't have the barracuda problem."

"Hey, stop it, you two. We're here to find antiques, not save the world," Wally said. He couldn't stop from tilting his head as he considered his two-year acquaintance with the Russian.

The exit sign said San Angel. A range of low dry hills disappeared into the 20-mile cloud of brown-red air that covered the city. Wally noticed lots of greenery. Substantial homes tucked into the tropical foliage suggested easy access to water. The section of the city seemed both old-fashioned and gentrified. Many people milled about the central park across the plaza from a Spanish colonial church with baroque spires. Citizens seemed content. Lovers kissing. Families walking together. It seemed oddly out of place with the huge mass of people here on the polluted plateau. Wally figured there were many such neighborhood oases in Mexico City, and scolded himself for judging a metropolis by its slums.

The neighborhood road tunneled into lush foliage as it met the forested crown of an urban hill. Under the trees, the temperature dropped noticeably; the flower-scented breeze through the windows felt good.

A Spanish-style home sat in a lush tropical garden at the end of a long driveway; they caught glimpses of the city far below through gaps in the banana trees.

Wally noticed security measures that started with a remote-controlled gate and ended with a very solid door operated by a keypad.

Yvgeney said nothing. A brown-eyed beauty met them, opening the massive metal-strapped teak and ebony door as they approached. She gave a dutiful kiss and embrace to the big Mexican, smiling and mugging to Yvgeney over her husband's shoulder.

"Maria, please welcome Señor Wally Winchester to our home. You know, of course, Yvgeney."

The woman offered her cheek to Wally. He had been to Chile. He knew the drill. He kissed one cheek. His buddy followed with some familiarity.

She spoke in Spanish-accented English. "Welcome, Señor Winchester. Hello Yvgeney. You look just fine for a UN guy who's gone toe-to-toe with Slobodan Milosevic."

"I guess my story precedes me," the Russian said.

"We're in the UN family, Yvgeney. We pay attention to our losses. Sorry about your friend."

"Thank you, Maria."

As he entered the house, Wally found himself surrounded in good taste. The furniture was native to Mexico and had bold style, new, but well thought out. Colorful artworks dotted the walls, suggesting that Julio and Maria filled their home from high-end contemporary local galleries. The lighting was clean and new, aiming illumination where it was needed. Large Oriental rugs covered the tile floor.

After a round of rum-filled tropical cocktails, he listened as Yvgeney and Julio swapped UN news stories, rumors, and international crime scuttlebutt.

Julio was sort of a policeman without portfolio. He worked in an Interpol Foreign Section, investigating everything from high-seas piracy to terrorism. Yvgeney's UNESCO group recovered stolen art and cultural artifacts. Their paths had crossed frequently and their friendship had grown.

Wally and Maria sat back sipping their drinks while the two detectives chatted, trading yarns and gossip.

The world, thought Wally, listening to the conversation, *is a small planet indeed*.

"I heard that the German art forgers who worked out of Vancouver Island were finally prosecuted," Yvgeney said to the huge Mexican.

"Not really. Three years each in prison's all they got. Frustrating, but at least we shut them down for a while." He paused. "The murder of your friend Valerie in Serbia is still open. Sorry. There's a lot of politics in the Balkans. It's hard to pin a conviction on a dead Serbian leader for the actions of his caretakers."

"Bastards."

Wally spoke up, eager to swing the talking toward antiques.

"How's the flea market scene here in Mexico City?"

The question was directed at Maria. Old UN story-swapping was fine with Wally, but the itch to scare up something wonderful was the reason he'd come south.

"There are many wonderful markets in this region, Señor Wally. Our own little village here is quite famous for its weekend market. It begins tomorrow morning."

"The boys have come down here to shag antiquities, my dear." Julio gently stepped into the conversation. "I am to be the first link to their new Latin American network. Our local market may seem tame."

She said, "There are occasional antiques that appear here in the hill market. I've seen some wonderful textiles show up, and once a concha belt to make even Maximilian proud."

"From what Yvgeney tells me, dear, they're after bigger fish," said the big man in English. "European greatness, not local crafts, even old ones."

Julio seemed reluctant to correct her even in familiar company. Wally watched the Mexican as he chose his words carefully.

"Our heritage is not local craft!" Her eyes narrowed as she glared at her husband. "Great art was being made in Mexico when Europe was up to its lily-colored neck in feudalism, ignorance and intellectual despair. They called it the Dark Ages over there."

Her cheeks flushed red. Eyes opened wide.

Julio's sleeping on the couch tonight, thought Wally.

Their host looked to his visitors, then to the sofa, and shrugged. Wally understood the gesture.

Julio said, "Wonderful and valuable things have occasionally turned up out here, gentlemen. My wife is correct, but there are two principal exchanges in the heart of Mexico City where serious buying and selling of expensive treasures takes place. One is *Mercado la Lagunilla*, called the thieves' market. North of the *Zocalo*. It's said that if criminals burgle a house on Friday evening, the owners can find their things and buy them back at *Lagunilla* on Sunday morning. The other is *Bazar de Antiquedades*. It's been a marketplace for treasure for 150 years, maybe more. Of course, most of what gets to these places comes from local wheelers and dealers. That's the network that I can possibly help you to log into. I'm a policeman. Most of my professional time is spent investigating bad men, but that gets me into a lot of neighborhoods where art and antiques are collected." Julio turned to his wife. "That's why they need me, sweetheart. My

profession brings me into interesting homes. The availability of great things is usually a narrow window, just like amazing women!"

To Wally's surprise, Maria kissed his huge unshaven jaw.

"When does the thieves market open?" Wally asked.

"It's a Sunday market, but the stalls are permanent fixtures. Spaces at *Lagunilla* are inherited like family heirlooms. It's rare when one changes hands. They open at six tomorrow morning, señor."

Yvgeney winced at the mention of the hour. Wally, running on picker energy, perked up. He asked, "How do I get there from out here? Is there any public transportation?"

Julio said, "You should not go there alone, Señor Wally, not without Spanish language skills and someone to watch your back."

"I can take care of myself, thanks. You UN guys seem to think that anyone who's not an international cop should not walk the streets alone. I've got 20 years of mean times at the Brimfield Market under my belt. Nobody's killed me yet."

Yvgeney said, "Seen a lot of extreme poverty around Sturbridge Village in the summer, John Wayne? There are people in this world with nothing, absolutely nothing to lose. You don't meet these folks during your long frustrating wait in the latté line."

"I cannot join you *mañana*, señor," Julio said. "I have an early meeting on some new information that's coming out of Chile. I recommend a good night's sleep and a visit to the local market here in our San Angel. If you insist on visiting this market, there are bus routes into the city, but Yvgeney is right. It's not a place to be on your own with your skin color and your vocabulary and a wallet full of money or bankcards. There's no hurry, my friend, they're old, and these things you seek have been around hundreds of years. This is Mexico. Nobody rushes about down here without good reason."

"All right, all of you, I'll relax. The local market will be enough to get the boogieman out."

"Boogieman?"

"I've got a jones for finding neat objects."

"Jones?"

"Never mind."

The evening sunset showed through the copper air below them in the vast Mexican population fishbowl. A million souls went to sleep without a proper supper. Wally, Yvgeney, Julio, and Maria feasted on Canc_n prawns and local vegetables in a fiery red sauce and downed Cuervo Gold margaritas while the UN buddies chatted about European art crimes.

Chana observed the entrance gate from a grove of low fruit trees. She made herself comfortable and ate a green banana she found over her head. She turned the hood up on her poncho.

Chapter Twenty-Four

Mexico City, San Angel District

At dawn, Wally leaped up, as was his habit on flea market days, energized even before his first cup of coffee, and walked on stocking feet across the hardwood floor. He brushed his teeth, grabbed his floppy explorer's hat, stuffed his money belt with about $2,000 US cash, and patted his back pocket for his wallet and ATM card.

Despite the early morning hour, a full-blown flea market setup greeted Wally as he walked down the winding cobblestone street toward the town center. The smell of tropical blossoms filled the warming air. Bird sounds mixed with the clanking and banging sounds of table and booth preparation. The market was an indoor venue as well as a large, open common area with a statue of a conqueror in the center.

Wally saw few things being uncovered or unwrapped that held the interest of a savvy antique predator looking for Christie's auction items. Fruit and flower peddlers ruled the open space.

He spent a few minutes at the jewelry tables to see if any Spratling-designed art deco ornaments from the great Tasco silversmiths of the 1940s and 1950s had found their way to the sleepy village square. All of it was new.

Fifteen minutes into his walk, he concluded that no truckload of low-priced artifacts from another century would show up today. He saw a taxi and approached the sleeping driver.

"How much?" he asked into the open window.

The driver wrinkled his face, apparently ignorant of English. Wally reached into his bag of handy Spanish phrases and came up with, *"Quando dinero a flea market de Lagunilla?"*

"De Lagunilla? Si. Claro."

The man's face was now lit with the thought of not only a big fare, but a big stupid Anglo fare. No translation was necessary now.

"Dos ciento pesos, Señor."

"Two hundred pesos?"

Wally crunched his peso math. Thirty-five dollars.

"Let's go, amigo," he said.

The driver raised his eyes to heaven and opened the back door.

Chana panicked when she saw the taxi transaction. Her instructions were to keep the gringo alive till they found the chair. She raced for her rental car, parked two blocks away. After 15 minutes of frantic driving she spotted Wally's cab heading into the heart of the city.

This is more like it, Wally thought as a narrow street opened to a vast open area dominated by exposition buildings. Acres of stalls angled off in all directions from a series of concrete Quonset huts that had been built a century ago.

Me against a thousand pros. Just like 5:00 a.m. at Brimfield flea market with a flashlight and a pocketful of cash. I love the odds.

185

He paid off the cabbie with an American 50 without questioning the handful of peso notes he received in change and waded into the melee. Screw the language barrier; fuck a bunch of safety issues. These are his people. He could swim in the ocean of crooks and swindlers and keep his head above water all day long. He'd been trained by experts.

Chana rolled her almond-colored eyes when she saw where the gringo was headed. She knew the realities of Mexico City. Her job just became more difficult.

Wally quickly determined that most of the interior booths under the cement aerodrome were old established dealers who knew exactly what they had and how much each piece was worth. He assigned them a low priority.

It took a few minutes for Wally to understand the layout and the hierarchy of the setup. Priority number one is fresh items sold by rookies or people who do not know the value of what they are offering. By experience, he knew that these people are usually concentrated at the edges after the good spots are taken, where the pecking order pressure is low. As the sun rose above the central cathedral, Wally found himself in the still-deep shadows of the outer plaza. He imagined himself a wolf at the edge of a caribou herd, waiting for the vulnerable cripples to fall behind.

Away from the throng of shoppers, empty spaces of the plaza were bordered by old brick buildings flanking dark, shadowed alleys. As he paid attention to items and tables of new arrivals, Wally didn't notice the street kids until he was surrounded.

They made no sound. He felt a sharp sting in his backside and turned quickly to see a gaggle of three-foot high children holding box cutters.

"Jesus." He turned quickly toward the throng of market people. Thousands milled in the plaza beyond, but with these crowds came the cacophony of the marketplace, complete with music, shouting, and a thousand conversations.

This is broad daylight, for Christ's sake.

Another sting.

He yelled: "Hey! Get the fuck away from me!"

As he turned, tiny villains quietly surrounded him, each with blackness in their determined eyes.

"Ouch!"

More cuts, now from three sides at once. Lots of hands pulling at his clothes. "Help!" Wally screamed in pain, but the few adults who were within earshot froze.

He spun and tried to kick and swing his fists at the attackers but that only earned him two deep quick cuts on his forearms. His pants fell down before he could catch them. The money belt was gone. A ragged remnant of his shirt hung in tatters off his shoulders, the front pockets slashed.

As quickly as they'd appeared, the children were gone. Wally looked helplessly down at ruined clothing and red-stained arms. In the distance he thought he heard the trilling of a police whistle as he lost consciousness and crumpled to the cobblestone plaza floor.

Chana watched the street attack of the gringo she was expected to protect. Even if she had wanted to help the Anglo, the attack was too fast for intervention.

"Hello, honey. I'm calling from Mexico City."

"Hey, Mr. World Traveler, found any Mexican Mission oak yet?"

"No, babe. Actually I ran into a little trouble this morning and I need you to cancel my credit cards and set up a new ATM account."

"Are you all right?"

"I'm fine. You know I'm indestructible."

"Oh my God. Are you hurt?"

"Not really. I'm a child of the mean streets back East."

"Did you get mugged? I told you to be careful down there."

"I'm OK. Just some cuts, that's all. And a bump on the head when I fell."

"Wally," she gasped. "You got cut? Oh my God. How bad?"

"A bunch of stitches, they tell me. They say I lost a little blood. Sort of passed out, they say."

"Sort of passed out? Lost blood?" The words in his ear were an accusation.

"I'll be OK. Don't worry. I'm not in any danger, just a little woozy and a little embarrassed. They say I was out cold, embarrassingly exposed when the police came."

"Wally, you promised me. No ladies! You bastard."

"No, no, babe! I was mugged, in a way, by a gang of nine-year-olds. They cut my clothing away, took everything I had."

"Nine-year-olds?"

"Nine or ten. Lots of them. Trust me. It wasn't like recess in the third grade."

"Are you drunk?"

"No, this is all real, although the whole thing feels surreal."

"Holy shit!"

"Exactly."

"You're sure you're all right. Anything else you haven't told me?"

"No, I'm going to be fine. Yvgeney's here. The doctor said no problem. This is just a big wakeup call."

"I want you to come home, now."

"Really, I'm all right. I get out of this hospital tomorrow. Think of it as a really long office visit, nothing more. I'll just be more cautious now. Yvgeney's got lots of cash still. I just need a new ATM code so I can do my thing. I'll need a replacement card. ASAP. They'll only send it to my Camano Island billing address. You can send it to Yvgeney's friend down here. I'll give you the address. How are things at home? How are you?"

"Everything's fine; you got another call from that guy in South America, Claus Braun. He still wants that chair you've got stashed at your refinisher's. I told him you were in Mexico City. He told me his bodyguard, that redhead we worked with at the site, Chana, is also in Mexico City. You met her. He wants you to call him. Says he's got a new offer."

"That asshole, I don't want to sell the chair. You tell him that?"

"Yes, Wally, I did. He said, please have him call. Collect. He gave me the international operator's number for the connection."

She recited the number, a long string of digits, as Wally called it out for Yvgeney to record.

"I still want you to come home, now."

"I know, love, I'm fine. This guy Julio knows about some good stuff in Panama. Yvgeney says we're still working."

"Damn you! I love you."

"Ditto. Bye"

"Come home!"

"No."

"I tell you, Yvgeney, you and your friend are crazy to expect to get rich finding great antiques in South America. It's sheer folly"

"I found a $30,000 chair in South America on my first try," Wally said. "Who knows what's been brought here from Europe over the years? I root out greatness like a truffle pig, Julio. The stuff's down there and no one's looking. It's an untapped resource."

"It is a dangerous thing you attempt, señor. Look at your wounds."

"Yvgeney's a soldier."

"You are not. Please wait for me to return next week. Perhaps then I can join you for a week of so."

"Search your memory, Julio," Yvgeney said.

Wally said, "Been to any really good yard sales in Medellin Cartel country? Ever run into any piles of gold leaf furniture while busting a corrupt official? Can you remember any artifact smugglers who had a taste for Tiffany lamps?"

The Mexican tilted his mustached face up and looked at the ceiling for his recollections. He said, "The most amazing collection of expensive objects I've seen was in a villa deep in Panama, half way across the Darien Gap. I wouldn't recommend trying to reach it, if I were you. The Darien is a dangerous region."

"Tell me more," Wally said.

"It belonged to a drug cartel underlord. This guy was different, he had, as you North Americans say, style. He had a gate to the main house, they say, that eventually ended up in the collection of an American art deco specialist. They say it was worth 2 to 3,000,000 dollars."

"For a gate?"

"For this gate, yes."

"There's another collection of fine antiques I've heard about, a famous guy in Chile that Interpol is keeping an eye on. I was told he an amazing house with important art on every wall. I can't talk about that one. It's something I'm involved in. Inappropriate to discuss, even with you. I probably can help you with the Panama mansion."

"We'll need a guide," Wally said.

"I know a broker in the Canal Zone who may be of help to you there."

Yvgeney jumped in: "I want to know more about the man from Chile."

"You're retired, amigo. Remember? It's only rumors and fancy thinking at this point. There's too much at stake, too many reputations on the line."

"Even with me?"

"Especially with you!"

"Come on, Julio! We've worked together before, what harm can I do? I'm, as you say, out of the loop now."

"Exactly why I can't talk about it, my friend."

"Bastard."

"There's this other guy I've met in Buenos Aires ..."

Three days into his recuperation, Wally called Claus Braun to ask him what he wanted.

"I want your chair, Mister Winchester, of course. But, also I want to be of assistance to you."

"I'm afraid the chair is still off the market, sir."

"I expected that response, señor. I, too, am a collector, as you witnessed when you were in my country. My solution is still in the works, as you say. The serious collector's only real weakness is the offer of something even more desirable. Am I right?"

"It's going to take something really amazing to get me off the egg rocker, sir," Wally said. He wondered idly what such an object would be. He knew that Braun was correct. It was just a matter of what was more important. "Go on."

"Your wife tells me that her photo essay about the discoveries down here will be published next week, despite the loss of many photos. She is a remarkable woman, Señor Winchester, but I'm sure you know that."

The comment was phrased as a statement of praise, but Wally detected an ominous note.

"She also tells me that you're in Mexico City. Are you on the prowl again in my continent? I regret that my interests keep me from doing the same. I'm sure that nothing of value south of the border is now safe."

Wally uttered a guarded "Thank you!"

"I would like to offer you some assistance."

"In what way?"

"My ... security chief ... is also in Mexico City, as we speak, doing some business for my foundation. Perhaps she can accompany you and act as a translator and a guide. She is extraordinarily competent and not without her own influence. She speaks Portuguese, Spanish, English and, of course, her own indigenous Amazon language. You met her when you were here in Orsorno and, of course, at the archeological site."

"The girl, Chana. The cute redhead. My wife mentioned her the other day."

"Don't underestimate Chana, señor. She is formidable as an ally in a tough spot. I trust her with my life and so can you. It's a dangerous place down here, nearly as dangerous as your United States."

"I'm fine, sir, and I'm not worried about my safety."

He glanced down at his stitched and bandaged arm wounds. Last night after a painful shower he'd checked himself out in the mirror and decided he looked like an ad for a zipper company.

"I'm traveling with a competent partner, ex-Russian Navy man. He's brave, strong."

"Please consider. Chana can get you into places no gringo would ever see. She's a native and quite savvy. Very self-contained, that girl. She'd be an asset. She even has her own credit cards. She's officially on Future Club business, but she could flex her schedule to accommodate you. Think about it, please. It is my gift to a fellow collector."

"I'll consider it, thank you."

"Where exactly are you going on your search?"

Wally hesitated, then said, "We have many avenues to explore."

"If you intend on visiting Colombia, Panama, Brazil, and Venezuela, she will save you many steps. She knows the natives in many regions as well as those in political power. My influence will be an asset to your journey." His voice lowered. "Perhaps I can even send you to some of my personal contacts in the antiquities world. As I said, I am far too busy to be in the chase these days."

"Hmmmm."

Wally debated consulting his partner and made a decision.

"I accept your offer, and the help of your security chief as a translator and liaison. Chana."

"Chana."

"Give me the address, Señor Winchester, and she will contact you tomorrow."

Wow, Wally thought. *Now to break it to Yvegeney.*

Their trip would have a different face now, he knew, but it was the kind of connection that they'd hoped for, an open door to the insider's network.

Chana was on the phone.

"Hello, sir, how are you tonight?"

"I'm well, my dear, and I have good news for you," Claus said to Chana.

"Thank you, I look forward to your news."

She spoke with a normal voice into her satellite phone because the evening rustle of vegetation covered her spoken words.

"The man you're watching, our Mister Winchester, has accepted my offer of your assistance as a translator and personal security aide during his journey with his Russian Navy friend. You can now protect him without covert action. You will travel as an equal. No more cold bivouacs, Chana. You get to travel like a gringo tourist.

"I prefer the cold forest floor."

"I know, dear, that's why I love you."

"Thank you, sir."

"You may even gain the opportunity to find the location of my chair during normal conversation. At that point, your involvement with these people will be done."

"I look forward to being at your side as your protector and sword."

"I'm worried about the Russian you described. A skilled military person, you say?"

"Yes, military smart."

"Can you take care of yourself against two men?"

"I will be easily superior to these men in any combination. What means can I employ to find the location of your chair?"

"Do whatever you have to, my child. I will respect any action you take to help us in our goals. I trust that your judgment will keep the prize as the main priority."

"Thank you, sir. I have skills in areas that you have never had the opportunity to experience."

"I'm sure you do, my dear. I'm sure you do. Use whatever it takes."

"Yes, sir."

"You've done what?" Yvgeney asked.

The house of Martinez once again had provided a sumptuous table of exotic fruits, fresh fish, and local vegetables, steaming in brightly colored ceramic serving plates.

Wally's bandages were off, with stitch removal scheduled for the next day. The clean sharp cuts had healed with little festering. He looked at them as more badges of courage to show off to the neighbors.

"She's a translator and a local. Her employer believes she can get us into many regions we may need to travel to, Yvgeney. She sleeps outside."

"If I need a pet, I'll buy a dog."

"If we accept her company, Yvgeney, we gain access to Claus Braun's antique network. That's why we're here, you know. We need connections like these."

"Who is this Claus Braun? And why haven't you mentioned him before?"

"I talked about him, I think. He's the guy who wants the chair I just brought back from Chile. He's bending over backward to get on my good side so he can talk me out of the chair. That's why, I figure, he's offering this woman's services."

"In the Russian Navy, having a woman on board is considered bad luck. What's Rae going to say?"

"Hey, he offered a translator, not a hooker."

Wally continued, "I'll tell you what, comrade, she's coming over tonight. After we all meet, you and I can have a meeting and decide what's best."

Julio spoke up, "Take the backup and be glad. Wally's little adventure at the market is not an exception. You two are much better off traveling with a Spanish-speaking local, and, according to Wally, a pretty one to boot."

Maria's eyes narrowed.

Yvgeney said, "Julio has suggested a villa in Panama as our first destination. Perhaps she can help us on the first leg at least."

"Braun said that she knows Panama."

"Well, let's meet her."

Chapter Twenty-Five

Panama City, Panama

The man named Balifor, who met them in Panama City, was agitated. He spit out Spanish at Chana, who looked back at his corpulent face, unblinking.

"He says we are fools to venture into the Darien Gap, Señor Wally," Chana translated.

"Ask him what steps we should take to get to this villa without danger," ordered Yvgeney.

She turned back to a sweaty Latin American in a wrinkled suit and said, *"¿Qué caminamos debemos tomar tyo conseguimos a este chalet sin peligro?"*

He answered in a long string of Spanish words, gesturing with a finger across his throat.

Chana turned back to Wally: "He says that danger is not only unavoidable but probably guaranteed. Your only choice may be the option of which death will cause less suffering."

"Ask him what steps will minimize our exposure."

"Exposure?" She asked the question wearing a blank expression that Yvgeney found unnerving. Their translator had not smiled or granted either man any warmth other than a dutiful blank stare since the moment she stepped into the Martinez house in San Angel three days earlier. He hadn't mentioned his unease to his partner.

"Exposure in this case means vulnerability. Do you know this word?" Yvgeney said.

"Yes, very well, señor."

She translated and then waited through another lengthy response.

"Señor Balifor suggests four armed men to travel with us and all-terrain vehicles to get there since this is the rainy season and not a good time to travel. He also suggests 1,000 American dollars as bribes to at least three public officers in the villages we will pass to get there. He also emphasizes that 1,000 dollars, US, given to him as a consultant, will help ensure that the trip will not end in tragedy."

Yvgeney said, "Tell him the price is outrageous."

Chana frowned and spoke quietly to the man in Spanish. Yvgeney heard the words Señor Braun. He noticed perspiration run down the Panama trader's neck. The man spoke back, but with less volume.

"He adds that he will gladly do his part in ensuring the success of our venture for no charge, and perhaps a smaller sum will grant us safe passage through the villages, but we should not assume that the present owners of the villa will sell to us any of its contents, though he will encourage them to do so."

"What if we don't hire the guards or pay off the officials at all?" Wally asked her.

She turned the question into Spanish.

The man shrugged and lifted his palms into the air.

Chana turned to her companions. "What I suggest is this, we arm ourselves well. We forget the guards. Three people or six won't matter if we're ambushed in the Darien. I suggest paying nothing to any village officials also. I also suggest that we offer this man 500 dollars US cash for accompanying us through the villages and to the villa with the possible bonus of 1,000 more if he helps us secure the purchase of one or two of these things you want."

"Yeah, tell him that," agreed Wally. He was surprised at the cool logic of the twenty-five-year-old woman. He remembered days

back in New England when a wealthy Texan or Californian would show up at Wally's door with an empty semi, and pay him a good day's wage to reveal all the good picking areas and hidey-holes and secret stashes in the unmarked barns of the hidden network. At the end of the day, Wally would receive five to ten percent of the purchases made. He realized that Chana had never seen such a deal go down, but with native intuition she'd nailed the process on the first try.

Yvgeney saw Wally nodding approval. He bit his lip. These negotiations were new to him also. Working for UNESCO he had law and justice on his side. Here it is the dollar.

After renting a Toyota Land Cruiser with an extended covered cargo bed in back, Yvgeney asked Balifor to get them weapons.

"I'm a simple businessman," he protested through Chana's translation. "Not a gun dealer."

Yvgeney asked Chana, "How much would it take to turn him into a gun dealer?"

Chana spoke to Balifor and answered, "1,000 dollars—US."

Yvgeney bit his lip as he nodded assent.

In the back room of a blacksmith shop Yvgeney looked at racks of pistols and automatic weapons displayed on hooks in a pegboard. He watched the woman as she handled a series of handguns like she knew them well. She chose a Mauser C96 and six extra clips. He approved, and that frightened him.

He took a second to size her up as an adversary. A small alpaca cap pulled down level with her red-fringed ears gave her a look of innocence that he suspected she didn't deserve. She was physically fit, though he bet she'd never seen a gym. Her bosom was small, like an art deco figurine, and appeared to be as firm as her flat belly. Her

movements were direct and confident. She looked up into Yvgeney's eyes and stared back. He turned away.

Yvgeney settled on a used CZ-75 automatic pistol and 1,000 rounds of ammo as well as a Mossberg military grade shotgun. Chana nodded approval. The shipper chose to be unarmed, claiming through Chana that "My reputation and the reputations of my seven brothers will keep me safe."

They crossed the Panama Canal over the last Pacific lock and moved over muddy roads into the jungle hills. They carried five extra jerry cans of gas, a carton of ready-to-eat meals, two bottles of Johnny Walker Red, five gallons of water, and a propane camp stove. Two army-issue tents were tucked under a canopy.

Yvgeney drove through a mix of clear-cut slash and settlements and river crossings over ancient wooden bridges before the jungle swallowed them. Deep mud trenches were the only roads in many areas. The Land Cruiser wallowed and spun jets of mud as it lurched through lakes of rain-softened earth.

They finally came to the town of Yaviza after the mud met gravel, then hard-packed solid ground. Peeling stucco and collapsed balconies offered *carne* shops and *mercados* for the scattered locals. A decrepit movie house sported posters of Sylvester Stallone as Rambo and Mark Hamill as Luke Skywalker. Nearly naked children and hundreds of dogs joined a town full of listless men and dispirited women. No one looked hostile.

"These people don't look dangerous to me," shouted Wally to Yvgeney.

"Don't forget that chat line you found on Julio's computer, flatlander," said the driver.

"Yeah, I liked the one that said, 'If you have less than four weeks of jungle warfare training and you attempt it, you will be listed as missing'."

Yvgeney said, "The advice you received should be taken seriously. When 10 of 10 responses suggest a trip through the Darien is suicide, perhaps you should be a little more concerned about your backside, and don't forget what they told you about the *National Geographic Magazine* reporters."

"But those guys were released unharmed," Wally said, remembering another e-voice that said: "It's very, very difficult jungle terrain to start, it's full of paramilitaries and guerillas and it's also prime territory for smuggling anything into the South American continent. Two British birdwatchers were kidnapped by the ELN there last year. They were held for six months. If the corrupt Panamanian cops don't nab you, themselves, you're still screwed. The FARC crew will nail you for target practice, or the deep jungle Kuna Indians will mistake you for missionaries, and slice you to pieces."

A bent-over native man stood his ground as he crossed the road ahead. Yvgeney drove around him.

"Boo," Wally said out the passenger window as they passed.

The man didn't blink.

Chana said: "Don't do that. You live by their grace."

A cold ready-to-eat meal and a shot of Scotch were dinner. They sat in a green clearing surrounded by green-carpeted mountains topped by dark gray clouds hovering just above the high spots.

Balifor sat down behind Wally on the damp vegetation. Wally inhaled foul breath heavy with garlic. "Tell me about this villa we're headed for," Wally said to him with Chana at his side.

After a conversation, Chana answered back, "Before the Medellin and the Cali Cartels there were many small drug lords. They sent cocaine to France and Italy. Smuggled there in freighters that carried fruit and coffee. One of the suppliers had gone off to college in the *Estados Unidos*. A man named Louis Alvarado Iyes. He was a ruthless drug lord, feared by people in the region, but stories of his art collection were well known. In Europe he discovered French design. He filled his villa in the Darien with examples of this style. The local people thought he was making a museum. He was only a brutal gangster with money. They say he once drew and quartered—"

Wally interrupted Chana's translation and said, "Drew and quartered?" He was surprised that a red-haired hardbody from the jungle would know such an arcane phrase. "You know that method of killing, Chana?" he asked.

"I like that method of killing, Señor Wally," she answered and returned to translation.

"They say he drew and quartered a servant who tried to clean the green color off a statue."

"This drug lord was marked for death during the drug wars. The fat man here tells me that the drug dealer was forced at gunpoint by the relatives of the dead servant to polish all his green statues. Then he was thrown into a vat of acid nitrate until he himself turned green, and then dissolved. The gate to his hacienda ended up in an auction in Cartagena. Stories say that it later sold for millions of pesos to a rich gringo in California."

"Wow!"

"His empty villa was given to the village as a gift of the Medellin gang. There is a Catholic school for children there now. If you wish to buy something, Señor Wally, we have to clear it with the mayor, a man called Jesus. Your friend says Jesus is a relative and he can arrange it."

Yvgeney hadn't spoken for an hour, content to watch the slow progress through the knee-deep muddy soup that passed for a road. Few people were encountered en route, but signs of another settlement ahead brought life to the muggy atmosphere of the Toyota. He said to Chana, "Were you in the military? You seem comfortable with the ways of a soldier."

"My schooling is the University of the Streets. São Paulo Tech, we called it."

This was a dangerous subject for discussion; the Future Club's success depended on the secrecy of their true goals.

"I have studied weapons and self-defense, Señor Yvgeney. My position at the side of the great Claus Braun depends on my knowledge of such things. I do my job well."

"I spent ten years in the Russian Navy," he volunteered, "sitting on cold arctic ice floes, listening to the enemy chatter. Then the adversary was the United States. Mostly I listened to *The Flintstones* or *The Simpsons* on FM radio."

Chana told him she'd heard of Flintstones. It is some kind of vitamin for children. She said she'd seen them for sale at the *Pharmamercado* in Puerto Montt. As a child in São Paulo, pills were common. Uppers and downers. Traded for sex or stolen goods. Vitamins had no value. She asked Yvgeney to name his favorite gun.

He said, "I was trained on a Kalashnikov. These CZ-75's are not as accurate, don't you think?"

"I have some experience with the Russian gun also."

She picked up the automatic pistol and aimed the open end of it at his left eye, five inches away. "I've found that accuracy with these guns is not important in close quarters."

Yvgeney looked past the open baffles of the flash suppression nozzle to see her face and realized he had been holding his breath.

"What's your favorite color?" he said to release the air.

No hesitation. "Red."

The mud hardened again. Colorful rooftops of a village appeared as the forest thinned. Dark clouds hovered ominously just above the mountaintops.

Balifor tapped Wally on the shoulder as the Land Cruiser pulled up to a four-way corner. He indicated a right turn.

Two unkempt, slouching men on siesta lifted their heads at the sound of the vehicle approaching. They spit in unison and muttered curses before lowering broad- brimmed hats and becoming motionless again.

After more Spanish chatter in the back seat, Chana said, "We will find a hostel for the night at the town called Tecuma. It's three hours away if the bridge is good, six hours away if we have to drive around."

After sunset they pulled up to a two-story wood frame structure that called itself *Paradiso de Hotel*. A cluttered desk in a foul-smelling common room served as the lobby. The man behind the desk woke up, belched, and opened a register. Balifor seemed to know him. He arraigned for two rooms; one for Chana, one for the foreigners. Balifor explained to Chana he would sleep in a back room behind the lobby in case she was interested.

She looked him in the eyes without changing her expression until he dropped his gaze and turned away.

Wally watched the manager snort, wiping his runny nose on his bare pimpled arm. He reached under the desk and pulled out two

grease-stained pages. They were menus. With hand gestures, he suggested that they should eat.

"Continental breakfast for everyone," Wally bleated. He hastened back to the truck for a ready-to-eat meal. Yvgeney lobbied to try the local cuisine. The only taker was Balifor. Chana found no reason to participate in the North American middle-class game of "Where do we eat?" She wandered off without comment in search of fresh fruit.

Wally sat on a rusty iron bench beside the door to the hotel. He held the warming remains of a Colombian beer, its sweating green bottle almost empty.

Clouds of mosquitoes in the cones of light from the street lamps shimmered with life. He kept a lazy hand in motion to sweep them from his face. It felt good to be off the road. He wondered what it is like to live in a place that has no winter.

Chana appeared out of the darkness and stood with her back to the swarming cones of light. "Near the equator, the sun rises and sets at six o'clock, morning and evening, all year long," she said.

Wally thought she looked different, more natural, more relaxed.

"You look different, Chana," Wally said. "More natural. More relaxed."

"Here, I am at home," she said. "You are the one who feels out of place."

He was unprepared for the friendly tone. As it passed through the dense equatorial air of the Darien Gap, it sent waves of puzzling warmth across Wally's chest. In Chile, at the excavation site, she had never spoken. At the Austrian dream palace of Claus Braun, she had also remained silent. In Mexico City, it seemed that Braun had thrust

her upon them. Even yesterday and today in Panama, when she was valuable as a translator and as a power broker, wielding the name of her boss to get what she wanted, the darkness of her deep green eyes and her monotone had never allowed a personality to peek through. Wally had accepted it as the package.

"Jesus Christ, Chana, there's a girl in there after all. Hello, young lady, nice to meet you."

"Hello, Wally Winchester, will you buy me a beer?"

"You bet. Hey, *garçon*, Señor Mr. Runnynose. *Una mas cerveza a mia amiga, por favor.*"

Chana laughed quietly, giggling like a shy schoolgirl at the Runnynose word. Wally swooned and caught himself, blaming it on the heat and the beer. He was aware, of course, that she was an adult woman. The glow of her skin and her damp hair suggested that she'd gone for a swim recently. The beer arrived. She popped the cap off by heel-slamming it on the edge of the rusty cast iron bench and took two healthy swallows of the brew.

Wally found it charming.

His mid-brain was screaming: *Hey you idiot, you've run into this person four times now and she hasn't given you the time of day, much less a smile. She knows way too much about automatic weapons, she's apparently a trained killer, working for a fellow who wants something very, very much that you won't sell and now she's acting like a sorority sister who wants to be homecoming queen. Warning, warning, Will Robinson!*

"You seem like such an interesting person," he said. "How come you've never spoken and how come you're so personable all of a sudden?"

She looked at him with a serious face but spoke with the velvet-soft voice: "When I'm on the job I have to be serious. Mr. Braun is a very important man. Protecting him and his projects takes

206

all my energy. Would you expect less? I could not have predicted we would be sipping beer in Panama when I first saw you. You were just another asshole gringo, and one with a girlfriend at that, snooping around at the excavation and at my boss's house. English, by the way, is not my second language, it is my fourth. Translating is very hard for me to do. I follow my employer's wishes, easy or hard. Tonight I am near to my native land. I feel safe and comfortable here and I am, as you say, off the clock. Is that a good answer?"

"Works for me."

"Where exactly is your native land, Chana? Chile? Argentina?

"I was born in the rainforest," she said. "Later, I lived in Manaus. Do you know this city?"

"Never heard of it."

"The city called Manaus has 4,000,000 people and you, a North American, have never heard of it? I'm surprised."

"They stopped teaching geography in the third grade, Chana. I'm afraid I'm out of touch."

Wally tilted his beer bottle toward hers. It was a gesture she'd never seen. She quickly realized what he expected and clinked the glass necks together, holding the long green bottleneck against his.

Wally smiled inwardly as her awkward attempt and felt his misgivings melting. He ordered another beer.

She spoke in Spanish to the attendant. He nodded, and returned with a fat cigar of local marijuana. Wally hoped the man hadn't licked it when it was rolled.

One hour, three drinks and a joint of Panama Red into the conversation, she brought up the chair.

"Why is it that Señor Braun was so interested in the chair that you purchased in Argentina?" she asked.

"He's a collector like me, Chana." She looked interested, but confused. He pulled out a metaphor. "Collectors are list-makers who

spend a great deal of energy amassing objects that represent items on their lists."

She appeared transfixed by his words, and spoke softly: "I grew up in a small village in the rainforest. My parents didn't wear clothes. This list collecting seems to me to be a nonproductive waste of time."

"It is, my dear, it's an amazingly stupid waste of energy. That's why it's so much fun."

"Fun is another word that doesn't make a lot of sense to me."

"I'm sorry to hear that."

"Why is this chair so special?"

She sat beside him now. Their legs touched as Wally delivered a furniture lecture:

"The egg rocker is possibly the most beautiful example of a perfect line drawing translated into a functional three-dimensional object," Wally said, trying to define the essence of his interest in fine design.

"Excuse me for saying this, Wally, but I once heard an American expression, big fucking deal. Does it apply to your answer?"

Wally tried again, "A simple design is more wonderful if it performs a function. It's like making a perfect geometric shape turn into a machine for sitting."

Chana said, "As a child, I slept on nothing, and it worked quite well. Is that even simpler? And therefore more wonderful yet?"

"In a way, goddamnit, it is. Even Frank Lloyd Wright was approaching that philosophy near the end of his life. To him, everything became reduced to pure functionality. The last bed he designed was nothing more that a square piece of plywood, elevated from the floor. God, Chana, your thoughts are wonderful in their simplicity. Consider this ... maybe function isn't enough for perfection. Perhaps a dash of beauty must be added, like salt on a steak."

Chana hesitated as she processed the string of words, and then said, "I believe that the earth is the most beautiful thing in the universe. That makes my bed more perfect than yours. Checkmate, Señor Wally."

Her cheeks were glowing now. Wally blamed it on the beer.

"Girl, I bet you'd kick ass in a seminar at the Rhode Island School of Design. They're not ready for your kind of brain."

"And where is this chair now?"

"It's up in Seattle, where I live. You'd like it there. I live on a wonderful island where eagles fly by every day, and I get to watch whales spout air and chase brine shrimp into a shallow bay in front of my living room window."

"Do you sit in your new rocker, the one that Señor Braun wants, and watch these creatures?"

"Not yet. The chair was painted brown when I got it. I'm having it restored. I have a guy who's a master."

"Tell me about him," she began coyly.

"HEY, YOU TWO! YOU MISSED ALL THE FUN!" Yvgeney was drunk. His arm was draped around the soft shoulder of an equally sodden Balifor. "THE MOVIE HOUSE IN TOWN RAN AN OLD MOVIE THEY FOUND IN THE ATTIC. *SOME LIKE IT HOT*, JACK LEMMON, MARILYN MONROE. I WAS THE ONLY ONE IN TOWN WHO KNEW THE WORDS."

Chana deflated and sat back in her chair, murder in her eyes.

The waiter came out to greet the loud visitors. He saw Chana's face. He declared the bar closed. Balifor protested loudly, to no avail, before he disappeared into a door in back. Chana stood up and walked off into the night. Wally shrugged and went upstairs with Yvgeney, hoping he was sober enough to write a nice letter to Rae before he fell asleep.

Chapter Twenty-Six

Darien Gap, Panama

"Did you tell your Rae in your letter that you nearly tripped over your tongue last night, chatting with the redhead?" Yvgeney asked Wally, who sat in the passenger seat. They had stopped at a high spot in the broadleaf forest for a morning nature call. The destination was just ahead, according to Balifor.

Wally itched from last week's healing slashes, but felt upbeat. "So much for the most dangerous passage in the Western Hemisphere, old buddy," he said. "The most dangerous thing I've seen here is the food offered at the hotel last night."

"We're not there yet," answered the Russian. "And, we're certainly not out. Let's ask Annie Oakley back there." He turned his head slightly as he drove, keeping an eye on the deep muddy ruts. "Madame Chana, how do you assess our safety factor out here?"

"*Mucho mal hombres aqui*, all the time, never safe, señor."

She spoke in Spanish to the expediter.

He replied, and Chana translated: "Señor Balifor has many relatives in this section of the Darien."

"That's a good thing, right?"

Wally was paying a little more attention to the spaces between the trees.

"He says that a lot depends on which ones we happen to run into first."

"Hey, folks. I have a scouting report here. This is Wally Winchester on point. Other than the three hamlets, we haven't really

run into any people out here. Look around. Do you see a lot of bad guys? No one lives out here. It's the jungle."

Chana placed a hand on Wally's shoulder. It caused a spark.

"There are many people out there behind the trees, Señor Wally. Good people and bad ones. Please believe me—and trust me when I tell you that they all know we're here."

As the forest thinned into a clearing, Balifor began speaking Spanish again, agitated.

Chana spoke: "The road to the school we seek is up ahead on the right. See? There. A space in the tall grass. Turn here, señor."

The entrance road passed between two ornate wrought iron columns. It was paved, a luxury driveway in the wilderness. Grass growing in the cracks and broken plates of concrete suggested years of no maintenance. A fence topped with rusted concertina wire extended from the entrance portals on either side. Balifor, sweating, wiped his greasy brow with a handkerchief and spoke again. He seemed relieved to have arrived.

Chana translated: "There was a gate here many years ago, a very special gate made in Europe by a very famous man, a Frenchman. It was removed and sold after all the killing stopped. They say it was worth millions of pesos."

Wally murmured, "The Edgar Brandt gate. No shit! Here's where it hung? Wow!"

"*Si, Si, Edgar Brandt. Los Artistimo Franc.*"

"Get our your checkbook, Yvgeney."

High grass on the other side of the portal thinned to scrub bushes and a scant lawn. A series of low buildings with orange terracotta tiles on the roofs lay straight ahead. Children played soccer off to the right. As the Land Cruiser parked on a circular drive in front of the main structure, a nun in a black habit walked out the front door to meet them.

211

Chana draped a blanket over the automatic weapons and made a gesture something like the sign of the cross on her chest. Balifor did the same. Wally smiled at the sight, thinking that either of their lives probably disqualified them from the most forgiving confessional on the planet. He looked past the advancing nun at the metalwork that surrounded the entrance. An art nouveau architectural legend enclosed the front door. Twin greenish-blue metal exaggerations of tendrils arched like unopened ferns and connected, enclosing a red-painted lozenge of wood bearing the legend *Metropolitain*.

"A Paris metro entrance gate," said Yvgeney, who also recognized the familiar form. He'd spent a lot of time in Paris and was also quite familiar with the organic masterpieces designed by Hector Guimard that marked the entrance of a number of Paris underground terminals. The icon of France's art nouveau renaissance seemed quite out of place in the jungle.

Wally spoke: "I've heard stories of replacement parts for these entrances, stored by the Paris Public Works Administration in some secret locations. They're national treasures, you know. How'd this son of a bitch get one?"

"This son of a bitch was cut up and dissolved in acid, don't forget," said the Russian. "Be polite, Wally. Don't piss off the sister."

"Ten dollars says she doesn't speak English."

"Welcome to *Esquella Novo Christo*, *señors* and *señorita*," said the nun.

"*Hola Ernesto*," she spoke directly to the shipper.

She unleashed a string of Spanish that caused the man to wince.

Chana translated the next one: "Señor Balifor tells her that you men are students of French art and antiquities, here to study the furnishings of the villa."

212

The Egg Rocker

Wally and Yvgeney made eye contact with Balifor, lifting his open palms as if to say: "Come on, tell her what she wants to hear!"

"The book we're working on—" Wally began. He looked at Chana. She followed in Spanish.

The Russian continued, "*Principles of Art Deco Style in South America*. We're quite interested in the collection here."

"We want to be sure to get your name correctly," Wally said.

Chana pulled a pen off the dashboard and grabbed a small pad of paper used as an expense notebook.

"You are Sister ...?"

"Madre Superior Maria Mary Margaret Alvorez," she beamed, "Order of the Carmelite Sisterhood."

"Wally W—Walter J. Winchester, at your service," Wally bowed. "May I introduce Yvgeney Ivanchenko, PhD, and our translator, Chana, last name unknown."

"Just Chana."

The Mother Superior put her hand to her mouth and spoke through Chana.

"Oh, how rude of me on this hot day. Please come in out of this sun. You must be tired and thirsty. The lunch hour is approaching for the children. Please follow me."

The entourage walked up the steps under the Hector Guimard masterpiece. Wally thought its existence here in Panama represented an amazingly successful example of municipal corruption. They entered a hall that looked like it had been furnished out of a Sotheby's catalogue. Two light fixtures hung from a 20-foot ceiling. Wally noticed them right away. *More Edgar Brandt, I bet. Unbelievable.*

A circular stairway curved outward to the left and right, ending in a balcony straight ahead on the second floor. Yvgeney was surprised

at the volume of this vast entry hall. The villa didn't appear this large from the outside.

A bevy of schoolgirls in blue dresses and shiny black shoes entered behind them and smiled at the visitors as they marched past them.

A large French-looking carpet, an abstract pattern of lines and colorful worm shapes on a white woven ground that resembled a Chagall design, covered most of the marble floor.

Yvgeney noticed the paintings. Large gold-leaf frames over each stair held single voluptuous semi-draped nudes painted in the style of Tamara de Lempecka.

He'd never rescued a Lempecka from the spoils of Nazi war pillaging during his work for UNESCO. Germans would have classified Lempecka's sensuous characterizations of nudes and scientists as degenerate trash. Not even worth stealing. Art targets in 1940 were Rembrandts, Vermeers, Italian Renaissance masters, and true classical antiquities. They would have looked at Lempecka as another deranged modernist. *These two on the staircase*, he figured, *could bring half a million apiece today. Maybe more. Now*, he thought, *the art market is movie stars, comedians, and high-tech millionaires.*

The mother superior noticed his interest. Spanish tumbled out in earnest; English words flew from the Amazon girl's mouth: "We're somewhat embarrassed to keep these works of art on display ... considering the subject matter and, of course, the children. We tell the students that great art comes in may forms. Do you agree, Dr. Ivanchenko?"

Chana glared at Yvgeney as she spoke.

"Yes indeed," he answered. "It's important to look at the heart of the paintings, not just the subject it portrays."

Through Chana, Mother Superior continued: "Thank you. We have meetings every few years to discuss whether it's appropriate to

keep them. There's always some new bishop or cardinal sticking their nose in our facility. I hope I'm still here to defend them the next time there's a regime change."

"I'd be pleased to help you in their disposition if they're ever deemed inappropriate," Yvgeney said, catching Winchester fever.

Wally stepped hard on his partner's toe and gave him a sideways look that said, "Lighten up; this is what I do for a living." The unwary sister waddled on, leading the four toward the dining room.

"Please sit and cool off. I'll have one of our older girls get you some refreshment."

She disappeared, leaving her visitors sitting around a sharkskin-topped table with inlaid legs that curled in, connecting to a center pedestal. The chairs looked French to Wally. He counted four such sets in the large domed room behind the grand staircase. He guessed Rhulmann, maybe Sue et Mare. No matter, it was fun just sitting on this stuff. There was no indication given that anything was for sale. Whatever the mother superior said to Balifor was still unknown. He'd asked Chana to advise him anytime the subject of selling anything came up in Spanish.

Chana believed this worship of objects an exercise in arrogant capitalistic behavior, but she knew her assignment from Claus Braun involved a similar motivation, so she stifled her disdain. She told herself Claus Braun had a higher purpose than marking another object off his list. She nodded to Wally in agreement, reminding herself that there were bigger issues afoot than her personal feelings.

Wally's eyes roamed the room. More examples of a millionaire's spending spree in Paris studded the chamber. Four display cases in ziggurat stacked art deco aluminum sat against the walls. Now they held trophies and school photos. Museum-quality semi-circular sconces sent light up the walls.

Nice paintings hung on the walls. These looked North American. Great epic scenes of men and women working, muscles bulging, tools spinning, industry being industrial, farmers farming, welders welding, high-rise construction on frightening, lofty girders. All showed the worthiness of hard work in a decade where work meant prosperity. Wally wondered what WPA project was pillaged to get these federally sponsored masterpieces.

As he sipped the chilled water, he wondered how he and his Russian buddy with the checkbook could talk their way out of here with some of these great things under their North American arms. He asked Chana to see if Balifor had a prior agreement with the school to buy anything.

Chana showed her displeasure. She grimaced, repeated the question, and as the Panamanian looked left and right, she translated his reply: "White suit says that his job was to get us here because that's what we hired him to do."

"Remind him that he gets a big bonus if we get to buy some of this art deco."

"He says that one of his cousins works here for the nuns as a landscaper and groundskeeper. He will try to find him and see what he thinks."

The fat man rattled on. Chana filtered: "As far as the nun, she thinks that funds for the education programs here are always running low. She thinks it's possible to offer to help fund a program ... in exchange for a ... souvenir ... but Wally, Señor Balifor wants you to remember that because of that lie you told—"

"You started it," yelled Wally at the sweaty importer.

"She believes you to be serious scholars," Chana continued. "An admission of the truth, that you're actually lowdown dogs of the antiquities business, would place us in danger."

Balifor excused himself and wandered outside in search of his cousin, the groundskeeper.

The mother superior entered the room, followed by a dozen dark teenagers in blue dresses. She lectured the children in Spanish as Chana followed in translation: "You and Yvgeney are authors, she's telling them. She says that the furnishings of this school are famous, and that you and..." she winced, "Dr. Yvgeney are making a book so other people in different lands can see these things. She tells the students that someday these things may end up as important exhibits that you find in museums like the museum that they once went to in Panama City."

Bingo! Wally personally knew of three museums that were always on the lookout for truly great twentieth century decorative *objets d'art*.

"Tell her that some of these objects here are so important that they should be in museums right now."

Chana did. The children murmured in appreciation and looked around.

"Tell her that some of the objects here are in danger."

She did.

The kids and Mother Superior made fearful silent o's with their mouths.

"Tell her I know a museum that would not only save some of these endangered things and display them, but also, they might make a large cash contribution to the school and its programs."

Chana did as told.

Mother Superior's eyes went wide. Yvgeney's eyes went wide also as he watched Wally's manipulation. Chana's eyes went to slits.

Wally said, "Put the checkbook away, Yvgeney. We're in the museum procurement business today."

Smiling, Wally set the camera image quality on standard. He had a lot of pictures to take.

Chana found the search disgusting. It reminded her of stories she'd heard about pillaging. She watched the trusting mother superior enlist students to help the gringo and the Russian photograph everything within reach. She shook her head in disbelief as they dragged out a ladder for Wally to get close to the light fixtures. He climbed up and inspected the fixture. He turned to the Russian and shouted, "Eureka!"

At dinnertime the visitors were treated as honored guests. Balifor was absent. The meal was local pig with yam dressing. Chana remained neutral through the parade of lies she was obliged to translate; Wally and Yvgeney thrilled the students and the seven sisters with tales of the United States and Europe. Yvgeney told sea tales of life in the Soviet Navy.

"Imagine, a Navy man and a PhD!" one of the sisters said.

Stinking of tequila, Balifor showed up in the dining room as the sun set. He told the boys through Chana that there was another compound three kilometers to the south that had additional things. He suggested that a visit could be arranged in a day or two. He also had more information from his cousin, the groundskeeper.

He whispered to Chana, smiling as he kept his eyes on Wally. She frowned while relaying his words: "The attic of this school is loaded with objects, he is telling you. Even the nuns don't know."

Wally's heart beat faster. *The problem,* he figured, *is how to get our heads into the attic and still appear to be academic.*

The fat exporter solved it by mistake, tripping over a braided lamp cord in an unsuccessful attempt at standing. The frayed wiring gave Wally the clue.

He looked at Chana and asked the nun, "When's the last time you had your wiring checked in here?"

The mother superior shrugged. Wally looked up at the gorgeous chandelier.

"Old wiring is a hazard, particularly here in the tropics."

Behind the woman's back but still grudgingly translating, Chana rolled her eyes. Without speaking, she walked out, presumably to sleep in the tall grass.

In the morning after prayers and breakfast, the nuns spen fifteen minutes locating a trap door to the attic. When Wally climbed the ladder and put his head into the opening he saw that the groundskeeper had been right; it was the yard sale of his dreams: statues, bronzes, acid cutback lamps by Daum and Galle and Schneider, pottery, rugs, and art, lots of art. The mother superior looked confused as Wally passed down item after item. His mental calculator was humming: 1,000 dollars here, 5,000 there.

On the floor below, the pile of passed-down treasure grew bigger. Standing almost upright in the rich man's attic, Wally tried to stretch the knots out. Light from a tiny crescent window at the far end glowed amber. He crawled over to investigate, ducking to avoid the rough-hewn beams overhead.

Under a pile of sequined flapper dresses he spied the unmistakable rippling of light off a hammered surface and the orange glow of light shining through a mica shade. He plunged his hand under fabric and felt a bulbous base.

"Well, I'll be a son of a bitch!"

The Russian had heard the muffled exclamation. "What's going on up there?"

Wally's smiling face peered down from the opening above Yvgeney's head. A hand snaked down into the room below holding a basketball-sized copper lamp base by one of its support arms. Yvgeney

reached up to retrieve it. He was surprised by its quality and weight. Next came a lampshade fashioned of pressed mica in a copper frame.

"Eureka!" whispered Wally. "Our boy had a taste for California design before it was even collectible."

On solid ground again, Wally said to the head nun, "I'd like to take this lamp with us to give to the museum. I can authorize a check in advance."

"Nonsense," replied the nun. Chana's translation took on a new, lower, monotone.

"You take it with our thanks," Chana said, then gritted her teeth. "You've done so much for us already … taking all these photos for the museum, and possibly a chance to fund our programs, and that old wiring. How does it look, by the way?"

"Much better than I expected," answered Wally.

"I insist on paying for the lamp now. I can get reimbursed later. Do you have the checkbook, Dr. Ivanchenko?"

"Wally, she said we could have the old lamp," Yvgeney protested.

"Write a check for … 5,000 US dollars, my friend."

"What?"

"How many programs can you get started with 5,000 dollars, Mother Superior?"

Even Chana changed her tone in the Spanish.

"My goodness," came the translation. "I'm overwhelmed."

"Mr. Winchester, can we have a meeting?"

"It's all right, Yvgeney."

"No, I insist," the Russian said as he roughly pulled Wally into a study. "What are you doing? The woman said it was free."

"Do you know how much that lamp is worth?"

"Who cares? It's been offered as a gift."

"We're here to find great things, not to rob people, especially kids and nuns. I'll pay you back as soon as we get home, I promise. And we'll still split it."

"What kind of capitalist are you?"

"A Democrat."

"Well, get your pal Bill Clinton to pay for the lamp."

"Write a check, please."

The new photos took the rest of the morning. Halfway through, Wally caught Chana looking at him. She was smiling.

Chapter Twenty-Seven

Darien Gap, Panama

The deep green broadleaf jungle enveloped the rental truck again.

"How much farther is this other compound?" asked Wally.

Chana repeated the question in Spanish to Balifor.

He answered, *"Uno a dos kilometer, señor."*

"Wed better dig out our weapons, Chana," Yvgeney said. "We're exposed again."

She nodded and reached down into the storage compartment.

A jeep came out of nowhere and cut them off. Wally stomped on the brake and swerved to the left, ending in the brush, inches from a collision.

Six armed men aimed rifles at them. Four more appeared at the windows with handguns pressed to the glass. All four men wore hooded masks with eyeholes. Chana's hand was frozen, inches from a shotgun.

It was over instantly. Chana and Yvgeney's fury at the ignominious capture had no outlet. Wally was too surprised even to be angry yet. The finality of the takeover left him paralyzed.

No translation was necessary. They wanted the team out, now. Chana noticed that Balifor had not been herded like the other three. She spit at him, catching him on the greasy unshaven cheek. He shrugged and began chattering with the captors. Chana glared at him and at her compatriots. There would be no translation.

The captors, dressed in a paramilitary attempt at a uniform with gun belts and red bandanas around their necks, prodded the three

forward into the deep broadleaf forest. The sound of the whining engine signaled the departure of their truck.

Oh fuck, my lamp is in there, Wally thought, *and all those good photos*. His glance back prompted a sharp jab of a rifle barrel into his kidney.

"We should have a plan before they separate us," mumbled Yvgeney.

"*Silencio*," shouted the lead man. A pistol smacked across Yvgeney's temple. He stumbled and was kicked. He got up, blood covering one side of his face.

Fronds and branches smacked the gringos in the face as they walked on a well-trodden path. Chana remained unfazed. Wally fought a terrible thirst but didn't dare speak. The blood diminished Yvgeney's sight and he stumbled frequently. Chana dared to stare directly at her captors. They only laughed. One reached over to fondle her breasts. Hands bound behind her in police plastic restraints, she spun around and managed a kick to his groin, bending him over in pain. The other men laughed as he punched her squarely in the mouth. She stood her ground amid murmurs of respect among the men. He punched her again. This time she went down. Two hooded men helped her to her feet. Her walk was as wobbly as Yvgeney's now.

After sunset they reached a clearing with a cluster of tin-sided shacks on a hillside. Dark green mountains ringed them in. Stars and a moon, nearly full, were above them one minute, covered by a dark cloud the next.

Wally saw the jeep and their rental truck parked nearby and wondered why the men didn't drive them there. He didn't bring it up in conversation. Yvgeney and Chana knew that the walk was part of the process of subjugation. They knew the process, and both in their own way sensed what was yet to come.

A door was unlocked and opened. Without loosening the plastic restraints, the captors threw the three inside the enclosure. Wally pitched forward and scraped his face as he fell, hands bound behind. The other two rolled and landed on their sides with a thud.

A thin, lanky hooded man stood at the doorway. He said, "You speak, you die."

I'll bet you're the one who took English as a second language, Wally said silently.

The captor reached over and pinched Chana's nipple. He laughed and bolted the door.

Darkness was complete. Wally felt a pressure on his side. It was Yvgeney. The Russian placed his lips to Wally's ear and whispered: "Don't make any noise. One hostage to them may be as good as three. Chana is no use at all as a prisoner. I suspect they'll take her soon for their amusement."

Wally stared to speak.

"Shhhhh, I can loosen your plastic strap if you turn around."

Wally nodded enthusiastically. The Russian turned his body so the men were back to back. He felt fingers tracing the tight plastic to a hole-and-ratchet mechanism. He felt it tighten further, then release. Somewhere short of freedom, he felt the ratchet click back in. He started to protest and shut his mouth before a sound emerged. Yvgeney's head tilted back and he spoke so softly he could barely be heard.

"If they come in and find your hands free, they will kill you. At least you can move your fingers, is that right?"

Wally's nodding brushed against the Russian's head.

"Now, try to do the same for me, but take the cuff off."

Wally tried to grab at his partner's plastic hand restraint but couldn't get his fingers to work well enough to release the tight position.

The noise of a door swinging open came without the sound of footsteps. A lantern beam caught the two men back to back. The guard kicked Yvgeney hard in the skull. Wally watched as his friend's eyes lost focus.

Another man entered; they dragged the unconscious Russian over to the other side of the hut and turned to Chana. One held the light beam on her. Opening a dirt-caked eye Wally saw stained army pants unbuckled and pulled down to her knees.

They didn't bother with her shoes. The tall man spoke and the other agreed. One of the men looped her bound arms in a carry hold and dragged her out past the open door into the night.

Lantern light briefly caught the dried blood under her nose and on her cheeks. Her eyes were wide open. They were calm, but furious. Wally had never seen a look like that on a human being. She said nothing as her booted heels left drag marks on the hard dirt floor. Then the door closed again.

Goodbye, Chana, Wally thought. He squeezed out his best attempt at prayer.

The laughter outside grew louder.

Later the lights came on. Wally tried to look around but the pain was too great. He thought about Rae, so far away. It was a good thought to hold onto. But, then there was that remarkable lamp he found yesterday.

"Wally, don't move; it's me, Chana. I'm going to cut your restraints behind you."

"Chana?" he said the name, but no sound came out through dry vocal chords.

"Don't move, señor. It's going to be all right."

He felt the release of the plastic strip. It hurt like hell, but he moved his arms out to his sides and rolled over onto his back. Above him, the redhead stood backlit by the open door.

More motion. He turned his head and saw a man, a young Latin face with no hood, cutting Yvgeney free and offering him some water. Chana bent down and poured some water from a canteen into Wally's parched mouth. It stung his cracked lips; swallowing hurt. He gulped. He gulped again.

Chana smiled. "Welcome to the Darien, gringo," she said.

Odd thoughts still roamed about in his mind. She woke him again.

Chana said, "Wally, wake up! We have to get moving."

Sunlight filled the valley. Wally kept blinking, trying to focus. He noticed Yvgeney, moving about silently by the door to the shack. He walked slowly, limping a bit. The Toyota was parked 50 yards away, on the slope of the high open meadow.

The lamp! Wally remembered.

Painfully, he ambled over to the 4 x 4. Inside he could see the mottled copper surface. "Yes!"

Inspecting his daypack, still stashed in back, he found his digital camera. The automatic rifles were gone. Still trying to get his bearings, Wally straightened, arched his sore back and took in their surroundings. Their makeshift jail was a blue-painted tin shack at the top of a green meadow surrounded by low trees. Tan slashes scarred the green walls of distant mountains. There was no sign of the other captors. Shiny patches on the meadow grass looked like blood and morning dew; Balifor's white hat was near the forest edge.

Yvgeney limped over to Wally; Yvgeney noticed the shiny places. He recognized a killing field.

Chana appeared at the top of the hill. She smiled as she joined Wally and Yvgeney.

"I've talked with my employer, Señor Braun," she said. She held up a satellite phone that neither man had seen before. "We have an appointment in Cartagena. We're going on a short boat ride. To Colombia."

Chapter Twenty-Eight

Cartagena, Colombia

A black-and-white sign over a faded red door read *Mercado Zeus CA*. They caught blue glimpses of the Caribbean between buildings and waterfront businesses. Chana stopped by a warehouse three blocks from the shoreline. She seemed to know the way. *No flowers on the balconies here*, Wally noted, *just early twentieth century warehouse space gone to seed.*

The locked door opened after a buzzer into a small office with no one behind the reception desk. A stairway zigzagged up the back wall to a second floor office. Photographs of soccer players holding trophies covered the lower room walls.

Chana walked over to the desk and pushed a button on the phone pad.

"*Bruno, Chana aqui.*"

The door at the top of the stairs opened and a rotund man with a full black beard stepped onto the landing. His infectious grin and a massive amount of teeth lit up the room.

"Chana, my dear," he spoke in a Middle Eastern-tinged English baritone. He bowed respectfully.

Chana beamed.

Yvgeney lagged back at the front door, watching Wally and Chana advance up the stairs to join him.

"Bruno is a finder for Claus Braun," she said as introduction. "Bruno Moustafa, please meet Wally Winchester and Yvgeney Ivanchenko."

Yvgeney approached cautiously.

"Please come in, my dear. I've been expecting you."

They entered the office at the top of the stairs. Behind the darkened glass, a museum of African art dominated the walls. Masks and wooden sculpture hung from the ceiling and brackets on the wall. Animal hides dotted the floor; a French carpet covered most of the rest of the roomy office floor. The only seating was the desk chair—clearly a private space, a collector's lair.

"Nice room," said Wally.

"Thank you, it's a collection I've been working on for some years now. No need to advertise it to the locals."

Wally said, "I'm hip."

"I received a phone call from Claus Braun," bellowed Bruno, settling his girth behind the large polished desk.

Chana stood quietly in a dark corner.

Yvgeney scanned the mask-studded walls and left the discussion to his partner.

Their host wore a crisp tailored suit in tan with a bright red tie. He said, "Señor Braun has instructed me to assist you in your search for 'misplaced' European art objects." His eyes danced back to Chana. Air conditioning hummed.

A servant entered, bearing a silver tray with chilled water in crystal goblets. Wally guessed *Baccarat*, and focused on his host.

"Thank you, Bruno. Tell me. Moustafa, is that a South American name?"

"Moustafa? No, of course not. It's Egyptian. I found my way to this continent as a wandering youth bumming around on tramp steamers. Never left. This land is a wonderful place to live in. Don't you agree, Chana, dear?"

"Yes, Bruno."

"Are you interested in my collection, gentlemen?"

"Very much," Wally answered.

Yvgeney said, "I've spent some time looking at African art at the Smithsonian."

"Ah, the National Museum of African Art. Wonderful collection, don't you think?"

"I particularly remember a group of masks carved by the Dogon peoples."

"The Dogon are indeed great natural artists. I have some Dogon masks, but let me show you something special."

The Egyptian pulled his substantial frame out of his chair, ambled over to a dark wood cabinet in the back corner and extracted a crusty, carved wooden human face from the bottom drawer. He held it out, a meaty finger poking through an eyehole, for the visitors to examine.

"Careful when you hold it, please. Handle it only on the edges. The surface is fragile and said to be dangerous."

Chana's eyes widened.

Wally gingerly let the dark mask ride on his upturned palms. He held it up for Yvgeney.

Moustafa was clearly pleased, "See the delicate, somewhat grained surface? African sacrifice ceremonies have a long history. This mask was an executioner's faceplate. It is said that it had to be kept out of sight from women to protect them from the spirits on the surface. Tradition required the ceremony leader to wear this during the initial kill. Bloody business, these sacrifices."

Chana abandoned her corner and moved closer.

Moustafa continued, "Two hundred years of close wet work. It all becomes part of the beauty of the piece."

Chana smiled.

"You like it, don't you, my child?"

"Yes, I do, Bruno. It gives me what the gringos call a jones."

"I don't recall the term. Colorful language, English. Do you agree?"

"Yes, sir."

"Enough bragging. How can I be at your service?"

Yvgeney said, "We're interested in locating interesting objects that have found their way to South America."

"That's what I do, gentlemen. I keep an active network of associates who are on the lookout for such things. I have found some one-of-a-kind objects for Señor Braun."

"Excellent!" Wally said.

"Last week a fellow called me from Porto Velho in Brazil. Seems a small painting turned up at a local market. Sold for 50 Brazilian pesos by a down-and-out *garimpiero*. *Garimpiero*, that's the Amazon word for miner. It ended up at a cantina and had hung there as a portrait of Jesus until it was spotted by one of my people. Seems to be School of Fra Angelico. Haven't seen it in person yet."

Yvgeney raised his eyebrows.

Bruno said, "A nice carved Renaissance wooden coffin came to me from Bolivia last month."

Wally cocked his head.

"A coffin," said Yvgeney. "It's a box, Wally, like a bride's chest."

"A beautiful piece," added Bruno. "Ornate scenes of Christ descending the cross. Want to see it? It's in the back storage."

Wally was still scanning the room. "I bet everything you get is worth seeing, Bruno. Do you ever hear about twentieth century objects?"

"Some old German furniture comes around, but nothing very spectacular. One thing I remember you might like. It's not this century, though. More like 1880. It's a set of curtains. I'm told they're very

luxurious. Hanging still in a little Catholic chapel in Amazonia. The firm of William Morris and Company. Know it?"

"I'm very interested in these curtains, señor." An excited shiver tweaked the little hairs on Wally's skin. He remembered a legendary set of Morris curtains that surfaced in Portland during the good picking days in the 1980s. The dealer never offered them for sale, claiming he would go to the grave wearing them. When he died, the family sent them to Christie's Auction House instead.

"They hang in a dark corner of this church, I'm told, not too far from Manaus on the Negro River, near its confluence with the Amazon."

Chana's face changed.

"Your part of the world, isn't it, my dear?"

Darkness clouded her eyes. She twitched her lips nervously.

"I have much unfinished business in Manaus."

"Let's go," Wally said.

Yvgeney nodded. Moustafa continued, "Señor Braun asked the same question concerning twentieth century objects. He anticipated your interest and took the liberty of purchasing three tickets to Manaus for your party."

Yvgeney looked at Chana. She smiled.

Good old Claus Braun, Wally chuckled, thinking, *he certainly is kissing my ass to get his hands on my chair*.

He began to inspect the other masks more closely, careful of the crusty ones.

Chapter Twenty-Nine

Above the Amazon Rainforest

Varig Airlines' five-hour flight to Manaus took them over cloudy treetops, lakes and rivers. The clouds parted as they descended toward a wide, dark river. Civilization appeared as ramshackle huts that got more crowded before giving way to solid structures as the low approach took them over the city center.

"Manaus is a huge circle of poor people surrounding a small center owned by rich Europeans," Chana said. She was warming up to conversation again, the first time since they shared cold beers at a Darien Gap hotel. She pointed out the bright blue through the window. "Look down there, Señor Wally. The pretty blue dot is a temple built with the stolen lives of my people. A cathedral to the greed and domination of North America."

"Tell me how you really feel."

A quizzical look. "That is how I really feel."

"What do they teach you about us down here?"

"I don't understand what you are asking, Señor."

"When you open your Latin American geography books on the page with America on it, how do they describe us?"

"The geography books tell me about the population. Where the high mountains are, how many live in the cities, what they grow."

Chana pursed her lips. She looked at something far below.

"When you say Americans, I get confused. I am an American. A South American. You are a North American. Am I correct?'

Wally could only nod in assent.

"Your ancestors sailed on boats from Europe, took a land from the people who lived there, and made it your own. My people have lived in the rainforest since the beginning of time. I ask you, Señor Wally, who is *the* American?"

Wally frowned. She backed off, remembering the chair.

"We know, of course, that the great American evil is mostly in the government of the North Americans, not the people who live there. The leaders are crazy men. The normal people who live in North America, we think are fine. Just like us."

Wally didn't notice her adjustment.

"This is your backyard, you say, Chana. Do you know this village, or this church we're going out to visit?"

"I knew the village and this church as a child, but it was not wise for my people to be seen there. The inside of this church is unknown to me."

"Your people … is that a tribe?"

"We do not think of ourselves as a tribe. Tribe is a conqueror's word. We are The People. There is no misunderstanding who we are. Strangers misunderstand us. They kill and burn and take our women, puncturing our land for its treasures. You North Americans are a tribe. A big, pampered pack of pink overweight people who have nuclear weapons."

"Easy now, Che Guevera," Wally joked.

"It's an honor to be associated with Che. He is a hero to our people." She opened her eyes much wider.

"I'm with ya, girl. I read *The Motorcycle Diaries*."

"I know of the book. I'm surprised, señor, that you do."

"I learned a lot reading that book. I'd expected a fun story about two guys on a motorcycle road trip through South America. Turned out to be more about a young man's eyes opening as he sees his native land for the first time. I liked the movie. Made me think."

Chana said, "I'm pleased that you know these things about our struggle, Señor Wally. I have assumed that our troubles are unknown to most gringos above the border."

"You're actually right, Chana. The average American, sorry—North American—doesn't know squat about South America and its struggles."

"Squat?"

"Nothing, *nada*."

"That's what I was told also in the geography class."

"Too bad ... there are a lot of us who are really wonderful."

Chana smiled again and pointed out other parts of the vast city carved out of the jungle. Sunlight caught the Negro River and turned the dark waters gold.

Chapter Thirty

Manaus, Brazil

The rented Toyota moved slowly away from the city, through neighborhoods of thin-walled shacks. Scorched vegetation and deforested hills followed. They drove past squalid outposts and struggling attempts at farms.

Chana let out a long breath. "My people hunted here," she said, waving angrily at the destruction.

She pointed to an earthen scar off in the distance on a barren hillside, "*Garimpieros*, miners. They are the worst. They kill at will. I have much anger with the *garimpieros*."

Wally sat in the rear bench seat with Chana as Yvgeney drove. "Not a lot of law and justice out here, I bet," he said.

Chana continued, "There was no law for our people. We were not counted in the stranger's law."

"What was it like living out here as a child?" Wally asked.

"Memories of the time here are not connected to words in my mind. Life without lists, señor ... life without chairs. I remember people and the village and water and hunting celebrations. Always celebrations. I remember death and crying and sadness, and bad men, guns, and fires. Then I was in the city, Manaus. Very young and then not so young."

"Your family left the village and moved to Manaus?"

"I don't know where my family is. They are gone. I escaped to Manaus. From a *garimpiero*. A bad man. There was much confusion after the fires. I have no family now. Claus Braun is my family."

"You can count me in also, Chana."

"I don't think so, Señor Wally, you are OK for an Englishman, but you also are a *garimpiero*–a miner of objects. You don't see the people who stand in your way."

"That's not fair. Yvgeney and I have been very generous and friendly to the people in our way."

Chana's smile wavered, "Have you noticed the art of the regions that you go through in your four-wheel drive car? Have you walked in a village and left some of the cash in your pocket with an artisan or a weaver or a knitter of wool or even a beggar? I have not seen you pay any attention to the people we go by, the people whose land is your personal treasure hunt."

"I don't have a market for South American things, Chana. I wish I did. My market only wants Galle or Josef Hoffmann. I'm an expert on certain things made in America, North America, that is, and Europe. It's my job. I know people who collect or sell those things. They're my customers. I don't know much about Latin American crafts so I can't spend time here looking for them."

"So, you travel to our country looking for things that have nothing to do with our culture or our customs?"

"Easy now, girl. You make me sound like Anaconda Copper."

"Anaconda Copper, Dole Pineapple, Chiquita Banana, DuPont Chemical. There are hundreds more. They come here to take what we have, send it somewhere else, and keep the money in New York City or Houston. Tell me how you are different."

"I'm on the side of the people. I'm a registered Democrat. I even stopped buying coffee from the big corporations."

She batted her lashes against her freckled brown cheeks and smiled. "Oh, thank you, Señor Wally. Maybe there's a statue to you in the coffee-growing highlands."

Yvgeney bit his lip, smiling as he drove, listening to Wally hang himself. He said nothing, but his wariness was rising.

Vegetation began to dominate the scenery as the hills got steeper and the miles between them and Manaus increased. Frequent raging streams and creaking one-lane wooden bridges slowed their progress. The Land Rover inched across slippery planks and beams. They traveled high on ridges and steep cliff roads above an ocean of cloud-filled valleys. A familiar drizzle met them as the road descended to a darkening fold in the hills.

"There should be a place down near the river where we can make a dry camp." Chana said quietly, confidently. "We should get to our village by tomorrow noon."

She suggested a bivouac on the shore of a raging stream. A bend in the rock-strewn riverbank hid the truck and campsite from other travelers on the lawless road.

"It's rare to see the moon in the valleys," Chana spoke softly to Wally, swatting mosquitoes and other giant insects at the river's edge. A large river boulder shaped like a saddle made a comfortable seat with the white noise of rushing water as background. Yvgeney was in his tent.

Wally tossed out what he felt was a positive remark, "So, this is your paradise. I can feel the power."

"Perfection fills this valley. I'm glad that you can feel it, señor." Moving slowly in front of him against the backdrop of a phosphorescent river, Chana appeared to glide.

"I bought a bottle of pisco on the way out of Manaus." Wally said. "Care to join me? I didn't bring out the glasses."

She said, "When I was a child here, I didn't know what glass is."

She accepted the pint bottle and held her head back for two big swallows. Her voice quivered as she spoke, "I never knew what a chair

is until I started my second life in Manaus. Even then, the value of a chair was based on how much firewood it contained. Why do you and Señor Braun care so much about the egg chair?"

"I'll try to simplify it. Furniture was always decorated with ornate shapes, and carvings, and fancy woods. The busier the better. Then a couple of guys came around and made chairs and other things with shapes that are perfectly simple. What you would call now, modern. Form is beauty. That started a revolution. A design revolution that we live in today. That egg chair is one of the original experiments."

Wally felt pleased at such an eloquent defense of the birth of modernism.

She said, "I like thoughts about changing the world. Señor Braun thinks like that also. Change-the-world thoughts. I have to confess that to my mind, it's just a chair. My thought is, get over it. You sit on it. End of story. Get a life, as you North Americans say. Why is the condition of the chair's surface so important to you collectors?"

He said, "Most important objects are best shown in their original finish."

"Does 'original finish' mean shiny and new, like the day a chair was made, or does it mean dark and old-looking after a lot of use?"

"That's quite a question, Chana. The usual answer is number two … all the life of an object, the oxidation and the fingerprints and the bumps give a piece character that collectors want."

"Your chair, Señor Wally, the one that Señor Braun so admires. Did you find that object in its original finish?"

She stretched in the moon glow, the rapids behind her a celadon blur.

"The egg rocker? No, the chair had been painted brown."

"Brown paint." She pulled the army shirt off over her head, bunched it into a ball, and tossed it at the shore.

"Does the paint ruin the chair as a valuable thing?"

Wally's voice broke. "Paint over original finish screws things up, usually." He looked at her firm, small breasts in the moonlight.

"Tell me more about the chair," she said. "Has the brown paint destroyed the value? Should I tell Señor Braun? Perhaps it's ruined also in his eyes."

"The chair's fine. I know a man, a refinisher, who can remove the paint and retain much of the original finish."

"Refinisher?" Chana's hand gently massaged his thigh. "I've worked very hard to know English. This refinisher, is he a master in this skill? An old European craftsman? Let me guess. His name is Leopold."

"Close, actually, it's Constantine."

"A Turkish man?"

"Who knows these days? I never asked."

"Another island artisan, then, this refinisher?"

Wally's visual attention was drifting. "No, honey. He's a guy from the mainland."

"Let's play a game. It's a game we play in Chile. Hear the name, and guess the country. She idly ran her left hand up onto the gringo's knee.

"You know, Chana, I never asked him for his last name. I always pay him in cash. To me he's just Constantine, the wizard of the original finish. I think he used to be a chemist or something. Why all the interest in a guy you've never met?"

"How are those cuts you received in Mexico? Are they healing?"

"They itch a lot, but they seem to be on the mend."

"I know a curative. It grows nearby."

She stood up, stretched, and looked away. Wally followed her movements through the low vegetation along the stream bank. She returned with a handful of greenery.

"This will help the itch, and it will promote the healing also."

She broke some stalks, squeezing a pool of sap into her palm.

"Take off your shirt, Señor Wally."

He did.

Soft hands caressed his back, moving downward from his shoulders. Wally winced as the cool liquid met the cuts below his beltline.

Chana said, "I know how the children work, they use box cutters. They go for the back pockets first, the wallet side, then the others. Then two more for the money belt that tourists think is a safety zone." Her fingers traced circles on his slippery buttocks.

"You sound like you've got some experience in this kind of attack. Were you robbed, too?"

"No, señor, I was a homeless child in a big city. Come to my tent and I'll get to the other wounds."

"I'm a married man, Chana," he said with a smile.

"I know. The photographer with the cardboard cameras. Don't worry, señor. It is a medicine that I offer, not chucha."

"Chucha?"

"I think you call it pussy." She opened the tent flap for him and they entered. The moonlit canvas interior glowed soft blue. A daypack and a sidearm were the only things inside.

"Lie down on your stomach. Loosen your belt, señor. I'm going to take away your pain."

"Don't you have a foam pad or a blanket to sleep with?"

"Lie down here, please. It's soft. The soil under trees is a bed."

Wally unbuckled his belt and unsnapped the top jeans button. He felt her cool fingers on his waistband. Tilting his hips, he helped.

She gasped, "No underpants! Oh, señor, you are a wild guy, no?"

"Just an old hippie, Chana. Burn the bra and all that. It's a social thing. A lifestyle."

"When I wear no underpants it means something else."

The cool sensations of the natural salve mingled with the stinging of the sensitive cuts.

"You men and your collections. Señor Braun has a man from the Orsorno Museum come once a month to apply a polish to his chairs. That finish is so important to him.

"One time the archaeologist Schmidt dropped an artifact on señor's table and caused damage to the wood. Braun fired him. Right there. He told the German that if the value of the table was deducted from his salary, that the scientist would work the next three years for free."

Her soft fingers made light contact with his body hair where legs met buttocks. Wally stifled a grateful murmur.

"Perhaps Señor Braun would like to know about your expert refinisher ... this Constantine. I know he'd be grateful for this fellow's phone number." Her hand reached between his legs and cupped his scrotum.

"I don't think there are any stitches there."

A slight elevation of Wally's hips was not unnoticed.

"I can remember the number if you tell me. I don't have a pencil handy."

Her hand reached under him and grasped his penis. Slippery fingers tickled and taunted. Wally raised his hips further to give room.

"Señor! Goodness, you're so ... that phone number?"

Wally was debating rolling over and giving up. He felt the probing of her other hand. His arms went down to yank his jeans back on, but a slight nudge of his hips pushed him over onto his back.

242

He felt the unmistakable pleasure of a warm mouth. He felt his right hand guided to her sex as she knelt. Her pants also were down, a move he hadn't noticed with his cheek to the floor. His finger traced the wetness between her outer lips. She groaned.

Slippery muscles gripped his fingers. Chana moaned and croaked a couple of garbled Spanish words. Her rhythmic movement encouraged his exploration.

She pulled her head up and turned to face him, "What was that phone number?" She asked the question coyly, as in a silly interlude in their exotic game.

"Six, two, nine ... I can't do this, Chana."

She turned to resume the interrogation, but his hands were there, pulling the buttons into place.

"Wally ... don't stop now. I want you. I can fuck you like you've never known with your gringo women. I'll keep nothing from you. It's OK. Please."

Her fingers wrestled with Wally's as they fought for control of his belt.

Wally won and backed out toward the tent flap.

"I'm sorry. I can't do this."

"No one will know," she protested. A sheen of moisture around her mouth added to her wantonness. "She's 10,000 miles away. She'll never find out. I can show you things you've never known."

"She'll know and it will kill her. *I'll* know." He crawled out into the damp evening.

"*Chingate! Bastardito, Tu te clava!*" she yelled from inside.

"Sounds like you broke her heart," observed Yvgeney.

"I thought you were asleep."

"You were in a tent, Casanova. In a quiet jungle. Ten feet from here. It's not exactly a soundproof room."

"I'm married. It just took some time to get that understood."

"Hello, señor, have I awakened you?"

"No, child. I was working late."

"I'm afraid the interrogation failed. I still don't have all the refinisher's data, but I have some."

"Where are you, my child?"

"Two hundred kilometers west of Manaus in my land."

"What have you learned?"

"The refinisher has the name, Constantine. He lives on the mainland, not on the gringo's island. His phone number begins with the numbers six-two-nine. That's all I have, sir. I'm sorry it's not more."

"That's a place to start. I'll send someone in the United States to this area tomorrow. There are men who specialize in finding 'lost people.' Many databases."

"Should I continue my assignment with the gringos?"

"Keep the man safe, by all means. But I have some other tasks for you in Brazil. Things are in motion, Chana. The Future Clubs in Manaus and Brasilia and Buenos Aires are waiting for you to deliver a word from me. You will give this word to Ignacis in Manaus, to Maria Emanuel in Brasilia, and Fabio in Buenos Aires. You will deliver the word, a signal, to these three. Air tickets from Manaus to Brasilia and Buenos Aires will be purchased and waiting for you. I'll provide transportation for our guests also. Encourage them to join you. For now. How soon can you return to Manaus?"

"We are three hours from El Cazador, where this gringo can see these curtains that excite him so. It amazes me that cloth can cause

244

such excitement in a grown man. We can be back in Manaus day after tomorrow in the morning. Is that too late? If I stop the gringo's quest we can return by tomorrow evening."

"Finish your business. An additional evening will not change our timetable. I wish you were by my side right now, Chana. There are questions that are being asked about our … enterprise. Exposure now would be disaster. An Interpol busybody has been asking questions. I will feel better when Chana, my sword, is back at my side."

"I also ache to be at your back. You are a great man, Señor Braun. I hope to lay down my life to keep you safe."

"Three or four more days, my child, and you'll be home."

Chapter Thirty-One

Amazon Jungle, Brazil

A slammed car door woke the gringos in their tent. Morning light glowed yellow through the waterproof liner above them. Wally stuck his head out the flap and said to Yvgeney, "The other tent's gone. Chana has the campsite packed up and loaded in the four-by. Guess it's drive time. There goes my morning coffee, dammit."

They reached the village at 9 a.m. A rocky cliff-edged clearing surrounded by tall green peaks held a scattering of tin structures and meat markets clustered around the church. The main street was a mass of wet, muddy ruts. Few people were about. Chana hustled the visitors up to the huge wooden doors of the slowly crumbling monument to eighteenth century Christian zeal. Both men noticed the Amazon girl's new urgency. She had not spoken to either all morning.

They entered the quiet, empty church. Light through the leaded windows bathed the wooden pews and simple altar in Roman Catholic celestial magic.

A brown-frocked sixtyish European appeared from a door near the altar and padded over to the entourage on sandal-strapped feet. He was bald and chubby, the image of a friar. There was a twinkle in his eye as he spoke, "*Hola muchacha en muchachos.*"

Chana spoke to him in Spanish and he changed to an Irish accent.

"Hello, gentlemen," he said crisply. "You've traveled a long way, it seems, to visit this wonderful place. It's rare to see European faces here. Can I bring you some cold water?"

The visitors smiled and declined.

"We have been told of wonderful decorative fabrics that grace this chapel, Monsignor," Wally said.

"No, Monsignor, goodness no. I am a simple servant of God. Call me Father James."

Yvgeney stepped up and introduced himself, as did Wally and Chana.

The friar spoke, "We have many sacred objects here in St. Ignacio. The chalice here is from Spain. It's said that it was touched by St. Sebastian." He gestured toward a wooden cross bearing a slumping but wondrous Christ figure suspended in the red and blue light filling the high-ceilinged altar chamber. "The crucifix was carved over 100 years ago by a native artisan. He used a single tree, a giant one found growing in the lowlands." A thorn crown with green gems twinkled in the light.

Yvgeney's practical eye for ecclesiastical booty, honed by eight months in Bosnia, Serbia, and ethnic Albania, spotted bright fabric in the side room Father James had exited. He pointed this out to Wally with a turn of the head and eye contact.

He said, "We were told that some magnificent curtains, perhaps made in England at the end of the nineteenth century, are also part of the decorative interior. May we look at the curtains in your office?"

"That place is not my office. It's called the sacristy, the place for storing sacred things and vestments. But, of course, you are welcome to enter and look."

He turned and struggled to catch up with the determined strangers in his church.

Inside the vestibule Wally and Yvgeney stood face to face with a Pre-Raphaelite masterpiece. A ten-foot-tall cascade of brightly decorated fabric hung on both walls, flanking an ornately carved wooden door bearing large wrought iron strap hinges. Birds and trees and gargoyles and a colorful intertwined background shouted William Morris & Company.

God, the colors are so bright, Wally thought. He'd seen plenty of printed images of Morris motifs, but this was a wall-sized real thing, probably close to the original color. Wally was fingering the soft weave, tipping the lower corner of the curtain to see the underside color and hoping for a signature or cloth tag to seal its identity. Yvgeney leaned close and spoke quietly over his shoulder, "This is not a field that I have any experience in, Wally. What do you think they're worth?"

Wally whispered back, "They're good, top quality. I'd guess 5,000 easy. Maybe quite a bit more. I could make a few phone calls."

The friar behind them spoke, "Thank you for visiting us to see the curtains. Forgive me for being cautious. These are not trusting times. Do you like them?"

"Very much, Father. We have traveled a long way to see them."

With a conspiratorial crook of the head the priest grinned and said, "I'll bet you'd like to see the angel curtains."

"Of course," answered Wally, who had never said *no* to a *would you like to see…* invitation in his life.

"We keep them in here." The friar turned toward the door flanked by curtains and turned the heavy ornate handle.

Yvgeney looked at Wally who lifted his eyebrows three times. The Russian smiled back.

Chana wondered what all the interest was about. South America is full of colorful fabrics. Every village in Central America

has some kind of shirt pattern that marks them like an identification badge.

A dark musty cloakroom for more ornate vestments was behind the massive door. Colorful robes in purple velvet with ornaments of gold thread hung on simple hooks. A carved low chest sat in a dusty dark corner. Father James opened the ornate wooden lid that depicted the descent from the cross in High Renaissance relief.

The friar lifted a bulky roll of fabric out of the coffer and set it on the floor. A polished white painted rod extended from the ends.

"It's nice to speak English. I don't often get the opportunity here. The village has about 100 people, though many more appear on days of religious celebrations. They come from the farms and mines, although not many *garimpieros* show up these days to church celebrations, or to mass on Sundays. If one of you would grasp the rod here and here," he indicated the ends, "then another could unroll it without soiling the fabric. We're very careful with the angel panels."

He brushed the floor dust off the roll as Yvgeney grabbed both ends of the dowel, holding the cylinder like a giant rolling pin. Wally grasped the loose cloth end and pulled it open to reveal a brightly colored art nouveau panel, eight feet long.

Glasgow School, he thought. *Shit, it's really beautiful.*

His eyes danced over satiny threads embroidered on tan linen with orange-colored details. A long sliver, suggesting an abstract human form, resembled a stylized feather with a woman's head at the top, ringed with a halo. Long black-and-white checkerboard verticals ran down both sides, exaggerating the length. *Unquestionably the school of Rennie Mackintosh, maybe even the hand of Mackintosh's wife, Mary MacDonald.* Wally's knees wobbled. He wanted to sit down.

"This is amazing," he said, getting that feeling he got when near greatness.

"The other one has a small hole in it. A bullet hole, actually, but it's hardly noticeable."

Wally asked the question slowly. "You have a pair of these?"

"They've been in the chapel here for 100 years, I'd say."

"How did these panels find their way to a church in the middle of the Amazon Basin?" Yvgeney asked.

"Beyond my time," the smiling monk said. "They were hanging on each side of the confessional when I came here in 1968. We took them down when the fighting started 12 years ago, after the first bullet hole. We display them now only at festivals. Do you think they are also valuable?"

Wally said: "Yes, I do."

He felt a kick in the ankle, a painful one. It was Yvgeney.

"I ask, because there is a crisis here at St. Ignacio. Our funds have been canceled. No reasons were given. The mysteries of the diocese sometimes have no logical explanation. We exist here with very little. Our needs are modest. We prayed for an angel, one who would allow us to continue here, without outside funding. We prayed for the angels on the curtains to deliver us a miracle."

"Are you offering to sell the curtains?" asked Yvgeney.

Wally's eyes went wide and he pulled a mildly interested look over them as a matter of habit.

"The curtains in the front room, yes. The trader for Manaus said that he would send us a collector of European decorations. We need 20,000 pesos … just over 2,000 American dollars, to get us through the next round of the bishop's conferences with enough to spare for a representative from our village to go to Buenos Aires and plead for the future of our chapel."

"What about the angel curtains?" Wally asked. He tried to look casual.

"Oh, heavens no. We love the angel curtains. We march them through the town during festivals."

"I'd like to make you an offer on both," Wally said.

"Mr. Winchester, can we confer?" The Russian tipped his head and made face movements to suggest a private word.

"Excuse me, Father," Wally said, but the priest wasn't about to let go.

"What would your offer be? The angel curtains are beautiful but they're just embroidered, simple woman's work."

"I'm thinking of around 10,000 dollars for both sets."

Another kick in the ankle. It smarted.

"Excuse me, Father, but I must speak to Mr. Winchester privately." Yvgeney's disapproval was noticeable. He pulled roughly at Wally's arm.

The priest nodded and stepped back into the vestibule. Chana was thinking about the angel. She'd seen one, once, near a mossy jungle pool where water fell from rocks above. It was in her early memory, the memory without words.

"Are you crazy?" hissed the Russian in a loud whisper.

"Those are Mackintosh panels. I'd stake my life on it."

"You're staking my money on it, Wally. The good father had no clue as to the angel curtain's value. It's not your funds we're riding on. It's mine. He would have sold us both for another 1,000 and he would have blessed us all the way to Manaus."

"A set of Margaret MacDonald panels could go through the roof in a good Christie's sale. Museums and collectors would fight to the death for them."

"That's the point, isn't it?" Yvgeney concluded. "I'm talking to an idiot."

The disbelieving look on Yvgeney's craggy face reminded Wally of high school guidance counselors' expressions as they gave up on him, 30 years before.

"Ten thousand bucks is chicken feed if these are what they seem. The church is in trouble. We're asking them to sell us their miracle. I'm even thinking of sending some of our profits back here after we sell them."

"That must have been some piece of ass you got last night. Who do you think you are? Che Guevera? We're here to find great stuff cheap and sell it back home for a lot of money. Right? Isn't that what capitalists do? We're not here to provide foreign aid."

"I think 10 grand *is* cheap, Yvgeney. In the right sale, those angel curtains would keep this place running for 10 years. I'm tempted to just broker the sale for them. We'll still get 25 to 30 percent if we act as their brokers. Thirty percent of a lot of money is a lot of money."

"We're here to make money, partner. That's our primary objective, is it not?"

"Not at the expense of ethics."

"Wally, you're the capitalist, I'm the socialist, remember? Making money is your specialty, I thought?"

"I think your ideas about capitalism need some work, old buddy. I still like to sleep at night."

"That 10,000 dollar Stickley Morris chair that you bought outside Chicago from a farmer for 135 bucks. Did that keep you up last night?"

"That was different. That old boy pulled a hay-covered relic from the barn and dragged it off to market. To him it was pocket money for what he thought was Midwest barn trash. The curtains here mean a lot to these people. And they're probably worth a shitload of

money. We have a moral duty to reflect that. The priest asked what I would pay. It might have been different if he'd quoted a lower price."

"He was about to quote a lower price, a much lower price, until you blurted out 10,000 dollars."

"I know. I think I threw the number out to stop him from giving them away for nothing. Interesting, isn't it? Me helping the seller."

"I can't believe this. You told me early in our relationship that you always maneuver the seller into determining the price! 'It's the poker game of bargaining,' you told me. 'Always try to see the other guy's cards first.'"

"Do you want to get the church to consign them to us as sales agents, Yvgeney? That way none of your precious Russian bankroll will be at risk. We'll still do OK, especially if they break some records. The angel curtains are scary-good."

"If they're worth that much I want to have some ownership," said the softening partner. If you want to return some of your share to the church, it's up to you."

"Let's give them their miracle," said Wally. "We've got the funds. We're not going to lose, trust me."

"Agree to this, then. If these fabrics sell for under 10,000 dollars you'll pay me the difference."

"You bet your sweet ass I will. Sign the traveler's check, partner."

The 4 x 4 rode a little lower with the weight of the heavy English woolens and the wooden renaissance coffer that Yvgeney managed to shoehorn into the final agreement. Father James, gazing at a pile of traveler's checks on his desk, blessed them as they drove away.

Chana, sitting in back with the booty, spoke to the men in front, "I have a meeting in Manaus. Señor Braun's business interests are his Future Clubs. He asked me to visit three facilities before I return to Chile. One is ahead in Manaus. The second one is in Brasilia and then the third is in Buenos Aires. He said I should offer you my aid in these cities also if you would add them to your itinerary. Is that the word for your schedule of travel?"

"Yes, that's the right word. Brasilia, eh? I'd love to snoop around in a just-invented city. Could be a modernism goldmine. I've always wondered. What do you think, driver?"

Yvgeney still felt uncomfortably lightweight with the severe reduction of his stash of traveler's checks. "We should make some arrangements to ship these objects as soon as we can," he said. "I feel uncomfortable with all this treasure in a region with no laws."

"Manaus is a *zona Franca*," Chana said, "a duty-free zone. It's a good place from where to export. We can find an associate of Señor Braun there to assist us, after my Future Club visit, OK?"

"Great ... duty-free," Wally said. "I knew this trip was on the right track. Right, partner?"

He punched his partner's solid bicep. The truck lurched again as muddy wheel ruts grabbed the tires and pulled them back in.

Chapter Thirty-Two

Manaus, Brazil

In the colonial central core, a section of the city that Chana described as a monument to European greed, the city of Manaus looked clean and orderly. No one had slept during the uneventful exit from the hills beyond. It is not wise to travel at night, they'd been told, but they'd encountered no *banditos* or *federales*, two groups who promised to be equally dangerous to people with a truck full of treasure.

Wide, manicured sidewalks with beautifully landscaped grounds behind them seemed as out of place in the Amazon as the columned edifices that ringed the cobble-stoned central plaza.

People of many varieties mingled in a foot-traffic version of the morning commute. Tourists in white mingled with street hawkers and domestics and occasional businessmen on their way to work. Children filled the park benches and shady corners in listless, rag-tag groups.

Behind the entrance of a huge neoclassical structure, a tarnished golden dome high above them held Chana's attention.

"This is my city, señors. A hellhole built with blood and rubber. They say that famous performers from the big gringo cities came here in the old days to entertain 100 families, European families, who enslaved the true people and built their fortunes on the bones of my ancestors. This opera house is the monument to those times.

"Arrowsmith came here from America once and played rock and roll music in the great hall. I lived here then, but I had no money to purchase the tickets. I look forward to the day I can watch it burn."

"Tell us how you really feel, Chana."

"That is how I really feel. Two times now, you've asked me that question. Do you think I hold back my words?"

"It's just a North American expression, Chana. It suggests that I hear your pain."

She shrugged. "Turn left up here."

The streets narrowed to cramped lanes between brightly colored brick buildings with flowers on the balconies. The simple structures sported roll-up doors and grimy gray and brown office windows.

Chana's destination was a two-story stucco edifice with six windows above a brightly painted door. Yellow ocher stained the once-white exterior. Broad wooden trim around the Alamo-shaped façade was a bright fluorescent blue. Six or seven young people sat on the concrete steps below the front door. A signboard over the first floor window showed two brown hands clenched in a grip and a stylized modern typeface: *Clube Futuro*.

Chana directed the 4 x 4 to a shady spot under a mangy broadleaf tree, plucked of all its lower branches.

"No one will bother you here, señors. Not with me inside. Nevertheless, you should remain with these objects and be prepared—"

She locked on Yvgeney's eyes and pulled them down to the automatic pistol on the seat. "In any case."

The lounging youth parted as she entered. Animated conversation followed and they all stood up and entered the building after her, closing the red and yellow door.

Flies buzzed around the dog dung littering the thin soil beside the Toyota. Wally flicked them aside as they flew into his window, lured by the scent of humans inside.

An hour passed with little conversation. Fierce morning sun burned through the moist equatorial drizzle and added 10 degrees to the sweltering interior of the vehicle. Wally was falling asleep.

"I've got to get out and move around a little," he announced. "You OK here by yourself?"

"I can protect our interests here. Don't wander off too far, Dorothy; this isn't Kansas any more."

Wally exited the passenger door and carefully stepped through the fecal minefield toward the Future Club front steps. Occasional vehicle traffic interrupted an eerie urban silence. No birds, just distant low-frequency rumbles and the high-altitude whine of another Varig Airline approach.

Wally walked down to the corner of the deserted street. A truck was backed up to a loading door a few buildings ahead. Three men bent and lifted as they worked. A pack of six or seven dogs were mingling and humping willing females farther up the quiet street. He stretched again and wandered back toward the Future Club stoop.

He decided to take a look inside.

At the top step he looked back to check on the four-by. The glare of the windscreen made it difficult to see the Russian's head, vigorously shaking NO!

The door opened easily and led Wally to a spacious lobby with a YMCA-type front desk at the far end. Card tables with folding chairs dotted the interior. Divans in bright fabrics sat against two walls. A glass case holding trophies and photographs of sports teams, mostly soccer, covered another wall. Portuguese language posters for old American movies were the principal decorative theme. The room was empty, except for an adolescent Brazilian girl behind the activities desk.

"Hello," Wally said. *"A boa vinda o o clube futuro. Senhgor pade mim ajuda-lhe?"*

"Hi, I'm just looking around. My friend, Chana, is in here somewhere for a meeting."

The child tilted her head at the English words, but her eyes got wide with the mention of the name, Chana. She stood up with her eyes downcast.

"Excuse, por favor," she said and backed out of the room through an unmarked door.

Wally looked up to check out the lighting, but was faced with a fiberglass drop ceiling. He noticed four cameras, one in each corner. It seemed like a lot of surveillance for a youth center.

Music wafted in from a hallway leading inward to the left. He wandered down a corridor past closed doors on either side till he got to the source of the noises. Wally knocked and tried the knob. It turned. He poked his head in as the door swung inward.

Five teenagers sat on a torn but spacious flophouse divan. A CD player and a pair of base speakers were delivering music from the Doors's *Riders on the Storm*. Three girls, two boys. Heavy clouds of cigarette smoke filled the room and spilled into the hall. They looked up and politely said, "Hello."

Wally waved and closed the door on the music. He heard quieter noises across the hall. He was bolder now. He opened the door and stuck his head in with a disarming grin. Ten heads looked up from laps full of basketwork. A young woman standing over the weavers smiled and walked over to the door. There were no windows, but colorful fabrics lit up the light tan walls.

Handicraft class! Wally thought.

"Hello," she said with a smile.

Wally smiled back. "Do you speak English?"

"A little. Are you a *tourista*?"

The weavers all looked under 15 years old. Wally looked back to her almond face.

"No, not exactly. I'm here with Chana."

Her face lost a shade of tan. Eyes lowered.

"What do you request of me, my lord?"

"Eh … nothing … just nosing around. She told me she grew up here in Manaus."

"This is a weaving class, sir." Eyes lowered again.

"So, you know Chana?"

"Everyone knows her—The Sword of Braun. She is magnificent, yes?"

"She's quite the lady. Yes, she is."

"I am at your service, señor."

"Thanks, I guess I'll just wander around."

"As you wish." She smiled and lowered her head to withdraw. He closed the door.

He shuffled back out to the lobby, blinking at the bright light streaming in from outside. A silhouetted figure waited in the center.

"Welcome to the Future Club of Manaus, señor. How can I help you?"

The voice was young and male. Wally closed the gap. His eyes adjusted to make out a dark-haired Andean, large nose, big brown eyes. About 21 years old. He stood like a person who's had weight training, solid, but non-threatening.

"I'm here with Chana…"

"I know, she asked me to come out and give you a tour of our facility. She's in a meeting."

"You're sort of like the YMCA here, right? You know, sports, crafts, counselors…"

"Perhaps. Señor Braun says we are the building blocks of tomorrow. My life belongs to him. Forgive me, señor. My name is Lucio Brado, at your service."

"Walter Winchester at yours."

"I've been instructed to show you the facility, Señor Winchester."

"Can you rustle up a cup of black coffee?"

"You desire coffee?"

"Does the bear shit in the woods?"

The young man tilted his head. "Yes, in the woods. Do you want coffee?"

"Please."

They walked together to the spotless kitchen, then began a guided tour of the second floor activities with Wally holding a steaming cup of lousy instant Sanka.

They grow it here, for Christ's sake, he thought.

The guide directed Wally to a large room partitioned like an Internet café with two wall-length desks and phone booth-like partitions separating a roomful of PCs. Few of the workstations were vacant.

"For any child who wants to escape the street, we feel that computer skills are important to master." The youngster smiled. He swept his arm across the room. "A gift of your Bill Gates."

They toured the gym, currently involved in a T'ai Chi class, then three other classrooms, all holding a smattering of children appearing to listen to the instructors.

"We create complete people from the empty shells that live in the urban shadows here in Manaus. We fill them with skills and knowledge and physical strength and a love of … God. Then they are people in the family of Claus Braun."

A soft ringing.

The youth opened a pocket phone, listened, and then frowned.

"Excuse me, señor. Can you wait in front till I take care of another matter?"

Wally nodded, nearly asleep. As he shuffled out toward the bright lobby, visible through the windowed doors at the end of the corridor, he heard muffled loud discussion.

He opened another door, and everything changed.

A meeting in full tilt stopped. All heads turned. Three were in full Arab headgear. Chana stood at the front of the chamber. A projection of a South American map complete with arrows and red stars glowed on the screen beside her. She spoke softly in Portuguese and the projection went black.

"I'm sorry, Chana. Excuse me. I'll wait in the lobby."

It was a weak exit line and he knew it. A large man sitting near the door stood up from his chair. The look on his face made Wally back his way out into the hall and close the door.

Wally heard it click. He backpedaled his way into the sunny front hall, trying to find a place in his very tired brain to put the information he'd just gathered. It didn't quite compute, so he gave in to his fatigue and wandered out the door to sleep in the Toyota.

Yvgeney was awake, but losing his battle with sleep, also. He looked cranky. Wally kept his mouth shut, dreading the idea of a conversation. He fell asleep instantly, and dreamed of Arab babies using computers.

Even with Chana dropping names and pulling strings, it took four hours in sweltering warehouses to get three packages crated for their duty-free trip to Seattle. Chana's words had an angry edge as she directed them through the barrio and the mean streets at the edge of the

city to the airport, where they parked the rental and marched through security, too tired for banter. Even Wally was silent.

The turboprop business jet's engines whined loudly as they climbed up the ladder steps to the roomy cabin. A thousand feet below them, the Negro River spilled its dark waters into the fat green Amazon in a curling fractal plume. Low sunlight caught the waters and turned all the rivers shimmering gold.

Chapter Thirty-Three

Brasilia, Brazil

Sunlight hit Wally in the face. He looked up and saw Yvgeney out cold on the other single bed. He threw a pillow at him and he stirred.

"Goddamned socialist for a business partner," mumbled the facedown sleeping form. "Ten thousand dollars. 'Give them 10,000 dollars', he says. 'Think of the people; let's save the people.' God help me. I'm on a buying trip with Chairman Mao."

"Get over it, Ivan! We're going to be rich real soon. This city could be a mid-century treasure trove. I heard of a woman who found a marshmallow sofa here in Brasilia in the trash. A 10,000 dollar couch in the garbage!"

"I'd pay 10,000 dollars for a cup of Starbucks coffee right about now," mumbled Yvgeney. His tired face resembled a topo map of Badlands National Park. "Do you think we can find real coffee here?"

"Is Chana in the other room?"

"I heard her leave a couple of hours ago. I think there is more to this Chana than meets the eye, my friend."

As he dressed, Wally told him about his visit to Chana's classroom in the Future Club. Even now, with a clear mind, he couldn't make sense of this rogues' gallery crew sitting in a high school setting, listening to a lecture from his interpreter. If that group were the Future Club board of directors, Wally didn't want stock options.

Yvgeney was disturbed by the description of Chana's meeting. Of course a directors' meeting would be attended by mature adults. There was no reason to be surprised by Arab headgear, either. Muslims live all over the world. Chana running a meeting? This is a side of the woman he didn't know. He'd felt a distant rumble when he looked into her big dark eyes. Something Julio said in Mexico City still sat unreachable in his head.

A sheet of typewriter paper was taped to the door to the hall. In careful, childlike lettering it said: "The streets are dangerous here. Many desperate people. Remember Mexico City. I will be back by noon. Wait for me. Breakfast downstairs is free. Don't go out!"

Wally looked out the dingy hotel window, expecting to see a moving, active crush of cars, bicycles, strollers, and deal making. The street was empty. One solitary traveler, a cleaning lady-type with stooped shoulders and fat ankles in short white socks and tennis shoes ambled down the lonely sidewalk. A long multi-windowed building rose above the local businesses in the quiet neighborhood where they had crashed hard after the long night before. He spoke over his shoulder to his partner, "This is supposed to be a national capital city. Let's see if they have any real coffee brewing downstairs."

The thick, bitter blend left a film of sludge in the dregs of their empty cups, but it was perked. They chewed on the stale white toast and jam that was called a continental breakfast.

Wally read to Yvgeney from a tourist brochure he'd grabbed at the lobby desk. It was printed in English.

"It says here that Brasilia was invented in the 1950s as a new capital, away from the sea and safe from invaders. An urban planner named Lucio Costa won a design competition with a plan called *Plano Piloto*. The city is shaped like a giant jet plane with the government in

the body and the people in the wings. The primary architect was a modernist visionary named Niemeyer … think of it, old buddy, we're smack dab in the middle of an architect-designed hen house, and we're the big bad wolf."

Yvgeney's awareness of their exposure to danger had been sharpened in the last exhausting week. He read the back side of Wally's information sheet from across the Formica-topped table.

"Read the last paragraph," he said, chewing.

Wally turned it over.

"Brasilia is not a walkable city," it says. "The distance between buildings and sectors requires a vehicle. There are sectors for hotels, others for finance, commerce, sports, and diplomacy. Because of rigid zoning laws and the basic layout, the majority of the population lives outside the city limits. In these lower-income satellite cities, you'll find the essence of Brazil."

Wally's picker-brain was aching to be outside.

"I guess we'll need a cab! Want to shake the trees and find some old Eames chairs?"

"I prefer to wait for Chana. She warned us to stay put."

"She could be hours. We can stay inside the car. Check out the neighborhoods. There's usually a section in these South American cities where the used furniture turns up for sale. It's usually in the shitty end of the commerce section. Trust me, Yvgeney, I can read a city—"

"I know, Wally, like a woman."

Wally wasn't listening. "In Chile the secondhand stores were called *remates* and *antiguarrios*. Ought to be a similar word in Portuguese, don't you think?"

"I wouldn't feel comfortable on these streets without a gun."

"Lighten up, it's the capital city! Lots of bigwigs are coming and going every week. It's gotta be safe. The President of Brazil lives

here, for Christ sakes. Come on. The hotel can find us a tour guide with a car."

Wally didn't notice that even on the flowered street outside their modest hotel, the few pedestrians moved with careful steps, looking around nervously, like prey.

Guide service was summoned with a call from the hotel desk. A young man in a Yankees baseball cap introduced himself, in English, as Armando Cruiz.

"Can you take us to the place where used furniture is sold?" asked Wally.

The skinny dark-haired youth rubbed his pimpled face. A day's worth of black stubble crinkled under his fingers.

"Used furniture? *Oh, usado de casa, antiquarians, Si Mercado de pulga* ... the flea market?"

"Yes, the flea market."

"It is in a zone, not ... for tourists ..."

"That's OK. We're not tourists. We're businessmen."

"OK," he said: "Fifty dollars, US funds, for the first hour. After that we talk again."

Yvgeney started to complain, but his partner blurted out, "You bet!"

The twin square towers rising above the federal city were visible in the distance. Flowered, tree-lined boulevards of the central core were gone now, replaced with tin shacks and meat stores and milling groups of listless poor.

Armando was chatty, full of historical facts and hero stories, but as they headed farther away from the center of Brasilia, he quieted, looking intently down the littered alleys as they passed.

He drove boldly when clusters of pedestrians loitering at intersections failed to clear the road. He honked the horn and swore out the window in Portuguese, but he kept the vehicle in motion.

A gaggle of school desks spilled out into the street ahead. Large loading doors to the right opened to dark interiors, illuminated by sputtering fluorescent ceiling drops.

"Looks like we found the mother lode," said Wally. He was moving quickly, halfway out the door in front of the first loading dock when he asked, "Can you go with us in here, Armando? We could use a translator."

"He'll want to say out here with his car, I imagine." Yvgeney said.

The driver agreed: "I will remain here in the car, señors. It is not a good place to leave a vehicle unattended."

Unarmed with Portuguese words, the visitors climbed up the steps to the dock lid and entered an office through a man door to the right. Yvgeney held back, scanning the periphery for signs of danger. Wally spun his brand of western diplomacy to a squat, bearded lout clenching a cold cigar in a mouthful of black-stained teeth.

"*Hola*, señor," Wally began.

The proprietor sat behind a battered metal desk, covered with papers and half-opened boxes, and a hand-crank calculator. No trophy antiques adorned the shelves. No "look what we found" paintings on the walls. The man looked up, unsmiling.

"*We quiero modernismo* ... Brasilia modern ... Niemeyer chairs ... *mobiles* ... *antiquarios* ... can we look around?"

The fat man snorted, laughed out loud at some little inside joke, and waved them in with a sweep of his short hairy arm.

By noontime Wally's dream of a modernist treasure trove was forgotten. Torn urine-stained couches, rat-infested piles of cardboard armoires, and a boring variety of wood and metal chairs filled the warehouses on the street with a sense of profound dismay and a dreary, total disregard for style.

Yvgeney remained on alert. He shook his head, wondering how his idiot partner had dropped them, totally exposed, in the armpit of a dangerous section of town for nothing, nothing but busted-up castaway junk from a generation of the desperately poor. He looked behind him through the open loading door to the street. Their car and driver still waited.

"Let's go, Wally. You won't be finding any Frank Lloyd Wright down here. I don't like the exposure."

"You're right. This is crazy. How can they buy this crap to furnish such a beautiful city?"

A group of young people was crowded around the taxicab when they returned. They walked across oil-stained dirt through a surly crowd of unruly teenagers. No one moved to let them pass. At the car, an angry Armando had stepped out to threaten some of the bolder street children with his fist and a lead pipe.

"Get in, please! Hurry!" he said, glaring at the dark eyes that hovered just out of arm's length in the hot afternoon sun.

A small black boy, perhaps nine years old, came up innocently to Yvgeney and asked for spare change in Portuguese. His dark eyes wept a crusty rim, suggesting some hideous South American parasite. He had a face that, to Wally, looked like a *Save the Children* charity poster. Open sores on his arms looked like cigarette burns.

"Hey, *puto*," the driver said to the boy. "Why aren't you working? You're always playing. Life is not a football game."

He laughed cruelly and lifted the lead pipe. He feigned a swipe, pretending to hit the child. Tears ran down the boy's face.

"Huh? Huh? Always a beggar, *puto*. I should kill you, *rato*. Yeah, I'm going to kill you."

He lunged again and laughed. The boy shrank back into the crowd of kids in the middle of the street. Wally watched as the others kicked him and struck his tiny form with their fists.

"Please get in."

The sound of tiny pings filled the interior as a rain of stones rattled against the rolled-up windows. They sped away, producing a cloud of dust that enveloped the youthful angry crowd.

"Take us to the Future Club," the Russian said.

The driver's callous cruelty caused silent awkwardness as they headed toward the city center. Armando's window was open again. One hundred degree heat swirled through the bouncing vehicle, where it picked up the scent of evergreens. He appeared not to hear.

"Future what, señor?"

"*Clube Futuro*," said Yvgeney.

"Oh. *Si*. Why would you want to go there, señor? There are so many beautiful places to see, the university, for instance. How about the new Guggenheim Museum? We have a new nightclub now. A Hard Rock Café. If you want, later, I can show you the nightlife."

Wally began to object but noticed the "don't fuck with me" look on his partner's face. "Our translator is at the Future Club now," he added, wondering what Yvgeney had in mind.

"We're supposed to meet her there," Yvgeney said.

"As you wish, amigos. I still suggest the new library instead. It's a beautiful building."

The unpaved streets turned to chipped, broken concrete, then tar as the taxi neared the city center. Square white cubes and sweeping

concrete facades with expensive goods for sale replaced *carne* stores and *ferriterias*.

They turned down a side street and entered a parking lot with a massive cinderblock monolith, big enough to play basketball in, at the opposite side. The sun was high and cast no shadows as it blasted the city with vertical rays.

The driver cautiously crossed the open space and headed for the front door. A number of children lounged on the stoop outside. Four new Mercedes-Benz town cars gleamed in the sun. Yvgeney noticed a number of other big-ticket rides parked nearby. A beat-up old school bus that advertised *Clube Futura* on the side in simple black letters was parked alone near the door.

Armando seemed nervous and asked if they still required his services.

Yvgeney said, "Yes, I want you to stay."

The young Brazilian demanded another 100 dollars, US. Cash. Wally began to whine, and was surprised when Yvgeney paid it, with the warning that he'd better still be here when they got back out.

"Chana's name will get us in, Yvgeney." Wally said, knowing that her name had seemed to be a free pass everywhere they went.

"I'm sure it will."

Armando also caught the name; his face darkened. He lowered his eyes and said, "Is there anything I can do in addition, señors? I am at your service. Please remember that."

"Just stay here," ordered Yvgeney.

At the front door the lounging teenagers stood up. They all wore khaki shirts over jeans that could almost be mistaken for a uniform. They closed ranks as the gringos approached the front door.

"We're with Chana," Wally said, with a sideways wink to his partner.

The words visibly startled the young gangsters and opened an immediate path to the door.

"No YMCA I know of has guards," Wally said.

Yvgeney remained silent.

The soaring vault of the lobby was supported by marble columns with Doric scrolled tops. New leather club chairs sat scattered against the walls. Two checker players hunched over a board. Another brown-shirted teenager appeared from the shadows. He was talking into a cell phone as he approached.

"We are closed to the public today, señors."

The voice was deep and heavily accented, a surprising sound from the slight, but confident, young man. There was no room for disagreement in his tone.

"We're here with Chana." Wally smiled, using her name as a sledgehammer.

The aggressive demeanor morphed into respect. Another set of eyes tilted to the floor.

"Please excuse," he said, and turned to his phone. Out came the walkie-talkie for more hushed instruction.

"Please wait here. Please sit in these comfortable chairs."

He waved his wrist at the checker players and they vanished.

"Can I get you anything? A drink, perhaps?"

"Do you have coffee made with grounds?" asked the gringo.

Wally scanned the room. Two expensive contemporary light fixtures, Italian crystals sparkled with incandescent reflections, hung above their heads. He saw surveillance cameras here, too, and pointed them out.

"Quiet for a famous young people's drop-in center," Yvgeney said. A slight echo fuzzed the acoustics behind his words.

"They run a lot of classes." Wally said. "I got the lecture back in Manaus. Seems they look at the street kids as empty pastry shells.

They fill them up with Future Club cream filling and send them off into the world as keyboard operators."

He strolled across the hall toward a pair of double swinging doors with wire in the windows. Beyond them was a long, well-lit, blue-painted hall, punctuated by open classroom doors and gray-green lockers against the walls.

"I'll show you some classrooms, Yvgeney. This club seems to be laid out the same way."

The Russian nodded as he walked briskly to the doors. They went in.

The first classroom had 10 desks and a world map pulled down behind a teaching station.

"Geography."

Two more empty rooms, a science room and a chemistry lab, brought them to the end of the corridor with a turn to the left and more lockers and doors beyond.

"Hello, what's this?" Yvgeney made a wide turn toward a nondescript door in the corner.

The plain steel door had no window and no identifying numbers, but it had a keypad box beside the new bronze doorknob. Wally had pegged it as a broom closet and dismissed it.

Now he said, "Pretty fancy get-me-in for a closet, don't you think, partner?" He could sense Yvgeney's military mode kicking in.

Lifting the dust cover, the Russian inspected the keys and the functions. He looked around and said, "We better wait for our coffee in the lobby. Come on."

"But why?" Wally started to object.

"Just go. Hurry."

They started for the front door toward the backlit double doors. Click.

The gray mystery door opened. A twenty-year-old holding a clipboard saw the strangers and froze. She was halfway out the door and unable to retreat or advance into the hall.

"Chana sent us," Wally said, waiting for the expected reaction. He got it.

"How can I help you, señors?"

"We're fine. Just go about your business, señorita," Yvgeney said imperiously.

He held the door open and allowed her to pass nervously into the hall and disappear.

He looked inside at a concrete stairway to a lower-level door.

"Wally, stay up here while I sneak a peek at the boiler room, OK? Tell our greeter that I'm stretching my legs. You can have my coffee."

"You shouldn't be down there without backup, partner."

"I need you to keep the front guy busy. Take in another lecture. I'll be out in 10 minutes."

"What do you think is going on? This isn't like any Boys Club I've ever seen."

"I don't know, Wally. Chana is much more than she appears. I know that. Get back to the lobby, please. Hurry!"

Wally returned to the front room and was fingering the soft leather in the club chair when the tan-shirted youth entered, holding a tray and two cups in saucers.

Another corridor was behind the door at the bottom of the stairs—brightly lighted, but probably not a good place to be found wandering around.

The Chana card is all I've got, Yvgeney thought as he walked past windowless unnumbered doors. *Her name will be a stun-weapon at best. She'd kill me herself if she caught me here, I'm sure of it.*

The last door to the right wasn't closed tightly. Yvgeney listened for a moment. The only sound was the whine and hum of a system moving air through grates in the plaster ceiling. He decided it was empty.

Inside he found a light switch on the left wall. The bright, white classroom appeared to be a metal shop. Six worktables with vices and worn, oil-stained drawers sat in the center. A demonstration table occupied the opposite end. Behind it was a pull-down chart, describing the cleaning and breakdown instructions for an AK-47. On the wall hung charts and test data on various brands of ballistics. To Yvgeney it was a weapons lab, maybe even a shop class in warfare.

Settle down, Ygveney told himself. *It's just a weapons room under a building in a dangerous city.*

He noticed a picture on the opposite wall, hung under a flag on an upright pole. He couldn't make out the markings on the vertically draped flag, a geometric pattern in reds and yellows. The photo was of a handsome, gray-haired gentleman with a stern face. He wore a blue suit and black tie.

He reminded Yvgeney of an older version of the American actor, Steve Martin.

I've got to get out of here.

Twenty long steps brought him to the lower door. He reached for the handle to open it and get upstairs. It was locked.

That's crazy.

A muffled voice emerged from a door at his back.

Why would they let you in here, but monitor your exits ... monitor?

274

Above shoulder level, on his right, he saw a built-in monitor and a vertical keypad with 10 numbers; a fat bar displayed a Portuguese word—the word for "enter," he hoped. He pushed it. The screen displayed three spaces and apparently requested an access code.

Three digits. Is that all? he thought. *Who's in charge of your security here?*

He pressed 1, 1, 1, then the bar.

"Cancelar."

He bumped it back on, and tried 2, 2, 2.

Out again.

At 3, 3, 3, the screen opened to a wide-angle camera view. In a second Yvgeney realized it was a view of the corridor above.

Of course, he realized. *The comings and goings through the stairway passage would be carefully shielded from public knowledge. This Future Club is supposed to be a humanitarian learning center, a fucking Boy's Club, not a secret training center for weapons.*

He saw no movement down either end of the hallway above. He pressed *enter* again and the door clicked with the low buzz of a tiny motor. He heard more voices behind him. In six giant steps he reached the top of the stairs and slithered back into the classroom access hall, listening for a shout of alarm from below.

Chana entered the lobby from the access door to the left of the information desk. Wally sat in one of the soft visitor chairs, with a cup of coffee in each hand. He was talking with a young outside guard.

"Where's the Russian?" she bellowed, striding closer.

"Ah ... he went outside for a walk."

She turned to the door and stuck her head out, chattering in Portuguese to the children guarding the entrance. She turned to Wally.

"Liar!"

She looked around the lobby and stopped at the double doors.

"Actually, Chana, I think he's just peeking into some classrooms in the back. He's interested in your program."

She banged through both doors at once and hurried to the first door on the left, finding it locked. She tried the right side, twisted the handle, and marched to the next one. Wally hurried to get alongside. She opened it and leapt in, looking for a confrontation.

Yvgeney sat at the teacher's desk, his crossed feet up on the top, the map behind him. As he leaned back in the flexible chair, a fat textbook open on his lap, he said, "Chana, what a wonderful program you people are running here. I've actually learned a little geography. Did you know that the capital of Germany is Berlin? I thought it was Hamburg. It says here that Hamburg is the financial capital."

"You have no right to be in here. Get out!"

Yvgeney put his feet down slowly and acted hurt. He placed the book spine-down on the desk. He cloaked his face with nonchalance and got ready for a physical attack.

Wally stood innocently beside her in the doorway, "Well, we better get back to the hotel, don't you think, Yvgeney? We thought we'd surprise Chana and instead we just pissed her off. I'm sorry, Chana. We thought you'd be happy to see us."

"I told you to remain in the hotel. It's dangerous in this city."

Wally jumped in.

"Can you take us to the university? I hear it's a beautiful building."

"I'm in a meeting. I'll have two of the outside members escort you back to your room. Wait for me there."

She glared at Yvgeney with murder in her eyes as he passed her in the doorway.

"How was the meeting, Chana? Did you deliver my instructions and our timeline?"

"Yes, sir, I did. We had a little trouble with Trujillo. He wanted more money to torch the surrounding favelas. Said he had many relatives still living there. Wanted to double his funding quota."

"Did you make an example of Mr. Trujillo, child?"

"Yes, sir, I did. No one else here will oppose you."

"Did you find a replacement? We need the barrios burning in every city."

"I called a plane to pick up a young man I met in the Darien. I hope you don't mind. I promised him a place in the struggle. He's no stranger to death. I've seen him work. I hope you don't mind the authorizing of a plane, the Gulfstream. I wanted to have some time with him before I leave."

"You acted wisely, my child. The day we've been waiting for is near."

"I've found nothing more about the refinisher, sir. I'm sorry. Keeping this man alive is a full-time job."

"We had no luck with the information you extracted the other night. I've had an alternative plan in operation and it's now in place. Tomorrow, in Buenos Aires, call me when you are together in the evening and I'll speak to Mr. Winchester directly. I have something here he wants."

Chana marveled at the resourceful mind of her master. He pulled many strings at once.

Braun continued, "Are you prepared for tomorrow's meeting in Buenos Aires?"

"All have been notified. We gather at 9:00 o'clock."

"You still have a busy schedule this evening. What time is your flight?"

"Ten with the de Havilland Turbo, sir. It was too late with the new man arriving to arrange a commercial flight. Sorry to keep using the planes, sir. I know the price of gas is high."

"Spare nothing. The great day is near."

Her heart swelled.

"Sir!"

"Yes, Chana."

"What do I do with the gringos? Today, they showed up at the Future Club. I nearly killed the Russian, myself. He's a problem. He wandered around the classrooms. I don't believe our security was breached, but I ordered Francesca to review the surveillance tapes when she reports to work tomorrow."

"In a few days or weeks it won't matter, child."

"How can I protect them in Buenos Aires while the strategy teams meet?"

"Send some local people to baby-sit the hotel in the morning. Later you can take them to San Telmo. They'll find enough antiques there to keep them happy till we speak in the evening."

Chapter Thirty-Four

Camano Island, Washington

"Look at this, Lucy. There was a murder in Stanwood last night—poor man."

Rae was sitting by the hot tub on the porch as she read the morning paper. She read the story aloud, "Constantine Papalopis, retired engineer from Boeing was found dead in his home yesterday. It appears he interrupted a burglary after returning from an Eagles Club dinner. The family reports nothing missing. The widow feels that it is a vendetta against their family by persons unknown, since the son, also named Constantine, and a distant relative living in town reported break-ins as well. Nothing was missing from either home."

"How odd!" Lucy let the bubbly hot water dance just under her chin. "Any news about our men-folk starting a revolution in Brazil?"

"Nothing in the headlines, hon. I see a report on the international page that there is new rioting in Venezuela over the price of gasoline. That could be Wally's doing. He gets a lot of mileage from his whining."

"Yvgeney e-mailed me last night," Lucy said. "He wanted me to forward some encrypted messages to his old UNESCO boss in France. Said he's tried to reach his buddy, Julio, the fellow they stayed with in Mexico City, but the automatic response says he's away for four days and will return messages when he gets back.

"Yvgeney said there's something fishy about an organization called the Future Club. He didn't say more. Seemed nervous."

The mention of the Future Club passed through Rae's consciousness without stopping. She was focusing on news about

Wally. She asked, "Have they unearthed the mother lode of modernism in Brasilia?"

"He said that Wally dragged them out to a poor section of the city and nearly got them killed by an angry mob. They found nothing in Brasilia, but they expect to be in Buenos Aires by morning. Said their guide promised to show them all the back alley warehouses in the antique section if they behave."

Rae's eyes narrowed into slits. "I hope that strange girl stays away from Wally."

Chapter Thirty-Five

Archeological Site, Near Puerto Montt, Chile

Sunshine flooded the shallow draw. Lucas-Schmidt dipped a kerchief into the swirling lazy eddies of Monte Verde Creek and wet down his short white hair before repositioning his safari hat.

He could hear Spanish oaths and laughter. Sergio and team number two were clearing a new site for excavation farther downstream. It was easier to relax here at the archaeological site with the Amazon robot girl gone.

He walked beside the stream, through a green mini-valley running through parched scrubland that gave the creek its name.

"Sergio, Hector, find me a new vein. Our archeology mine is running low."

The men laughed. It was OK to be jolly today with Claus Braun's watchdog out of the country.

"*Si*, Señor Schmidt. I have a good feeling about this new location, it's on a level with the sections of the settlement already found."

"We need to find something soon, gentlemen. Our fearless leader is getting impatient for a breakthrough. I have a meeting with him at the mansion this afternoon."

He pulled hard on the tepid water from his plastic canteen.

Going to be a hot one, he told himself.

Chapter Thirty-Six

Casa Braun, Orsorno, Chile

Schmidt sipped mineral water while he stood with Braun in the mansion's well-appointed library. "We uncovered a new object yesterday, Claus, part of a sport stadium in miniature. It appears to be a roof."

"Does it affect any of your conclusions? The one about parallel evolution? Our announcement?"

"No sir, the proof is sound, a separate wave of Homo sapiens that spread from South America to North America to Northern Europe. Our discoveries are strong evidence for the revision of the evolutionary tree. That is our headline."

He noticed Braun's chest swell.

"Then don't worry about it right now. Is the media package prepared?"

"I have an envelope for CNN, Reuters, AP, Isvestia, and our website is ready to launch with streaming video. We have interviews, some archeology footage, old Leakey film clips and even that American photographer's pinhole glossies for *National Geographic*. Once the press release is added, everything is a go."

"And the scientific community? Will your paper stand up?"

"When coupled with the artifacts I've found, our conclusions are bulletproof, sir."

"The great wheel of destiny is above us, Schmidt, ready to roll. Our South American birth mother will be welcomed by pure-strained people everywhere."

"We can't point a finger to a white alpha mother yet, here, Herr Braun. Pushing back the American strain to half a million years is the first step. The earlier evidence will be found someday, it's just a matter of time. Migration theories will be, as the English say, out the window. People of the true race will rise up and follow you."

"Don't fail, Schmidt, but right now I need your help in another matter, one that involves a different discovery, an antique for our Mister Winchester."

Schmidt's face soured.

Chapter Thirty-Seven

Buenos Aires, Argentina

Chana woke them up.

"Señor Winchester!" She wiggled Wally's shoulder and smiled slightly.

The Russian stirred in his single bed against the opposite wall. He was up to his neck in the thin hotel blanket. Morning sun lit a rectangle on the thin mousy-brown carpet between the beds.

"*Buenos diaz, caballeros.*"

Two groggy heads looked up, blinking back sleep.

She spoke sternly, "This is a dangerous city. Few people have jobs. A million people outside this hotel are starving. You two, without Spanish, and wearing your gringo safari clothes, will stand out and be targets. There is no expectation of police protection. If you go out into the street unprotected, every other person will want to rob you. Then, they will kidnap you and take you to the nearest ATM. Do you know how painful it is to press the little numbers without fingernails?"

Wally pulled his toes under the sheet.

She continued, looking at the Russian with lowered lids, "Any taxi cab will drive around the corner and pick up two friends with guns. Any taxi. Trust none of them. If you try to get to a bank to get some cash, forget it. You'll never get there. If you do manage to get to a bank lobby, don't open your cell phone. You'll be arrested and thrown in jail. It's against the law in this city to operate a cell phone inside a bank.

"Don't go out until I return. Around noon. Have some breakfast and write a letter to your *chuchas*. As a reward, I'll walk you

through the antique warehouse district in San Telmo, as I promised. It's close by. Claus Braun wants to speak to you tonight, Wally. He tells me that he has found something wonderful for you."

"What is it? Did he describe it?"

"No, señor. He'll tell you after dinner. Remember! Stay here for this morning! Please!"

She left, slamming the hotel door for emphasis.

"Well, coffee sounds good to me," said Wally pulling on his socks.

"Order me a cup, partner," said Yvgeney. "I'll be down in a minute. Gotta make a call."

The phone rang for the ninth time. A message service kicked in a mechanical voice: *"Hola. Éste es el hogar de Julio Martinez. Deje por favor su número del mensaje y del servicio repetido."*

Yvgeney spoke, "Julio, it's me. Your hunches about big trouble brewing in South America are making more sense every day. I've found evidence of some kind of insurrection brewing. I think it involves the organization called the Future Club. Claus Braun is the head. We've been traveling with an associate of Braun's, the Amazon native, Chana. You met her. She's the interpreter who came to your house. This is getting scary, Julio. I have no proof, other than a weapons cache that I discovered yesterday. Be careful of these people, old friend. Chana is much more formidable than she appears. Don't proceed on your investigation without some security. Better call the big guns in from Interpol. Good luck."

The coffee downstairs was hot water and Sanka. The noontime sun had turned the little dining room on the first floor into a sauna.

285

Wally was trying to interpret world crises on page two of the local newspaper, *ARG-Diario*. Using the news photos and his handful of Spanish words, he'd managed to deduce that someone was captured in Iraq, someone blew up a train in northern Italy, and the United States seemed to be mad at the UN about something.

A smaller article on page three said, "UN investigator, *Se Encuentramuetro*." Wally's heart sank. The photograph above the article looked a lot like Yvgeney's Mexican friend, Julio.

Muerto, he wondered. *Does that mean death?*

"Yvgeney, look at this."

The Russian was looking across the street at an Internet café. He turned to receive the paper. His face fell.

"Does any one here speak English?" he bellowed.

A young employee said, "I have some English, señor."

"Can you read this and tell me what it says?"

"I think so, señor."

"Santiago, Chile … it begins. The body of a man found by a shepherd in the north Chilean desert yesterday was identified as Julio Martinez, an investigator for Interpol from Mexico City. Sergeant Victor Gomez reported that it appeared he had fallen from an airplane. No arrests have been made."

Yvgeney stood up. "I just left him a message!" Tears filled his eyes. He walked out the front door into the street and crossed it on the run, heading for the Internet café.

Wally sat a minute, thought about leaving a note for Chana, and hurried after him into the hustle and bustle of the Buenos Aires morning.

To Wally's estimation, it was an upscale neighborhood. He was assaulted first by the aroma. Fragrant blossoming trees lined both

sides of the quaint cobblestone road. Bright sunshine through the flowery canopy bathed the sidewalks and stone fronts and outside cafés in an impressionistic speckled light. Lots of people moved about.

They're normal looking folks—not a killer in sight, thought Wally.

A young couple in love were kissing not 10 feet from where he stood, looking across the street for Yvgeney. *That's a good sign. Lots of pretty girls, but what else is new?* Contrary to Chana's advice, he asked the kissing couple a question, since he knew the Spanish words, "*A donde San Telmo?* he asked.

"*San Telmo, aqui,*" the amused dark-eyed girl said.

Her curly-haired boyfriend unleashed a string of verbiage, his voice getting sharper near the end. Wally nodded and smiled at what he thought were appropriate moments; it didn't fool anybody. The youth switched to passable English.

"Are you from *Estados Unidas*, señor?"

"Ah … yes, Seattle."

"I hate your President." The youth seemed to be getting riled up.

"I'm not very fond of him, myself."

The couple advanced a step; Wally smiled and fled, backing into the light traffic cruising the cobblestone street. The safety zone, he figured, was the crush of pedestrians on the other side.

He looked back at the lovers as he entered the Internet café. They stood there watching him from across the street.

He found Yvgeney; it was a pleasant, friendly hangout inside, similar to the one in Puerto Montt. Slices of angled glass hung from pendants and cast interesting patterns of light around the room.

The usual gaggle of young people sat lounging in the windowed front area, like a South American version of *Friends*.

Wally didn't get a feeling that he was in a room full of desperate banditos, but he kept his mouth shut as he came up behind his friend.

"Investigator found dead in northern Chile" was the headline on a *New York Times* article, blown up on the screen. Wally placed his hand on Yvgeney's shoulder.

"So, it's true?"

"Yes, damn it!"

"Anything I can do? He seemed a pretty nice fellow. His wife must be devastated."

Yvgeney cleared his throat and sniffed. "I've e-mailed friends at the UN, but no reply yet. Martinez was nervous about something going on in Chile."

He turned back to the monitor and took a long breath. "Damn it, Julio. I told you to watch your back!"

To Wally he said, "I've got to wait for some responses. We should tell Chana that we're safe and sound."

Wally said, "I'll hang out and let her know where you are."

"You know what," the Russian looked up. Red eyes and a runny nose. "Don't bring up the story to her. I've still got a weird feeling. Watch your back, Wally. Go back to the hotel. Keep this to yourself. I'll be here for a couple of hours."

Wally said OK and walked out into the street. It was packed with people, moving and standing. He scanned the opposite sidewalk, looking for the couple with the attitude. They had disappeared. The safe haven of the hotel was across a street filled with perfectly normal people.

Looking across the cobblestone street, Wally spotted a sign: *Antiguares.*

Right next to the hotel! Great!

He crossed the street, angling left, watching for the occasional car.

"*Hola*," said a middle-aged stocky man behind a glass and wood showcase that protected a varied display of collectible small objects.

Wally nodded silently and started his search, secure in the belief that without speaking he'd be perceived as another un-robbable local.

The shop contained the usual collection of odd and barely desirable cast-me-downs. Nothing outrageous leaped up as he cruised the three deep aisles leading to an office in back. Wally left with the universal word, *Ciao*.

When he stepped out of the shop, another sidewalk display of old things lured Wally farther from the hotel to the sidewalk. He bought a lemon ice from a street vendor and drifted away from his safety zone.

The next antiques store offered nothing that deserved baggage space to North America, but more sidewalk piles of old stuff called to him from the next block down.

Feeling like the eagle looking for a careless rodent in a grassy field, Wally spotted four old chairs, sitting under an awning across the street 100 feet ahead. He angled in for the kill.

There was good stuff here, high-style design. German metal work by WMF, two pieces of Galle' glass and some Austrian bentwood café chairs on the floor. Wally couldn't sell WMF, but he liked it. It hadn't hit the high collectibility level of Roycroft copper, Dirk Van Erp lamps, and Wiener Werkstatte silver.

"*Hola, amigo*." Wally began.

The stout mustached beaver of a man, standing behind a cluttered desk, nodded.

"*Ya quiero*, Joseph Hoffman, Frank Lloyd Wright, Tiffany."

"*Si, señor*," was followed by a string of Spanish words.

Wally said "*Engles?*"

The man shook his head No, but held up one finger as if to say, wait, and pulled a photograph out of a drawer. The photo was from a Polaroid camera, one of the old ones, with a wide, white plastic tab on the bottom. It was a photograph of a *sitzmachine*.

Holy shit.

The shopkeeper, sensing his interest, picked up the phone and dialed. A moment later he handed it to Wally.

A deep voice said, "Hello, señor. You have an interest in my chair?"

"The reclining chair that looks Austrian?" Wally countered, not giving up any tells.

"Yes, the *sitzmachine*," said the person on the other end said abruptly. "You are interested in this chair, señor?"

"Sure, you betcha."

"The chair can be seen by appointment, señor. Would you like to schedule a meeting?"

"How about now?"

"An associate or I can be with you shortly and bring you to our warehouse. Can you wait for us?"

"No problem-o … I can wait." Wally drew out the conclusion to signify disinterest.

A well-dressed, thin man entered the front door, followed by a short, broad-shouldered native with a brown face shaped like a hatchet. Wally looked around. He was the only other person in the store.

"Welcome to my humble storefront, señor."

The thin man had a shock of white-blonde hair pulled across his forehead in a way that reminded Wally of David Bowie. A goatee

added to his quaintness. He wore a thin tie and a light leather coat. His angular face was a hard plane of tan.

"Claudio Mendez at your service," he said in English.

"Walter Winchester, ex-president of the Camano Island Chamber of Commerce, back at ya."

"You are a student of fine furniture?"

"I am a collector," Wally said. He'd found that, classified as a collector, he heard about a lot more things than he would have as a guy trying to make a buck on a yard sale bankroll.

"We maintain a warehouse off the street, where some higher-quality things are offered. Would you like to visit that place with me?"

Bingo, the second stash. Wally congratulated himself. One block from the safety zone of the hotel he'd found access to the back streets, where the real deals are made.

He said, "Sure," and found himself escorted into the back seat of a Mercedes-Benz town car.

Maybe I should check in with someone, Wally thought as he sat back on fragrant new leather in the shiny black box of German automotive excellence.

Chapter Thirty-Eight

Buenos Aires, Argentina

Yvgeney checked his mailbox again. The second message was a reply from his former boss, Alexander Bishop, in Lyon.

"Sorry for your loss. Two friends in one year, Yvgeney. I pulled some strings with UNESCO to get you information about Julio's cases for Interpol. It took some time, but here's what I found. He was assigned last year to the Interpol Public Safety and Terrorism Sub-Directorate (PST). This group investigates five things: terrorism, firearms and weapons trafficking, attacks and threats against civilization, maritime piracy, and weapons of mass destruction.

"His current case was to look into reports about a large-scale civil unrest *programme* in South America and Indonesia. There's been, it seems, a good deal of low-level chatter concerning a well-organized and -funded group planning a major action sometime soon (name unknown). Last report from Martinez focuses on an area in Chile, south of Santiago. He must have sensed trouble.

"In his file Julio had a list of persons of interest:

Francisco Descansito–Peru

Manuelita Ortega–Mexico City

Luis Alberto–Peru

Horacio Rubi–Brasilia

Claus Braun–Orsorno, Chile

Fernando Baldessari–Buenos Aires

"Last posting was two days ago, in the morning, from Santiago. Death confirmed. Details unavailable.

"Thinking about coming back? I still have your paperwork."

It was signed Alexander.

Yvgeney paid his two-hour Internet hook-up bill and walked into the street. Pedestrians still outnumbered cars on this pleasant commercial neighborhood. Yvgeney no longer listened to safety advice. He stepped into the street and raised his arm and hand toward the traffic. A full taxi drove by. Another stopped and he got in.

"Future Club," he said.

"*Que?*"

"*Clube Futuro?*"

Still no light bulb.

Then, "*Oh, Club Futuro. Claro, señor.*"

As the taxi pulled from the curb, he spotted Chana entering the hotel across the road.

After only three blocks of driving, the cab pulled into a small side street.

That's odd, Yvgeney thought. It was unlikely they were that close. The driver parked along a set of dumpsters. The back door opened and a man jumped in. He was holding a small revolver. The stink of unwashed clothes and perspiration hit Yvgeney in a smelly wave. The driver gunned the engine down the alley and they sped away. The driver was giggling.

"ATM, gringo," said the bushy mustache beside him. Red eyes and a quiver in the pistol hand suggested an addict.

"Credit cards! Now!" He reached out with the other hand.

Oh, Christ, thought Yvgeney. *I have no time for this.*

Outrage was still ruling his psyche. He slowly, unthreateningly, pulled his wallet out of the side pocket of his chinos. He knew there was a wad of Brazilian paper money inside that turned the billfold into a green deli sandwich. He was counting on that now.

The robber's eyes went wide at the sight of the wad of cash in the gringo's hand.

Yvgeney's left hand held the wallet high, as though he planned to pass it to the driver instead. He watched his assailant's eyes follow it forward. His cocked right hand snapped out and caught the gunman's jaw with the two middle knuckles.

Smack!

Yvgeney's hand hurt like hell, but the thief was unconscious. The driver tried to pull to the side and leap in to help, but Yvgeney brought the gun up behind his ear while yanking on the door latch.

He pushed the backseat robber into the road at 20 kilometers per hour. The cold metal gun barrel never left the driver's neck. The sprawled, still figure grew smaller out the back window as the driver slowed his speed.

"Future Club, asshole … Vamoose."

Chapter Thirty-Nine

Buenos Aires, Argentina

Wally sat like visiting royalty in the back seat of the town car, and scanned the two-story brick buildings lining the alley. He saw a series of roll-up doors opening to garages or storage units. He looked inside each one as they drove past, noting desks piled three high, like awkward leaning towers, and fancy gilt rococo ornament gleaming in the shadows.

An antique warehouse district, good! He tilted his head, eager to investigate the next open door up ahead. *Should I be nervous out here alone? Nah. This guy's a big shot. Look at his car. I'll be fine. Us antique people have a tendency to watch out for one another.*

His host asked him about his wish list.

Wally answered, "I like really good art deco. Designer objects, Bauhaus, Weiner Werkstatte, art nouveau, architect design, North American Mission oak."

It was wonderfully cool in the air-conditioned Mercedes. A bull of a driver, wearing the uniform of a chauffeur, drove slowly. The few people they passed looked at the car and waved greetings.

"At the next block we will be to my ... storage. Perhaps you will find something there that you like. How much money are you prepared to spend?"

"It sort of depends on the piece, Mr. Mendez. I have a deep funding source."

"Claudio, please. Call me Claudio."

"How much are you asking for the *sitzmachine*, Claudio?"

Both men, Wally realized, knew how good the chair is.

Nothing in this guy's warehouse is going to be cheap or misunderstood, he realized. *That's all right.*

Years in the business had taught Wally that the smartest place to buy what you want is the place that has lots of it. The real antique pros move lots of merchandise and they price their goods to sell. Great things usually have lots of room at the top end.

The toughest dealers to buy from, he'd found, are traditionally amateur pickers with a mall space, who finally find something good and intend to get every nickel out of it.

"I am asking 10,000 dollars in US funds. Is that a range you are interested in spending?"

"Of course," Wally said.

He was dying to get into this guy's place. These were the people he was trying to find down here, the dealers who know where the good stuff shows up. *Ten thousand dollars for a sitzmachine? It's a 15- to 20,000 dollar chair at auction level.* Braun *had a pair of these back in Chile. He probably would trade one or both of them for my egg rocker.* He wished for the company of Yvgeney and his book of traveler's checks.

An orange steel door was rolled down and padlocked. Spanish and Portuguese language electronic surveillance warnings posted by the door threatened would-be intruders.

The chauffeur proffered a big ball of keys and opened the entrance door to the right. No evidence of a shop name or a business suggested what was inside.

Lights clicked on, revealing a high-end repository. Polished mahogany gleamed. Two larger-than-life green-hued nudes frolicked in front of them in a frozen bronze wave.

"Nice."

"Thank you. You are interested in sculptures also?"

Wally, his eyes dancing over ornate shapes around him, said, "I like anything with style and a past, but I focus on twentieth century design."

"We recently acquired some chairs by the Finn, Aalto."

"I like his stuff. Can I see them?" Wally was dying to check out the *sitzmachine* but was happy to get the tour.

"These are the Aalto chairs, señor."

Two fat-armed club chairs sat with their backs to the pull-up door on the left. Wally smiled and put his hand on the blonde U-shaped bent birch arm to say, hello.

Nice chairs, he thought. *Newer upholstery. Looks 1970s. Not much wear to the cloth or the wood. Maybe there's a mark.*

He tipped the closest one back to search for a label.

None, even under the arms.

Not a lot of wear on the underside, either. The bottom surface didn't look like one that had spent 80 years on the floor with people sitting on it. The finish seemed too white. Oxidation hadn't yellowed the wood, even underneath. He thought, *Maybe they've been skinned by an overzealous refinisher.*

"These chairs are recent?"

The thin goateed chin stood out, "Of course not! They are of the 1940s, don't you think?"

"The Finns still make these, I can buy new versions in Seattle. They still make them great, though. I'd say maybe 1970s or 1980s or maybe new."

The chin dropped further. There was anger in his eyes. Wally sensed the bulldog driver moving about the room.

"Are you suggesting that I sell reproductions, señor? I assure you I would never do such a thing."

"You're probably right, Claudio. Forties for sure. Probably didn't get sat in much. Can I see the *sitzmachine*?"

No need pissing the guy off, Wally, he reminded himself. *You're supposed to be here to make connections.*

Yvgeney's arm was getting tired holding the pistol against the driver's neck, but he was very angry with this little man and was enjoying the sweat that poured from his defeated abductor's forehead as he contemplated his approaching demise.

"Club Futuro, señor." The voice was meek.

Across the potholed concrete slabs called roads sat a three-story red brick expanse that looked as if it had once been a public school. A large red and yellow door marked the entrance. A gaggle of surly teenagers occupied the front steps.

Yvgeney pressed the pistol into the driver's neck as he opened the back door with his left hand. A nervous, fat unshaved face looked over to the meter.

"Thirty pesos, please, the fare."

The man suddenly knew English.

"Fuck you! Scram!" He wiggled the gun at his face.

Yvgeney loved the chance to use the American word, scram, in a sentence. He felt like Humphrey Bogart. The anger came back as he watched the taxi race away.

He looked around at the paper cartons and empty plastic bottles littering the sidewalk. A folded newspaper looked dry and usable as a prop so he picked it up.

An hour's worth of strolling listlessly, pretending to read the paper now and then, got him a long look at all sides of the Future Club's façade. There didn't seem to be easy access to the inside, like

an open back door, or a basement window. That left the front door with its teenage Republican Guard.

Not getting in there, today, Yvgeney, he told himself. Go to Plan B.

There was no Plan B. There wasn't even a Plan A, just a knee-jerk reaction to news of Julio Mattinez's murder.

Yvgeney's thoughts returned to Claus Braun's name on that person of interest list. The same Claus Braun that Chana worked for. The fellow who wanted Wally's chair ...the mind behind the Future Club?

He felt a need to do something, anything, to avenge his big happy friend's death. He analyzed his situation. He was at the Future Club of Buenos Aires in broad daylight without any backup and without a plan, just an anger burning in his chest.

He noticed the cars. In this forgotten industrial backwater district of Buenos Aires, few businesses seemed open. Moving cars and pedestrians on this sunny humid day were few. An eerie silence was broken only by a truck rumble, and the chattering of some magpies on a nearby telephone pole. He noticed the cars again.

Why am I looking at parked cars? Because they are all very expensive and this isn't Beverly Hills. They're out of place here. I wonder if they're here for the Future Club meeting that Chana's attending?

Trying not to attract attention, he copied all the license tags into the notebook he kept in his top pocket.

It was the first time Wally had seen a *sitzmachine* face to face. It felt great to actually sit in one.

299

No, that's not true, he told himself. *I saw two at Claus Braun's house, though just for a minute. And I think there was one in that Paris Museum, the Orange.*

He leaned back against the row of square cutouts on the mahogany plywood back. His collector's hands felt good on the red-brown arms. It felt solid, almost too solid; he climbed out and turned it over. His host Claudio and the young, hatchet-faced hired muscle hovered nearby.

"You like the chair, señor?"

Wally's head was under the chair now.

He said, "Very much."

The branded mark of J. & J. Kohn, Austria was impressed on the underside of the seat. A yellowed partial label with a discolored area behind the missing paper was beside it on the bentwood rail. It wasn't right.

Fuck!

Wally wondered how far to the hotel. His face revealed his thoughts.

"What's wrong, señor? Are you dissatisfied?"

Wally felt the muscled driver violate his personal space. A change in the thin man's tone made him nervous. "It's a beautiful shape, isn't it?" he said.

"What currency do you carry for your purchases?" The dealer's voice was a monotone.

Sort of a personal question, Wally thought.

"Traveler's checks," he said before he knew it. "But, my partner has them and they're unsigned."

"You saw something on the chair bottom you didn't like." It was a statement.

"Ah ... well, there didn't seem to be a lot of oxidation where the brand is pressed. Usually those areas are dark or at least nut-brown by now, but I'm sure it's fine."

Both local men stood together close to Wally's face, the tall owner looking down and the weightlifter looking up. Wally sensed them taking some serious offense to his misgivings.

"Gee, look at the time. Think I can have a ride home?"

"Where is your hotel and your partner?"

"Actually, I can't remember the name. Can you believe that? We got in late last night ... Rio Something, it's called. It's near your shop."

"And you think I am making reproductions? This is a great insult, señor."

He stepped closer. Wally knew he was looking into the eyes of an exposed forger.

In the total silence of the warehouse he could hear his heart beating.

A strong female voice carried across the room. "I TOLD YOU TO STAY IN THE HOTEL!"

Wally sagged in relief. Chana and another young woman stood in the office door. He saw anger in her face.

The tall owner snorted and grinned, seemingly unimpressed by the notion of an all-girl rescue team. Displaying an ugly sneer, he turned back toward Wally.

A string of Spanish curses raced across the room. Chana's voice had an eerie authority; the string of orders wiped the smirk off the dealer's face and replaced it with wide-eyed respect.

Wally heard "Claus Braun" and "Baldessari" among the unintelligible words. The men melted back like servants.

"Come on, idiot." She spoke to Wally without humor. "It's taken me an hour to track you down. Claus Braun wants to talk with you. Where is the Russian?"

"I dunno. I saw him at the Internet café across from the hotel ... he got some bad—"

He stopped, remembering Yvgeney's warnings.

"Some bad what?" asked Chana the interrogator.

"Some bad coffee. Why can't you people grind your own beans in South America? They grow it here, for god's sake."

Chana relaxed slightly, ignoring the now-docile swindlers. She barked orders in Spanish to the other woman, who disappeared into the street.

Smiling strangely, she pinched Wally's earlobe with her thumb and a finger and dragged him out into the street like a misbehaving child in church.

Yvgeney was sitting in the bedroom when they arrived 10 minutes later. He smiled.

Chana glared at the Russian with a look that made Wally shudder. She said nothing but began punching numbers into her cell phone. She spoke in a voice different from the one Wally was accustomed to. This voice was a soft, respectful dulcet tone that sounded like a caress. Her speech turned back to ice when she turned to face him.

"Come here! Señor Braun would like a conversation," she ordered, handing him the phone.

"Hello, Señor Winchester. This is Claus Braun. How is your exploration going?"

"I just saw a *sitzmachine*, here in Buenos Aires, but I think it was a fabrication."

"Ah, you met Claudio Mendez. He is well known to many of us collectors. He is not a nice man."

"And, I got the William Morris curtains that your man located in the rainforest. Thank you."

He didn't bring up the MacIntosh panels. No need to complicate the gratitude.

"I have located a piece of furniture that you might consider in exchange for my chair."

Wally noticed the "my." Paying attention to tells at a closing is one of the first things Wally learned as a dealer of objects. He was now in a poker game, and knew it.

"What is it?"

"It appears to be fabricated by that fellow you search for, Gustav Stickley. A sideboard of massive proportions."

"Really!"

"Found in Chile, amazingly, in Valdivia on the coast. I'd like to show it to you. Can I offer you a plane ride back to Chile, señor? We can drive to see it. It's still in the barn where it was discovered."

"I don't think I'd be a sensible fellow if I said no."

"A plane awaits for your arrival. Chana can make the connections. Thank you."

"You bet."

"Yvgeney, pack your bags, we're going to Chile ..."

Yvgeney signed, beginning to tire of the midnight travel schedule. He watched Chana and she watched him back.

The third night flight in three days was scheduled to leave at 11:30 p.m.

It was 7:15 in the Internet café. On the green computer monitor, Yvgeney read a reply from Interpol. The auto license tags he'd recorded during his walk around the Future Club had been data-matched with their owners. He scrolled down the column, remembering the car that went with each license plate:

Argentina 2D-715–George Lopez–Buenos Aires–(black Porsche)

Argentina 7-14T–Max Careillo–BA–(turbo SAAB convertible)

Argentina GGY-B22–Fernando Baldessari–(bad ass Dodge Viper).

Baldessari?

He scrolled back to the afternoon's list of Martinez's interesting persons, e-mailed earlier. There it was. Baldessari, Buenos Aires.

"Hot damn," he said out loud.

Chapter Forty

Puerto Montt Airport, Chile

The airport at Puerto Montt looked very much as it had the last time Wally landed there, except this time it was dark. A familiar face at the gate smiled when he met Wally's eyes.

"Hello, Señor Wally."

"Julian! How the hell are ya, son?"

"Very well, gracias. I saw the photographs that Señora Rae made with her paper cameras. She sent copies to Señor Braun and to Dr. Schmidt. They will soon appear in the magazine *Geographic*, I'm told. She is very good, yes?"

"I miss her," he admitted.

Wally introduced the red-eyed Yvgeney.

Chana nodded and Julian bowed in respect.

They headed west from Puerto Montt on deserted dirt roads. The Volcano Orsorno, bright moonlit yellow in a cloudless velvet night, loomed over them.

Claus Braun looked all of his sixty years and more. Yvgeney eyed him warily but acted honored and unaware of his growing conclusions. Chana was soft and hard at the same time, clearly happy to be home. Wally was trying to look behind him at the furniture he knew was inside.

Chana was the last to enter. As the two visitors staggered inside, dragging their packs, she pulled Braun out the front door and closed it behind them. She spoke rapidly in Spanish, "The Russian is

an ex-UN investigator. He is dangerous to your enterprise. I think it's a bad idea to allow him into your house, sir."

"What do you propose, child?"

"I think that this man dead is better for your enterprise than this man alive."

"I don't want violence here on the grounds, Chana. Keep the gringo, Wally, content till we get my rocker. Then, we'll see what needs to be done. I'll assign you a bedroom next to the Russian if you like."

"Thank you, sir."

"Good night, my child."

He kissed her on one cheek. "Welcome back."

At breakfast, Braun took advantage of his groggy houseguests to boast about his upcoming publication. It was painfully obvious that he relished the conclusions: "We therefore suggest that a second Index Mother, a second Lucy, evolved in the South American subcontinent and spread northward, possibly reaching Northern Europe."

His animated eyes danced as he recited the passage by memory.

No mud people in your family tree, right, Mr. Master Race? Yvgeney thought as he nodded and smiled over the marmalade toast in his fingers.

"I expect that article will cause quite a splash, Señor Braun," said Wally.

"It will cause a splash, Mr. Winchester, but now we should talk antiques. Would you like to visit the object I've found? I believe you will be surprised."

"Let's go."

Yvgeney and Chana found themselves trading wary glances over the sugar and cream. Dark eyes met his and moved on, as though the recognition wasn't noticed.

The road to Valdivia was a dirt-road version of highway travel through low coastal hills and farmland. Julian drove one of Braun's Land Rovers. Chana sat in front. Braun, Wally, and Yvgeney had the back seat.

Taking Braun's direction, Julian turned off to the left, and bounced down a dirt road into a green valley five miles from the Pacific Ocean. The Land Rover descended into a thick grove of aspens in full green.

"The piece was discovered down here in an old farm house," Braun said. He seemed utterly exhausted, yet animated.

An old post-and-beam barn in faded white paint appeared in a field as they entered the clearing. Before them were a sprawling colonial farmhouse and the lazy remnants of the stream that carved the valley behind it, insulated by tall green-blue lines of summer foliage.

"Pull in here, Julian."

An open door awaited them on the right. Julian drove into the cool dark barn, scattering a group of pecking guinea hens outside. In the cool of the dimly lit barn interior, Braun hopped out like a child.

"We found the parlor piece in the tack room, back here."

He led the group to a closed wide-plank door by the rear wall.

"I haven't touched it, Mr. Winchester, thinking you would like to experience it ... in situ."

Wally nodded back with respect and entered a musty chamber as his eyes adjusted to the dim natural light inside.

"This is impossible! There's only one of these!"

Wally bumped Braun in his hurry to get closer. Yvgeney entered next and saw a massive sideboard in thick dark planks. A scattering of paint cans and liniment jars protruded from a deep bed of dust on top. It looked like a room after a hundred years of neglect.

There were no lights glowing in the long unused storeroom. Two windows coated in speckled grime allowed some filtered sunlight. Wally was all over the sideboard, murmuring and opening drawers. Dust from years of neglect sifted down as he disturbed the surface.

Braun cleared his throat.

"Ahhhemmm. Gentlemen, Chana and I have much to discuss. This is an eventful time. Please excuse us. Examine the piece, Walter, and tell me if you're ready to make a trade."

"This piece for the egg rocker?" The trained professional living in Wally's brain chilled his croak into a normal questioning voice.

"We can discuss it after you're satisfied that it's something that you want."

Wally looked up, unsuccessfully veiling his wide pupils.

"Do you know what this is?" asked Wally in a whisper when they were alone.

Yvgeney shrugged. He knew that North American Mission furniture is as hot as its European counterparts. He figured this one was big enough and clunky enough to excite his partner.

Wally continued, "The Columbus Street sideboard is a custom piece that old Gus Stickley had made for his private digs in New York City. Supposedly, it's is the only one made. It came up for auction in the 1980s. Barbra Streisand bought it for more than a quarter-million dollars and blew everyone's minds.

"My friend, Horace, in upstate New York had a chance to buy it before the sale at 45 grand. He passed. Thought it was ridiculously expensive. Boy, did he kick himself after the auction."

Yvgeney looked around the dim chamber. It looked empty, safe, and rarely visited. It seemed as dusty and unused as an ancient tomb. He said, "It's been a while since Barbra Streisand entertained in here, don't ya think?"

"She sold this piece in the 1990s. I think it brought about half a million, never heard about it again. I can't explain this one here. It makes no sense, but it feels real. Maybe Gus made two, and sent one to some rich dude down here in South America."

Wally lifted a paint can from the top surface, a nine-foot slab of two-inch thick wood. An orange brown glowing circle of aged oak was revealed in the thick dust.

"Look at that color, Yvgeney, 100 years of oxidation is the only way to get that color."

He stood back to take the whole thing in. Four massive vertical posts held 500 pounds of oak two inches above the ground. It had a trapezoidal footprint protruding forward like a sawed off ship's prow. Five drawers in graduated sizes in the middle were flanked by massive cabinet doors, wearing broad iron straps and fancy hammered iron latches. The triangular recesses under the flaring top gave the sideboard a pair of dark oak wings.

"Let's pull it away from the wall to see the mark, Yvgeney. It should be right on the back."

Both men stood on one end, then lifted and grunted, feeling the shudder as fat oak feet skidded against the concrete floor.

"Jesus Christ, there it is, big as life."

A five-inch red decal of Stickley's compass mark with his name beneath it in script was clearly visible on the wide chamfered backboards. Wally whistled.

Yvgeney was looking at the floor beneath it. There was something about the pattern on the old concrete that caught his attention.

"This piece has been moved recently."

"Impossible! Look at the layer of dust in here, on the floor." Wally answered, still fixated on the bright red decal and shaking his head in awe.

"Here," Yvgeney said. "Let's pull it farther from the wall."

A distinctive trapezoid shape in the deep floor dust marked the original spot where it had rested. A number of fresh scrapes and small white broken grains of concrete disappeared under the layer of dust that marked the original placement. "That's odd." Wally said, crouching near the fat rear leg post, now in a square of sunlight from the window.

"What?" Yvgeney was lifting various containers and objects on the sooty nine-foot top. Bright contours in golden brown polka dotted the dusty surface where they had previously rested.

"There's a fresh repair here on the back leg, comrade," said Wally. "Streisand's sideboard reportedly was damaged when it was dropped, just after she bought it for all that money. News of this accidental leg break actually made it into the newspapers on a slow news day in the 1980s. An employee of Streisand's let the piece fall off a dolly while they moved it into her house. Snapped the back leg off. Mission dealers cringed at the thought of looking Ms. Barbra in the eye after breaking her then-perfect 300,000 dollar pride and joy."

Yvgeney quietly pointed out the shiny container-shaped footprints marking the dusty top like crop circles. "Notice how all of these paint cans left clean areas under themselves?"

"Of course," answered Wally, still wondering about the coincidence of the broken rear leg. "Dust falls around them and on top, not under."

"All these containers, horse medicine, old paint, boxes of oils and other jars leave clean spots on the dusty surface when they are removed. See?"

Wally murmured, guiltily admiring the wonderful color of old varnished quarter-sawn oak underneath.

"In the comings and goings of a horse barn, these objects would find their final resting place on this handy surface all in their own time. Over the course of years, even decades. A paint jar placed down here one day ..." Yvgeney lifted the paint can and repositioned it on the round spot in the dust. "Ten years later, a bottle of liniment put down here ..." He repositioned the liniment bottle. "And later, here, someone placed a box of nails ..."

"What's your point, Yvgeney?"

"All the stuff left on the top of this hunt board was placed down on top of a dust-free, perfectly oiled original finish. See? Under each container it's perfectly clean."

Wally lifted another paint jar. Below it was polished oak. "Hmmmmm."

Yvgeney wasn't finished speaking, "Every piece here was placed on a clean, waxed, good condition top and then dust was sprinkled down over everything to suggest 50 years of neglect. I'm sure of it. That explains the sliding marks under the apron also. It's a setup, Wally. I bet this piece was brought here last week, not last century."

They turned, hearing Braun and Chana re-enter.

Wally smiled at them.

"We'll take it," he said.

Yvgeney turned toward his partner in astonishment. He noticed Chana's deadly stare as he looked to Wally for an explanation.

"It's *da kine*," cooed Wally. "Who cares how it got here. I've got just the place for it on Camano. "Mr. Braun, if we agree to swap

the egg rocker for this sideboard, how soon can you get it up to Seattle?"

"In two days, Señor Winchester. I will accompany it on its trip to Seattle and retrieve my chair. Agreed?"

"A swap? Even Steven?"

"In Buenos Aires, the blackjack dealers call it a push."

"Deal."

Two unlikely allies shook hands. Yvgeney shook his head, slowly. This was not his play. It was Wally's chair, and thus his ballgame to win or lose, despite the atmosphere of deceit he felt here, as thick as the artificial dust. He felt public service calling him back.

Chapter Forty-One

Camano Island, Washington

Four packages from Cartegena waited in the living room with the million-dollar view of Puget Sound. Unopened backpacks filled with dirty clothes, still bearing the dust of another continent in their flaps, sat forgotten by Wally in his eagerness to inspect the freshly delivered crates.

He nuzzled Rae's neck, telling her of his emptiness while they were apart.

"It seems like I've been gone a lot longer than 10 days," he murmured, glancing about the room over her shoulder. The box with the copper lamp in it showed freight damage on one corner.

"Hey, there's the egg rocker!"

"Yes, it came back yesterday," she said, trying to hold onto the moment.

"Wow, what a nice job on the finish." He said, letting go of her and heading for the chair.

He was on his knees by the rocker now, fondling the black-red underglow beneath the waxy sheen.

"Constantine delivered it, and I paid him. He charged 220. Isn't that a lot?"

"Oh that's fine, hon. He's a master. Thanks."

He was lost in the dancing circles of steam-bent beechwood chair.

"Funny thing," she said. "We had a murder a couple of days ago, in Stanwood. Another Constantine ..."

Wally turned his attention to the Manaus shipment. He didn't hear her story about the Constantine family home invasion; he was too focused on the South American swag.

The lamp was unpacked and found undamaged. Wally gave silent thanks. No trauma from the smashed carton corner had found its way inside. The fabrics had survived the trip just fine. Wally was holding up one of the Scottish embroideries to the sinking orange glow in the twilight sky when Yvgeney walked in, eager to see their joint-venture booty. Lucy followed. She looked disheveled, but alert and cheery.

Wally was in a state of ecstasy. "Everything arrived intact, partner," he said, smiling. "Victoria and Albert Museum, here we come. Hey, Yvgeney, that rocking chair's back. Come take a look … an egg rocker, right from the refinisher. The man's a genius."

Yvgeney walked over to admire the chair that had caused so much fuss. It was a wonderful form, for sure. He'd seen it somewhere before, maybe in an older auction catalogue search for UNESCO.

A bubbling bad-dream memory flirted with the investigator's conscious mind. Something about that chair disturbed him. Something he couldn't put a finger on.

"I got some steaks for dinner, boys," announced Rae.

Conversation ceased, and they looked toward the grill on the sunset-flooded deck.

Broken thoughts and unconnected worries dashed in and out of Yvgeney's mind as they all sat before the computer monitor and looked at the digital images of world class museum bait that he and Wally had captured in the Darien Girls' Catholic School.

In retrospect he was impressed that in 10 days, a sizeable number of interesting leads and some pretty cool objects had been

uncovered. Some of the treasure they'd found was on Camano in the just-delivered crates. Most of what they'd found was in the Darien jungle, guarded by nuns, waiting for their return with museum purchase funds in their pockets.

The alarming certainty that something major was afoot in Chile with Braun and Chana and the Future Clubs at power positions had grown frighteningly clear. Yvgeney felt a sense of responsibility to the international community, but he was retired. It was not his worry anymore. He is an antique dealer now. A memory associated with the egg rocker, one he couldn't call up, troubled him.

Lucy asked, "Didn't you take any pictures of the countryside, or the people, Wally?"

"I only had one memory card, darling. I saved it for the money shots."

"We want to see the people, darling. Falling in love and chasing chickens. Where's the Latin mommas rocking their babies with a bambino at the breast?"

Mothers in rocking chairs? Photos of mothers and rockers?

Then Yvgeney remembered where he'd seen the chair.

"Leaping Lizards!" he exclaimed, startling everyone in the room. "Wally, Wally, Wally! Stop. Stop now! Stop talking, for Christ's sake!"

"Just a couple more, Yvgeney."

"No! Stop!"

Yvgeney stood up, strode over to the Austrian rocking chair, and switched on the floor lamp.

"What's up?" Wally and the women followed. The Russian lifted the oval bentwood in his hands and turned the chair over.

"You say this has been refinished?"

"Rae said it got returned yesterday."

"Have you looked it over carefully?"

"It had a thick coat of brown paint when I got it. Didn't see anything then except J. & J. Kohn brand."

"Have you looked at it since?"

"Haven't had time. We only got it this morning, remember?"

"Is that the manufacturer's brand?"

Yvgeney pointed to a slightly flat area under the seat rim. Two lines of dark colored impressions spelled out J. & J. Kohn, Austria.

"That's it!" shouted Wally. "Just as I said, it's signed. Right people, right mark. I bought it on guts."

"Then what is this?"

Yvgeney stared at some other markings under the seat rim but on the opposite side. A line of capital letters in a steady, careful hand, like a penmanship class, shining in the moonlight, suggested a hard, sharp pencil that pressed its message into the soft wood.

"DIESER STUHL IS DIE EIGENSCHAFT VON EVA BRAUN."

"What does that say, Yvgeney?"

"It reads, this chair is the property of Eva Braun."

"Jesus, that was Hitler's girlfriend." Wally mentally connected the dots. "And now it's the property of Claus Braun. Holy shit!"

Rae looked at Lucy. They smiled and shrugged, allowing the men to rant.

Yvgeney spoke. "I saw some photographs when I was in Serbia."

He paused. Pulling back this memory was like peeling the bandage off an unhealed wound.

"We were under a dacha of Milosevic ... Valerie and I were inspecting a pirate's den of art that the son of a bitch had acquired during the Balkan wars. I was looking at some framed photos in a corner when the explosion came. There was a photograph of Hitler, Goering, and maybe Himmler, in what looked like an underground

room. In the photo a woman was sitting in a chair, shaped like this one. I'd forgotten that photo. I buried it with the rest of that day. Until I saw the chair today."

Wally and Yvgeney said simultaneously: "He thinks he's Hitler's son."

"And now, he owns the chair, Wally. You traded it with him for the Stickley piece," Rae said, hands on hips.

Yvgeney felt uncomfortably exposed. He switched off Wally's Handel lamp and walked to the picture window. He looked out at the dark landscape beyond. A bank of clouds hovered over the dark slab of Whidbey Island. The dark waters of Elger Bay twinkled between dark, fat cedars. The yard itself was dark.

"Wally!"

It was Rae.

"Don't sell that man our chair."

She touched it cautiously like a finger to a hot stove.

"This chair gives me the creeps!"

"It's still a great chair, Rae."

"You told me he is about to publish a scientific paper, some things that might use my photos? He said it's coming out any day now. Oh, Lordy, he is about to announce proof of a separate line in the human evolutionary tree, one that leads to white folk. It's going to cause a sensation. Gonna piss off a lot of people. And then he announces that he's found his mommy's rocker. Pretty good media coup. More than the usual 15 minutes of fame, don't you think?"

"Sounds like the beginning of a political party. A pretty effective IPO for Claus Braun," Lucy said.

"Maybe more," said Yvgeney. "I was in the Future Club in … where was that, Brasilia? It's been hectic. In the basement, I found a classroom for weapons training, a weapons class."

He thought of his Mexican friend, Julio.

"Julio was on to it, God bless him. He had this guy nailed. And they got him." His face darkened. "I think the Future Clubs are part of a network."

"They're all over the world." said Wally. "In Afghanistan, Indonesia, India, the Philippines. Oh, oh. I see a pattern developing."

Yvgeney jumped in: "Julio had made up a list of persons of interest in his investigation for Interpol. Claus Braun's name was on the list. A guy named Baldessari was also on the list. His car was parked at the Buenos Aires Future Club. It was a Mercedes convertible, no, a Dodge Viper."

"They're flying into Seattle tomorrow with that Stickley thing," said Rae, accusingly. "What are you going to do?"

"That charming smile on Chana's face ..." added Wally.

"She's a big part of it," said Yvgeney. "That wasn't a charming smile. It was the pathological grin of a stone killer."

"We'll have to call off the deal somehow," said Wally. "He's not going to be happy after carrying that sideboard all the way up here."

"Not to mention missing out on his chance to rule the world," added Lucy.

"I have some phone calls to make." Yvgeney said.

He did some time zone math. "No, it's midnight there, I'll need a computer." Yvgeney's groggy mind had the military overdrive kicking in. "Rae, please bring Wally's shotgun out. And his shells. Wally, better go find those fake weapons that pissed off Rae last month."

"The paint ball guns?"

"Might buy us time. Do you really think he'll take a no at this point? I doubt it. The first thing we have to do is hide that chair. Hide it where a fanatic can't find it."

"Jesus Christ, this is America," Lucy said.

The Egg Rocker

Yvgeney said, "Not tonight!"

Chapter Forty-Two

Camano Island, Washington

"Hello, Walter? Walter Winchester? This is Claus Braun. I'm here in Seattle with your sideboard."

"Hello, Claus, this is Wally. I'm afraid I have some bad news."

"Oh?"

"Well, sir, when I got back, the chair had been returned from the refinisher. As you remember, the chair had a heavy brown paint overcoat."

"Yes, I saw the photos."

"Well, the refinisher took off the paint and he thinks, and I agree, that the chair is not old. It's a reproduction. I'm very sorry to have caused you this much trouble, but I'm afraid this trip for you was a waste of time. I'm terribly sorry. I hope this doesn't affect the quality of our relationship."

"I don't understand. I'm sure the chair is old. You bought it in Argentina at the estate of a retired nurse. She would not have a reproduction chair, and she certainly wouldn't have painted it brown and then died so an idiot like you could come down from the United States and buy it!"

"I'm sorry, Claus, I can't explain it. I feel terrible. I'm out 3500 myself."

"I don't believe you."

"I can send you photographs of the chair in its original state if you like. It will take me a little time to get hold of a digital camera."

"You have a digital camera. I saw it in my home. You showed me pictures of the chair on it."

320

"It broke. Got wet in South America. The rainforest, you know, but I'm sure I can get my hands on another one."

"I want to see the chair. Then I will decide."

"Of course, Claus. I can arrange for you to see the chair, new as it is. Please be prepared. Today is impossible. What time can we arrange a meeting tomorrow?"

"I want to see it today. I'm here in Seattle. I've transported this elephant-sized piece of furniture all the way from Chile! We had to wait for a 747 with bigger cargo doors. I'm very upset at what you are telling me, and I'm a busy man. Today is mandatory. I have much to manage back in Chile."

"It's impossible. I have to oversee an estate sale way up in Skagit County."

"It's 10 o'clock here now."

"It starts at noon. A one-day sale. It's been booked for weeks."

"This is outrageous. Is the chair at a place where I can see it? Perhaps your wife, the photographer, can meet me."

"She's already gone for the day."

"The Russian, your partner. Is he around?"

"Gone, too. Off to the San Juans with his sweetie … sorry, Claus. Tomorrow morning. Eight o'clock. Here. It's the earliest I can see you. I'll give you directions. You're in a great city, Claus. Seattle. Check out the art museum. They have a great Native American exhibit from the Hauberg Collection. Go to the Experience Music Project. There's a new Science Fiction Museum, another Paul Allen project, supposed to be a lot of fun. The Mariners are in town. They're worth a visit."

"Mr. Winchester, I'm very angry. It's a reaction that you should not take lightly. I will see you at your home at eight tomorrow morning. I know the way."

It was done. Wally called Constantine, his master refinisher, to see how the new chair was coming.

The rain began again around noon.

"Hello, sir, I'm at the gringo's cabin."

"Are you still able to listen to the interior conversations?"

"Yes, sir. The microphones are still in place from two weeks ago. I have the recorder on. The audio is operational."

"How many people are inside?"

"I have heard four, the gringo, the photographer, the Russian and the British woman."

"That shit. He said he was alone."

"No, sir, there are four."

"Can you tell if the chair is there?"

"It would be difficult for me in daylight to determine that, sir."

"Keep listening. Call me if anyone leaves. Winchester claims he's taking off before noon to run a sale up north."

"I would expect that is not the truth. It's almost noon now, sir. No one has left yet."

"Just as I thought. Is the second team ready?"

"Yes, they're in a car up on the South Camano Road."

"I suspect our Mr. Winchester is trying to back out of our agreement. Reproduction chair indeed! Schmidt was right about not trusting used furniture dealers. I've certainly known enough of them. They're worse than the Arabs."

"Yes, sir."

"Don't let the women slip through your net, child. Have them followed if they leave the island. I went to a lot of trouble to put that Stickley piece in Winchester's path. I'm amazed that he didn't take the bait."

"He took the bait, Señor Braun, but by the sound of their conversations, they've got a pretty good idea of what your organization is about to reveal. They have talked about the publication and about your connection with the chair."

"My chair. My legacy."

"Yes, sir, they don't seem to expect the day of the fires. Their concerns seem to be about your public relations."

"The fires will consume many that oppose me. No one betrays me and lives. Chana, don't forget."

"I am your sword."

"Don't lose track of the women. We need another incentive in our negotiation."

The rain now soaked her hair. It was of no consequence to a woman who learned adult lessons, too many adult lessons, when she was homeless and nine years old. A sound of soft footsteps took her attention away from contemplation.

"*Hola gato*, nice to see you again."

She reached down and stroked the misty, wet fur of the tiger cat. The gringo's cat. The one named Frida. A strong, friendly purr said, welcome back!

"We have to get you girls out of harm's way."

Yvgeney was working on limiting their exposure. He hadn't said much since Wally's call and his outrageous lie.

A string of e-mails to and from UNESCO headquarters in Lyon had used up most of his time. Wally had contacted Constantine again, checking on his hurry-up construction project. "The mahogany arrived this morning," Constantine said.

The old-world craftsman had complained to Wally that his fabrication wouldn't fool anyone who knew fine furniture. Wally

assured him it was fine, as long as it looked refinished. If it fooled no one it would be perfect. Just make it, paint it brown, and take enough of the paint off to reveal the new construction.

"I don't want to leave," said Rae.

Sandwiches and milk sat before them on the table. Lucy agreed. "You guys need more help. Where are the police? Where's NATO?"

"UNESCO has my briefing, but there are many levels of bureaucracy in the international community. My voice is just a retired one. I have no standing in the network. At least I have UNESCO's ear. Lyon's help will cut much red tape, but I don't expect any cavalry over the hills. We're on our own."

"It's just for a couple of days, Rae." Wally was talking again with his mouth full of food, but it was not a good time for retraining. "I have friends in that neck of the woods, hon. They operate a restored pioneer roadhouse for travelers. An old rustic inn. Called the Bush House. It's pretty there, right on the river. Please, Rae, take Lucy and spend a couple of days there. It's going to be very unpredictable here and worrying about your safety will limit our choices when the shit hits the fan."

"I'll keep my cell phone open in case you need us." Rae said. "Promise me you'll call us in if you're in a tight spot and promise me you'll take no dangerous chances. You're not bulletproof, you know."

Wally took another bite and was about to speak.

"And don't talk with your mouth full, for Christ's sake."

Wally swallowed. He said, "Take the van, honey, in case you find another Stickley sideboard in the boonies."

"Wally," Rae said. She took him aside. Tears moistened her eyes. "I want to tell you something. Something I'd forgotten till now."

They walked outside and she told him about the phantom cigarette and her conclusions about the exposure of her film plates. Wally listened, knowing that any information he could gather might be helpful when Braun showed up. As they spoke he thought about the Columbus Avenue sideboard, a collector's dream, sitting just south of them in Seattle. He kissed it goodbye.

Chapter Forty-Three

Camano Island, Washington

Chana met her mentor at the top of Wally's driveway and hopped into the back seat of a rented Land Rover. She was surprised to see Lucas-Schmidt beside Braun on the passenger's side. They made eye contact. There was no greeting.

"She looks like a drowned rat," Schmidt whispered to his boss. He was ignored.

"Hello, my child. Did you get any sleep?"

"Sleep is not necessary. It's a choice that I didn't take."

"Any movement?"

"The women left yesterday in the blue transport. They are planning to hide out in a mountain lodge. Our people are there. We can take them whenever we want."

"Good. Anything else?"

"A visitor last night after midnight. I believe it was the refinisher, Constantine. He delivered an object in a blanket, probably your chair. I had him followed by the others. We now know his location."

"Alas, but too late. He has no place now in our plan. Call them back. Let's go see this chair."

He put the truck in gear and rolled down the dirt driveway into a tunnel of wet green foliage that led to the cliff-edge bungalow.

"They're here."

"Rock and roll, Yvgeney. Ready to play some Indian poker?"

"Bring 'em on, comrade."

Wally's falsely happy face darkened when he saw Schmidt. It lightened a bit when he saw Chana exiting the back door. Despite the clear threat that he knew she represented, he couldn't help but remember the softness of her touch.

Braun looked presidential in a gray Armani suit, with a bright red and yellow tie that looked out of place in Washington's woods.

Wally said, "Come in, Claus. Welcome, Chana." He ignored Schmidt. "Do you want some coffee? It's local coffee. Ground daily at the north end of Camano. They support the natives in Guatemala, you know."

Braun brushed the offer aside and walked in.

"Where's the chair?"

"I can't tell you how sorry I am—"

"There it is."

Braun walked boldly without invitation into the living room. Chana followed.

Constantine's newly fashioned version of the egg rocker sat on the cheap Oriental rug. It looked much better than Wally had expected for construction on short notice.

Braun tipped it over and felt the new roughness of recently sanded wood. "This is not the chair you brought home," he said angrily. "I'm sure of it."

"I was just as surprised as you when the refinisher called and told me the bad news, sir."

"*Schrecklich! Furchtbar! Scheisse!*"

"It's the first time I've been fooled this badly in years. The shape is right, isn't it? The brown paint put me off."

"Do you think you are dealing with a complete fool, Winchester? I want the real chair, the other one. You have no idea who you are messing with."

"It's the only one I have. Honest."

"There are things you know nothing about, very big things. To me you are no more than a slug in the path of a bulldozer. Your life means nothing, and neither does the life of your beautiful photographer and her English tart of a friend."

Wally was shocked to hear the fuming madman refer to Lucy. Her presence here had never come up in any conversations.

Yvgeney stepped out of the back bedroom door at the words. Chana tensed and prepared for a physical confrontation. The Russian held the shotgun.

Braun spoke, "Perhaps you will tell us where the real chair, *my* chair, is? Perhaps you, my Russian friend, love your wife more than Mr. Winchester loves his."

"If you threaten Lucy I'll shoot you right now, you freak." Yvgeney raised the gun's blue barrel, giving Braun a look down a wide hole.

"Easy, Chana," Braun said. "He won't hurt me because he loves his English slut more than Winchester's chair."

Chana's pistol was pointed at Yvgeney's ear.

"Shoot him, Yvgeney," Wally said. "He doesn't know where the women are. Save the world another holocaust."

Chana had inserted her body between the shotgun and her boss.

"I think I can get you both at this range, girl," Yvgeney said.

Schmidt stood silently beside them, caught between hatred and fear. Braun didn't appear bothered by Yvgeney's aim.

"Yes, Russian, I have your woman. And the lady photographer, too. A hotel named Bush? You surprise me, Wally. I thought you more civilized than that. A hotel named after a president."

Yvgeney and Wally made eye contact.

"How do you want them, señors? Drawn and quartered? Roasted on a spit? They say the flesh of women under the charred skin tastes like pork."

"You bastard!" Wally croaked.

Schmidt smiled for the first time.

"I'm telling you. This is the only chair!"

"I don't believe you—I'll call you tonight with instructions. Tomorrow we will exchange the chair for the women. Do not call anyone. The police will only get your women killed. Both of them."

"Does this mean the trade for the sideboard is off?"

Yvgeney kicked Wally in the ankle as Chana opened the back door for an exit.

Guns still high, the visitors backed out of the house and stepped into their expensive rental. Braun rolled down the window.

"Nice house, Winchester. I particularly like the floor lamp next to your feeble attempt at deception. I think it's a Handel."

"It is a Handel. Fuck you."

The phone rang. Wally picked it up as Yvgeney grabbed the extension and put it to his ear.

"Do you have my chair?"

Wally looked to his partner who nodded. He said, "Yes."

"The original?"

"I want to talk with Rae."

"Do you have my chair? The one you purchased in Argentina?"

"Yes. I have the original chair. Sorry I tried to deceive you."

"I'm not a fool, Winchester."

"Let me talk with my wife."

"First we must agree on a meeting place. For the exchange. Two women for a chair. Sorry you miss out on the sideboard. Two

people died to get the bloody thing into your path. Now I have to ship it back."

"You can meet me here. Make the exchange."

"I tell you, I'm not a fool. A hundred police could hide in your back yard in the trees. Suggest another location."

Yvgeney shook his head no.

Wally bit his lip.

"Winchester?"

Silence.

A familiar voice reached Wally's ear, "Hi, cowboy."

"Are you all right?" Wally asked. "Have they hurt you or Lucy?"

Braun's voice returned, "Give me a location. One with a long line of sight, or I'll begin to remove fingers."

Wally heard a muffled scream. Tears welled up. He looked to Yvgeney who pointed to his heart.

"The Brit, you ass hole. I want to hear her voice also."

"No more games."

"There's a Catholic Church in Stanwood with a vast parking lot." Wally said.

"Tomorrow is Sunday."

In the earpiece Wally heard Rae shout, "Don't forget my photos. I love you." He heard the sound of muffled words. Then silence.

Braun's voice returned, "We can pull the fingers off with pliers or cut them at the knuckle with branch cutters. Which do you prefer?"

"Bastard!"

Wally heard a cruel laugh.

Wally said, "I know a bridge."

Chapter Forty-Four

Mount Erie Summit, Washington

Yvgeney and Wally sat on a rocky ledge with a view south of Puget Sound 1,000 feet below. A parks department steel panorama under glass sat before them, describing distant points of interest.

"There's Deception Pass, Yvgeney." Wally pointed to a string of islands in the distant fog. "You can't see the bridge from here. It's behind those trees over there. It's past that outcrop over there. Here. I'll show you on the map."

Yvgeney asked, "Is there a steel undercarriage on this bridge? Something I can approach on without being seen?"

"Beats me, Yvgeney. I've never looked underneath the bridge before. We're going over there now. We'll take a look. I just wanted to give you a sense of the landforms around the pass. Who knows what you military types need to know before a battle? I've seen those desktop renditions of the Battle of Gettysburg. I'm giving you a look at the board."

"Take me to the bridge, please," Yvgeney said.

"The bridge is just around the bend," Wally said as they cruised at 40 miles an hour through a grove of massive evergreens. He parked at a tourist turn out just before Deception Pass and they approached the span on foot.

The bridge was built in two parts: a short span that reaches an island, a hundred foot granite tooth jutting up from the channel, and a longer span that connects the little island to the other shore. Graceful

green metal arches lift both roadbeds over turbulent tidal rips 150 feet below.

As they entered a narrow pedestrian walkway beside the two-lane traffic, Wally could see the graceful arch under the second span ahead. The underside looked climbable. *For an acrobat*, he thought.

"Can we get a look under the bridge?"

"There's a walkway that takes you under the bridge when we get to the island," Wally replied.

They marched out over the frightening drop.

Vertigo gripped Wally as he looked over the side. Far below him, at the base of weathered gray cliffs, a rocky shoreline changed to swirling green tidal flow ringed with white turbulent foam. A truck passed by a couple of feet from Wally's ear. Its motion gave the bridge deck a foot-high wow, tripling his vertigo. He gripped the rail and moved cautiously ahead.

A vertical wall of gray granite rose up from the surf below as the roadbed met the jagged island sitting solidly in the swirling rapids of the narrow channel. Ahead, a sign said: "Do not cross the road to access the other side. Use the pedestrian walkway on island."

On the right, a set of stairs led down and under the road surface to the left.

"That's what I want," Yvgeney said.

Underneath the roadway, riveted I-beams zigzagged across the top of the arch, holding up the road. A posted sign read "Climbing on Bridge Prohibited." Access is a short leap with a 100-foot penalty for a misstep.

A climber could spend a week under here, negotiating the supports, Wally thought. *Hell, even I could climb that thing.*

As they reached the stairs up the other side, Yvgeney looked up.

"See," he said, pointing. "A man could climb out and over that pipe and gain access to the hand rail and then the roadbed. That's good. We'll have to set up some communication system, maybe walkie-talkies or a pager-beeper to signal some kind of action."

"What kind of action?"

"We'll figure that out later. Now, where are you going to meet?"

Wally walked out from under the roadbed to a broad spiral of concrete walkway that lead to a dizzying drop to the swirling foam below.

"Braun and I agreed to meet here, on the island," Wally said.

"That's no good. It's too exposed. Meet on the bridge instead. His bridge. The bigger one."

"We're both starting from opposite sides. We agreed to meet here."

"You two start the same time. You're walking the shorter bridge on the Anacortes side. Just walk faster, and you'll meet on his bridge, the big one. I'll be underneath."

"You're the general." Wally thought it answered nothing, but it sounded like a plan.

Yvgeney sat on the handrail, his back to the panorama of islands and distant mainland and the swirling flood below. He said, "I think I'll need a few things from the house. I'm going to bring anything that even looks like a gun."

Chapter Forty-Five

Deception Pass Bridge

Wally took the van. The true chair was wrapped in a blanket behind the driver's seat. The plan was simple: each party would walk toward the middle from opposite sides. Wally from the north, Braun from the south. He remembered Yvgeney's words: "Walk fast, ignore the island for a meeting place, and meet him on his span, the longer one."

He parked and carefully lifted the egg rocker out, kicking the door shut behind him. The chair wasn't heavy, just a couple of bentwood loops with a plywood seat and back. He walked briskly across the highway to the east side of the road.

With the sun just above the line of mountains to the west, he balanced the chair on his shoulder and walked out onto the bridge.

Braun herded Rae and Lucy ahead of him as he began his leg of the walk. Chana and Schmidt were beside Braun, followed by two others.

The pedestrian walkway is a single-file passage with a thin cable separating the walkway from the road beside it. Braun prodded the women forward with his entourage behind. They started across the bridge, lit yellow from the last rays of the setting sun. Traffic was sparse. "Keep moving!" he yelled at Rae and Lucy, their wrists plastic-cuffed before them.

The bridge dipped up and down to the rhythm of a monster semi that nearly brushed their shoulders as it passed. Lucy grabbed the rail.

"Keep moving. We're late," shouted Braun.

He carried a Ruger .38 in his jacket pocket. All were armed but Chana, who was her own weapon.

Wally was 100 feet out on the longer bridge, Braun's span. He carried the oval chair on his shoulder.

Fifty feet from Rae, his heart soared, trumping the panic in his gut. Her perfect face caught the setting sun, glowed like a plane of iridescent gold. Tears welled up involuntarily as they closed the gap. He nearly swooned, but checked himself, feeling the impact of her love and the full range of fears he'd denied himself till now.

"Hey, girl."

"Hi, Wally."

"You OK?"

"Will be soon," she said.

Braun brushed past Lucy and Rae in the narrow walkway, pushing them to the waist-high handrail with the dizzying drop below.

"Talk to me, Winchester. Let me see that chair."

He tried unsuccessfully to wrestle it from Wally's grasp. Without letting go, Wally tilted the bottom up for Braun's inspection.

Instantly Braun appeared younger, almost childlike.

"Ah, there's that little mark. Hello, J. & J. Kohn."

"Look at the pencil marking on the other rail, asshole," said Wally. They were on familiar terms now.

He angled the chair up so Braun could catch the glint of pencil lead in the waning light. He held on to his end with an iron grip.

Braun's face lost its remaining dignity. He cried "Aooooh!" like a little boy as he gazed at the handwriting.

"Hi, Mommy," he cooed.

"Señor Braun, where's the Russian?" Chana asked from behind him.

"Shush, child. In a minute."

335

He leaned and reread the inscription again, pulling the chair toward himself like a favorite childhood blanket.

Wally jerked the chair from Braun's grasp.

Braun reacted, reaching for his lost hold, but Wally held it behind him. In the narrow ledge saved for tourists on the road-edge, Wally bobbed like a cork to thwart Braun's advancing grabs.

"Señor Braun." Chana, at his back, spoke up. "The man-Yvgeney is a danger to you and your mission! I want to check under the bridge to see if I can find him. He won't be far."

"Suit yourself, my dear," he said without looking back.

Braun's head bobbed left and right as he vainly angled closer to his beloved rocker. Chana nimbly climbed over the outside rail and peered under the roadbed.

In his pocket, Wally pushed the talk button on the small walkie-talkie. Yvgeney felt the low buzz and flattened himself against the rivets. In the darkness of the undercarriage, he became part of the green-painted steel.

Chana craned her neck to the side and tilted her head up to inspect the understructure. The shadows were deepening. She looked casually down at the swirling currents far below, then climbed back up to the roadbed, taking her place behind Schmidt. Before her, the standoff continued.

Braun vibrated between boyhood and leadership. "You read the inscription, gringo?"

Wally nodded yes.

"Then you know the truth. You know now the blood that fills my veins."

"Yeah, you think you're Hitler, Junior, you fucking freak."

Braun laughed, a high-pitched giggle.

Jeeze, the guy's losing it, thought Wally. His eyes locked onto Rae's behind the ranting dandy.

"The world will know. Very soon. The wheels are in motion. When Schmidt's conclusions are published and when the press reception shows me as the legitimate inheritor of my father's vision ..."

Wally watched in amazement as Braun's right arm snapped up into a German salute that he suppressed and pulled back to his side.

"It was just a paper trail, you know, Mr. Winchester, till you found the chair. I was told things as a child, shown documents and photos of my mother and me in the chair you hold. I was groomed and nurtured, always preparing for the day when I would lead. Schmidt here provided one key with his discoveries. You are now handing me the other. The fires of revolt will soon be burning. Now give me MY CHAIR!"

Wally's body blocked Braun again, holding the oval rocker out of his reach.

Another voice interrupted the battle of wills. It was Rae's.

"I have the photograph, Schmidt. I bet you thought they were all destroyed."

Schmidt, behind her, bumped past Lucy to confront Rae. His white hair glistened in the misty setting sunlight.

"I don't know what you are talking about! Don't listen to her, Braun!"

She continued, aiming her voice at Braun, "I captured the unearthing of a cigarette—three inches *under* your landmark discovery. A Winston, I think. You know the object, professor, the one that's part of the basis for your conclusions about the South American master race."

Schmidt's blue eyes widened in rage.

"Yes, Schmidt. That one." She turned to the Chilean, whose face was crinkling into a confused scrunch.

"*Under* it, Mr. Braun. Your boy here found a Winston *under* the object, before he lifted it from the earth."

Braun looked directly at the German archeologist. He had a questioning tilt to his head.

"I think the good professor here's been salting your goldmine, Mr. Hitler."

Rae looked at Schmidt, then Wally.

"Hey, sweetie. Did you find the photo where I hid it?"

"Sure did, hon."

He reached into his unbuttoned shirt and pulled an 8 x 10 glossy from his waistband. He passed the wrinkled sheet to Braun.

A soft-edged pinhole image depicted a seated Schmidt next to a partially uncovered, pockmarked metal slab. Blurry motions turned the arms and hands into smears of movement.

A barely formed image was circled in fluorescent orange marker; an exposure of 30 seconds in a two-minute shot. It was clearly the filter tip of a cigarette butt, emerging from under the Paleolithic relic.

"What's this, Schmidt?"

Braun's shoulders grew wider and higher as his outrage grew.

"A workman's castaway perhaps. Who cares? Get your chair, kill the man and his women, and let's get off this bridge."

"There goes the new master race theory, Claus, laughed out of town as a bungled forgery." Wally was winging it, but the idea seemed to put Braun on his heels.

"Did you send the photo to the *Seattle P.I.* with an explanation, honey?" Rae smiled into the amazing light blue angry eyes directly in front of her.

"Photo's in the mail, as they say. Sent it this morning."

"The *P.I.* and every other newspaper in the world will either portray you, Braun, as an inept counterfeiter or the fool who hired one.

So, go public with your new theory. Go on! Ought to create some good chuckles in archeological circles."

Braun spun and pulled his pistol. He swung it toward his scientist and pulled the trigger.

Chana, behind Schmidt, felt a sheen of brains speckle her face. The dead man collapsed in a heap.

Yvgeney, under the fat conduit beside the rail, scrambled up at the sound of the shot. As his head cleared the road surface, he looked at a pair of legs near his grasp through the vertical railing. One of Braun's people, he could see. He couldn't tell which.

The legs moved forward.

He grabbed the foot and yanked; the man stumbled, lost his balance as a Winnebago Wanderer, with oversized side mirrors, drove by and caught the fellow's head. The force of the impact slammed the mirror into the passenger window, cracking it into little squares.

Chana caught the movement behind her and turned back to see an arm vanish over the side. The inert body, still, broken and useless at the side of the road near Braun and the women held no interest. "That was the Russian," she said to Braun. "He's under our feet."

Brakes screeched on the damp macadam. A horrified, stout bald man ran around to the passenger side and gasped at the grisly scene.

"Chana, please go and kill that Russian man," ordered Braun, looking over the side.

She was already making her way over the rail to find a handhold and access to the underside as she spoke.

"What are you talking about? What's going on here?" the tourist demanded.

"Oh, I don't need this." Braun said. He was almost whining. He casually swung the Ruger over and shot the vacationer in the heart. The man crumpled and fell like a stone.

Braun looked to the other South American and said, "Come here, you fool."

He stepped over the fallen scientist. "Get all this garbage into the RV and drive it off the bridge before anyone else drives by. Park it where it won't look odd and hurry back."

The man nodded and began pulling bodies up into the open side door. He zoomed away just as the next vehicle rounded the curve toward the bridge.

Chapter Forty-Six

The gloom under the bridge deepened; Yvgeney lay flat on a one-foot I-beam when he saw Chana's legs swinging inward for a platform underneath. It was time to move. The long featureless diagonal strut looked frightening. No crisscross steel or handholds till it made an "X" in the middle, far above the darkening currents.

He wrapped his arms around it and slid down toward the center. There was safety and some help on the other side. Friction burned his hands. His extreme fear of slipping off the narrow flat surface and ending up underneath the beam made his hands slippery. If he did manage to hold on after that, Chana could shinny down herself to pry his fingers off the steel. He felt his foot meet the crossbeam and stopped, still hugging the metal to his chest.

Straddling the lower section, he continued the descent to the top of the opposite arch. A minute and a half of held breath came out in a *whoosh*. The Amazon was following. He was not surprised.

"You've been waiting for this for a while now, haven't you, Chana?" Yvgeney's voice echoed in the under chamber.

"Yes, Yvgeney," she said as her sliding feet met the opposing I-beam. "It's time for us to have a dance."

For Yvgeney, moving on the flat arch was relatively easy. A broad slope of riveted green angled gracefully down to the low point where it met the granite wall of the island. Strut by strut, he made good time, knowing that his pursuer held all the cards, leaving him with nothing but the joker.

A glance behind showed her gaining, moving fearlessly. Five feet from the edge of the cliff, the I-beam terminated at a cement slab that joined the two.

Below him white and dark green whirlpools swirled and dissolved into upwelling coils.

It was dark now under the span. Yvgeney slapped his hand up across the dusty top of the concrete block beside him and reached for the shotgun. Chana was closing quickly, 20 feet away. Even in the twilight he could see her face, expressionless, as she neared. He watched her eyes and reached back to the concrete ledge behind him, feeling for the 12-gauge he'd stashed there. As he grabbed the stock, it squirted from his grasp and tumbled over the side into the dark water below. His hand flailed behind him, hunting for the backup piece. There. The plastic stock scraping on concrete identified the gun he'd grabbed. His heart sank as he pulled the paint ball replica into the battle.

He felt the cool grip in his fingers as his adversary reached the landing.

Chana neared the Russian and instinctively leaped.

He pulled the trigger and an odd muzzle sound echoed around the undercarriage.

Chana looked down to see three green splatters on her shirt.

Yvgeney leaped. His big hands connected with Chana's shoulders in mid-jump. Locked in a death embrace, they hurtled together over the side.

Two cars drove by, illuminating four people standing tensely on the center span.

Braun made another lunge for the chair. Then he smiled a madman's smile. "You have to die anyway. Why am I wasting my

time? My family must live to go forward." He turned to the shackled women behind him and raised his pistol.

"I'll kill your girlfriend, your meddling girlfriend, first. Just so you can watch her die."

"Hey, asshole!"

Braun turned back to see the rocker suspended in space outside the rail. The dark shapes of the narrow pass and the broad swell of water behind them formed a backdrop for his chair. Wally's arm ached as he held on to the back of one oval, his arm straight out. Tendons burned but the effect was devastating.

"*Mein Stuhl,*" the South American moaned. "Don't drop my chair. Everything now rests with my possession." His face twisted in an ugly caricature, he moved toward Wally, but Wally's shaky extended arm stopped the advance.

"Now, now, Claus. We wouldn't want me to drop it now, would we?"

He faked a dip and watched the frantic man react.

Forty thousand dollars, Wally told himself. *Coolest thing you ever bought. Nearly killed yourself getting it. Nearly lost your girlfriend getting home. You got to own it for about two weeks. What else is new?*

"You know what, asshole?" Wally's eyes were clear.

Rae could see his thoughts, so could Claus Braun. He looked at his useless gun.

"You know, Braun, fuck you and your Future Clubs! Fuck you and your world domination!"

Wally opened his hand and watched his egg rocker float down and down and down toward the dark water far below.

"No!" Braun screamed, "Mommy!" He arched his upper body over the handrail and vainly willed it back.

With a flash of phosphorescence, the egg rocker entered Puget Sound with a tiny splash.

Still handcuffed, Rae watched the wailing Braun lean far over the void below them. She glanced at Lucy beside her. Together they reached down and grabbed an ankle each and lifted.

There was no time for Braun to react. Equilibrium shifted to his chest as his feet left the pavement.

He went over the side rail feet up and bounced against the fat conduit, the pistol falling from his grasp. He flailed for a handhold but the smooth metal pipe was featureless and round and wet.

Bewildered, he looked up as he fell.

Sirens screamed in the distance and grew louder as echoes bounced out to the Deception Pass Bridge off the trees. Out on the long southern span three figures stood against the handrail and looked down.

Wally held Rae tightly to his side. Damp blonde hair spilled over his shoulder as she sobbed.

Lucy looked down into the water. Tears ran down her cheeks. "Where's Yvgeney?" she asked. Cupping her hands, she shouted his name into the dark passage below.

Rae left Wally's arms and went to her friend. She held Lucy as she sobbed. Wally peered into the mist. He saw no life in the whirlpools below. He said, "He saved our lives, Lucy."

She wailed louder and collapsed onto the roadway. She regained her footing and dashed to the rail. "Yvgeney!" she cried into the abyss.

Wally grabbed her shoulders. "Come with me," he said, and sprinted for the island. Lucy followed.

Under the span now, he looked out at the ironwork frame. Darkness. He shouted Yvgeney's name but heard no response. On the concrete at his feet he noticed spots of fresh liquid. Blood. He fought a

shiver. The fluid felt sticky to his touch. He held the tips into a yellow glow from lights above. The blood looked green. *The paintball gun*, he thought. *Yvgeney was a fighter till the end. The poor bastard. He faced a killer with a toy.*

Yvgeney," he shouted again. Lucy repeated the call.

A small sound from below came back. "Wally, the current is strong; I'm cold; the wall is slippery. Send a boat."

"Yvgeney?"

Lucy added, "Yvgeney!"

"Send a boat. I'm freezing."

"Do you see a chair floating nearby?'

"Send a fucking boat. Chairs float. Russians sink."

Wally bolted up to the roadbed and an ocean of flashing lights.

Chapter Forty-Seven

Camano Island, Washington

"You have a habit of falling into water during crises, you know."

Wally swirled a San Michelle Merlot in his glass, watching the vintage claret clinging to the inside.

Yvgeney shrugged in a Russian way. Three Band-Aids crossed his cheek. A bigger pad of gauze covered part of his skull.

"I came up under that cut-away. Tremendous hydraulics under there. Slammed me into the wall again. This antique business is rougher than I thought."

Lucy kissed his undamaged cheek.

Rae stoked the burning fireplace wood taking the nip off a Northwest starry night, and waited till the conversation waned. "Hey, Wally," she said, "in the excitement, I forgot to tell you. Your pal, Mike, stopped by this afternoon with something the boaters found while searching for Braun and your Amazon friend."

She narrowed her eyes into slits, and smiled again.

"The chair?"

Wally leaped up and looked around the cozy craftsman room.

"It's over here," said Rae.

She lifted a blanket to reveal a soggy brown seat and part of the oval cutout that had decorated the plywood back.

"That's it?" he asked

"That's what the tide brought in."

He lifted the seat and looked underneath. Strands of seaweed still wrapped around the broken back post. There were no ovals, no egg-shaped elegance of form now, just part of a seat.

"You can still read the pencil marks, Rae. Maybe we can sell it to an autograph collector or a Nazi nut."

Three mouths opened in protest and he nodded agreement. He stood up and tossed the remnant into the crackling fire. It sat there steaming, as if resisting the ending of a family line.

I'm burning a chair to keep warm, Wally thought. *Chana would be pleased.*

EPILOGUE

Camano Island, Washington

"There's an article that you might be interested in, babe."
Rae passed the *Seattle P.I.* over to her breakfast partner.
"We'll have to e-mail it to Yvgeney," she added.

"I'll be contacting him anyway tonight. The Scottish curtain panels will be sold by then. What time is it in England right now? Must be evening. Hope they make the reserve."

"Ninety-nine thousand dollars is a lot of money to hold out for. Sure you didn't price it out of reach?"

"If they can get a million-five for a Mackintosh desk, honey, a Margaret MacDonald embroidery for under 100,000 is cheap. Besides, we're splitting with the rain forest church."

The newspaper article said that a rare Gustav Stickley sideboard, the one purchased by Barbra Streisand for a record $363,000 in 1988 and stolen from the New York stockbroker, James V. Hill, during a robbery last summer, was discovered in an unpaid storage unit auction near Sea-Tac Airport.

"There goes the Columbus Avenue miracle," said Wally, shaking his head and turning the page. "I thought it was too good to be true."

"Hey, here's a story." He continued, "It seems that there's a serial killer loose in Manaus, Brazil. We went there. It's a really big city in the middle of the rainforest."

Rae sighed, and said, "Yes, I know about every city and every stitch you received, and all the cool things you saw. Everything you

did in South America is etched in my brain, my hero. Lucy, by the way, wanted me to ask you about an evening in the rainforest."

Wally cut her off with the rest of the article: "Known child molesters have been dying like flies in Manaus. Twelve were found murdered in a single week. The newspaper down there had published a number of names as part of a police report. Seems that someone is using it as a checklist, like a collector. The police are baffled."

He looked at the glowing embers in the fireplace and remembered the sputtering of the beechwood oval when it burned.

Rock and roll, Chana. Wally thought. *I'm glad you finally found a hobby.*

Jack Gunter is a prominent Pacific Northwest writer, artist, and antique dealer who specializes in twentieth century decorative arts.

With a degree in biology and graduate training in organic chemistry, he was teaching school in Massachusetts in 1973 when he wrote and illustrated his first book, "The Gunter Papers," which he describes as a futuristic junior high school science curriculum.

A self taught artist using the ancient technique of egg tempera painting, he exhibited his large format works in several New England museums and was included in an Andrew Wyeth and Family show in the Sharon, N.H. Art Center in 1979. That year a studio fire claimed all of his existing paintings and landed him in Washington State with a pick up truck, his dog, and the clothes on his back, relocating because in Puget Sound he was the only person in a thousand mile radius who wanted mission oak objects and the Northwest was chock full of Mr. Stickley's furniture.

Since moving to Camano Island he has created over one thousand additional paintings, three movies as a SAG indie filmmaker, and four books -- an illustrated guide to Northwest history narrated by a flying pig and three novels in the Wally Winchester adventure series.

He lives in a cliffside cabin with views of the Olympic Mountains, eagles, and spouting whales out his front window.

CPSIA information can be obtained
at www.ICGtesting.com
Printed in the USA
FFHW021435050719
53407550-59116FF

9 780984 184118